WHERE
IS
AFRICA

EMANUEL ADMASSU
ANITA N. BATEMAN

WHERE /S AFRICA

VOL. 1

CENTER FOR ART, RESEARCH
AND ALLIANCES (CARA)

INTRODUCTION

Where Is AFRICA Vol. 1 has been a multiyear, extended set of exchanges with contemporary artists, curators, designers, and academics who are actively engaged in representing the continent—both within and outside of its geographic boundaries. By examining artist collectives, new currents in art history, and the rise of contemporary art festivals in and about AFRICA from the past ten years, the project seeks to unpack the imperialist foundations of cultural institutions and their anthropological fascination with African objects, people, and places.

In 2017, Anita N. Bateman, PhD, and Emanuel Admassu initiated research on the traditional positioning and mispositioning of the arts across the continent. This book emerged from their shared antipathy to deeply inscribed hegemonic Western canons of art and architecture, which are reiterated in art school curricula and museum culture. Recognizing that they had questions—and criticisms—about a supposedly "globalized" art world that is elitist, cliché-ridden, self-referential, and limited in its range of inquiry related to AFRICA and its diaspora, they began a series of conversations to connect diasporic and continent-based people of interest. These conversations led them to New York and Dar es Salaam, Addis Ababa and Boston, in search of the connective tissue that links people of African descent across the diaspora through visual culture and a shared commitment to authorial reclamation. At the same time, the book challenges any concept that would represent an authoritative voice for a vast continent, which is home to over one billion people.

A NOTE ABOUT PROCESS

Where Is AFRICA reflects many entry points into an inherently interdisciplinary conversation about art education and the equitable representation of African ideas, intellectuals, artists, and educators. The project begins by accepting the premise that placemaking is an elusive endeavor in postcolonial contexts, and it proposes an elastic definition of geographic and disciplinary positioning to engage with artists, designers, and academics who are actively making "AFRICA" by short-circuiting systems of global inequity. Refusing to forge a unified image of a culturally diverse region, instead it considers access, movement, and transformation as compulsory imperatives to a sustained and critical discourse on contemporary cultural production. The conversations herein were created and conducted through collaboration with participants. In instances where one editorial voice is present, questions were either formulated in conjunction with, or passed along from, the nonspeaking editor.

7

FOREWORD

MABEL
O.
WILSON

cartographer
mapping contour
and structure
shape
the serene elevation
of silence

M. NourbeSe Philip, *Looking for Livingstone*

Observed from voyages that skirted the thousands of miles of coast whose contours were then traced onto countless maps, AFRICA became for Europeans a space into which they poured centuries of desires as well as scorn. They scribed empty white pages with black lines composing maps, diaries, ledgers, engravings, and stories of AFRICA — some practical, others historical, and a few phantasmagorical. "Africae," "L'Afrique," " AFRICA " served as a canvas for the projection of Europe's colonial imagination, conjuring signifiers of whiteness that affirmed their superior countenance. Merchants and explorers mapped the continent's terrain from the coast to inland regions in order to best determine from where to extract its golden and human bounty. A signifier and place, " AFRICA " stimulated reason's quest to know and incited capitalism's need to possess.

On archival maps of AFRICA drawn by white cartographers, we can find documentation of vast kingdoms, like those on a 1554 German map that named the "regnums of Melli, Senega, Nubia, Melinde, and Orguene" across the upper half of the continent, while parrots and a tusked elephant demarcated the unknown, geographically diminished "Africae extremitas" to the south. That same map also envisioned fantastical creatures like "monoculi," cyclops-like beings believed to reside in the Niger Delta. Dutch cartographer Willem Blaeu's equally enigmatic map from 1644 depicted flying fish and mythical sea horses swimming in the "Oceanus Aethiopicus," the South Atlantic Ocean. As empires fell and monsters faded under the rapacious appetites for commerce of European explorers and merchants, including the trade in human flesh, maps like the one by English cartographer Herman Moll, published

in 1710, embellished regions with racialized monikers such as "Negroland" (the nations of Mali, Burkina Faso, and Niger—located above extractive shores of the "Grain Coast," "Ivory Coast," "Gold Coast," and "Slave Coast" (today, Côte d'Ivoire, Ghana, Togo, Benin, and Nigeria). When the trade evolved into the colonial project of territorial domination, seventeenth-century Dutch cartographers began to include *cartes-à-figures* that populated the edges of their maps, such as the pair of Moroccan merchants in the North and the half-naked inhabitants of the Cape of Good Hope in the South in Blaeu's map of 1644. Representations that portrayed AFRICA's strangeness, darkness, backwardness, and savagery filled Europe's archives, libraries, and galleries. Collectively, these documents spurred further colonial expansion and validated exploitation by spinning popular and scientific narratives of difference in terms of who and what counted as modern in the West's universalizing episteme.

Amid this cartographic and historical project, European imperialism (which was embraced by their colonial descendants throughout the Americas) found perfect expression in the nineteenth-century World's Expositions where the descriptive two-dimensional diaries and maps were extruded into three-dimensional displays of might and promise. *The Great Exhibition of the Works of Industry of All Nations* (1851), for example, was housed in the Crystal Palace, whose glass and iron enclosure rendered Britain's imperial bounty from AFRICA, India, and the Caribbean visible and legible, but most importantly desirable to British subjects and foreign visitors. To commemorate the occasion, British cartographers and cartographic publishers released *The Illustrated Atlas, and Modern History of the World, Geographical, Political, Commercial and Statistical* (1851) whose title indicates how the vast territory of Empire was maintained by a massive bureaucracy of public, private, and military interests. *The Illustrated Atlas*'s map of AFRICA was a palimpsest of cartographic representations of the continent that included ethnographic representations of habitat, flora, fauna, customs, dress, architecture, and climate—all the requisite signifiers for how culture ranked racial groups from primitive to civilized. It is precisely these representations of savagery and Blackness that animated the emerging technologies of moving pictures and photography and informed the new sciences of anthropology and race.

Imperialist fervor reached its apotheosis at the Berlin Conference in 1884, where the heads of Europe's nations carved AFRICA into discrete colonial holdings to more efficiently extract its precious resources to feed industrialization and national coffers. In his work *Scramble for AFRICA* (2003), artist Yinka Shonibare restaged this

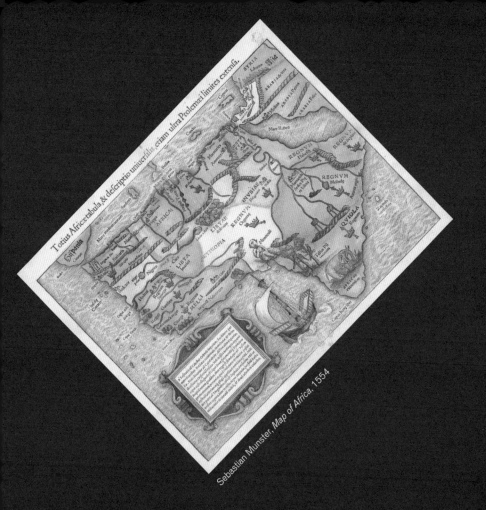

Sebastian Munster, *Map of Africa*, 1554

historic scene at Berlin with fourteen headless fiberglass mannequins. He clothed the diorama's characters in brightly patterned Vlisco Dutch wax fabric, emblematic of colonial trade routes that circulated between cotton production in the colonies and textile manufacturing in the metropole. Shonibare poses the group, each figure gesturing to the others, around a long wooden conference table etched with the outline of the African continent, perhaps emphasizing how exoticized woods harvested by colonial powers were used by designers and craftsmen to build tables, chairs, doors, and cabinetry found in bourgeois and aristocratic homes in cities and the countryside. Shonibare eliminates the physiognomic markers observable in each figure's skull, face, and profile that were key characteristics necessary to affirm the superiority of the white race and their natural right to lead Africans out of darkness. Perhaps even more relevant, Shonibare's decapitation renders the figures voiceless, hence one aspect of the historical record — testimony and narrative — is silenced.

M. NourbeSe Philip, in her novel *Looking for Livingstone: An Odyssey of Silence*, writes about a Black woman who follows in the footsteps of the British missionary, explorer, and physician David Livingstone, known for having crossed from Angola into the inner regions to Mozambique. She imagines a conversation between

the unnamed woman and Livingstone: "'No, Livingstone-I-presume, you did not. Shall I tell you what you did?' He was all huffy again at my interruption and merely shrugged. 'You captured and seized the Silence you found — possessed it like the true discoverer you were — dissected and analyzed it; labelled it — you took their Silence — the Silence of the African — and replaced it with your own — the silence of your word.'"[1] What was withheld and not told? What places remained hidden and not found? Who refused the gaze and thus disappeared from the narrative and from the map? Blank page. Black lines upon black lines — written and drawn. Eventually a black page. What are AFRICA's other stories?

If we were to abandon the omniscient birds-eye view central to cartographic communication and logic, can AFRICA be known and experienced in other ways? What if we learn place through dialogue, memory, and everyday practices in order to construct what theorist Mpho Matsipa calls a "counter-cartography" that overrides and short-circuits colonial infrastructures of extraction and domination? This is a different way of knowing, one that aligns with Katherine McKittrick's project of "how we come to know [B]lack life through asymmetrically connected knowledge systems."[2] *Where Is AFRICA* shares dialogues unfolding in cafes, art schools, and galleries from Dar es Salaam to Cape Town to Addis Ababa to Brooklyn. As people share their narratives of home and migration, these trajectories take us not only across town but also across continents. In theorizing the "dialogic," Mikhail Bakhtin posits that all language is referential and relational. In this way, discourse is never a monologue, but instead woven from dialogues between people and across texts, whose temporalities and spatialities move in multiple directions rather than along the West's teleology of Progress. While educational and professional institutions serve as catalysts, the dialogues of *Where Is AFRICA* share how art, architecture, and design practices transgress disciplinary boundaries to learn from everyday spaces of cities in AFRICA and its diaspora to transport us to other possible futures.

1 M. NourbeSe Philip, *Looking for Livingstone: An Odyssey of Silence* (Stratford, Ontario: Mercury Press, 1991), 69–70.
2 Katherine McKittrick, "Curiosities (My Heart Makes my Head Swim)," *Dear Science and Other Stories* (Durham: Duke University Press, 2021), 3.

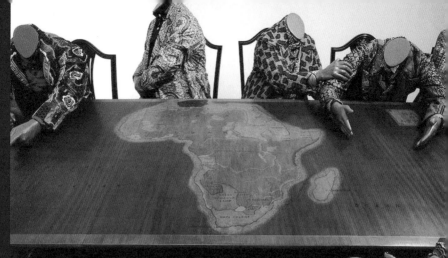

13

INTERVIEW WITH

SALOME ASEGA

EMANUEL ADMASSU
You're first generation African American.

SALOME ASEGA
Yes.

EMANUEL
Born and raised in Las Vegas, to Ethiopian immigrants. Is there an attempt to resolve
the friction or overlap between these conflicting layers of influence and sensibility?
It was interesting to listen to your *Hyperopia* interview, actively questioning specific
labels that people try to impose on your work and your identity. One of the terms
that came up was the notion of a translator — maybe because you have always been
actively translating between multiple identities?

SALOME
I like to think of my practice as an active practice in translation, reinterpretation, and
negotiation with collaborators. I try not to center myself in the work, and instead
collaborate with other artists to learn all the ways we exist in multiplicity. I think of my
practice as storytelling that honors legacy, community and my traditions.

EMANUEL
So, it's been productive to think of yourself as a translator?

SALOME

Yes, although there is a power dynamic I want to acknowledge in the term translator. When I make work it's very much situated in a diaspora identity. I'm making work that can't be distinctly "tagged" to place defined by borders. It's just of the diaspora, as a global player, as someone who moves between nodes. But also, when I make work, I ask myself, can my Ethiopian mom understand this?

EMANUEL

Absolutely.

SALOME

And that's always a filter when I produce something, is this legible to her? Would this resonate with her? So much of how I learned about a "Black experience" happened in school learning history, which started with the transatlantic experience. And so, I'm caught in-between. Ethiopian representation in the US is also very limited in scope.

EMANUEL

In your *on the line* series, you make postcards from digital, archival images and then send them to your grandmother. Can you talk about the functional aspects of the digital versus archival in your artistic practice? And the idea of a multitemporal collapse as a visual strategy.

SALOME

We are living in an increasingly tech-enabled world, and our arts and archiving institutions, specifically those that focus on African diasporic culture, need to build a digital brawn to ensure we will see ourselves in the future. So, as we move into a more technological and digital space, I'm coming at it with this rigor of ensuring the things I care about will be on record. *on the line* was just a silly thing I started doing when I was having Skype issues with my grandmother. Our calls were never fruitful, her access to internet is limited. So I decided to try the mail. The first time I went to Addis, I found a bag of photographs underneath my mom's old bed. I don't think anyone had known that those photographs were there, so I started going through them, and realized my grandfather kept meticulous notes on the back of all these photographs. They had dates and the names of the people who were in the images. This is an archiving practice, and it was just in a bag under a bed. I scanned them and sent disks to all my family members of all the images. They were seeing themselves again. They were OK with just having them as memories, but now they

also have physical, or I guess, digital references to our family history. Then I started taking it a step further, manipulating the images in Photoshop, or running them through simple algorithms and then printing them as postcards. I started communicating with my grandmother that way, because the Skype drop call situation was not cute. I was sending her these postcards, but I think only one has ever made it to her, because of, I don't know, infrastructure. Our two countries' systems for sending and receiving mail are very different, but equally frustrating. But part of what I still love about that project is that the postcard has been touched by so many people. So even if it doesn't get to her, I like the idea that images of my family, of Ethiopian people in the 1960s and 1970s in suits, looking fly, dancing, drinking wine, have traveled outside of the US, and, at minimum, it's joyful, unlike usual images we associate with Ethiopia.

EMANUEL
You're taking a physical artifact and disseminating it online, and then, roping it back and making another physical artifact from that process. Are you actively investigating how your practice goes back and forth between the physical and the digital realm?

SALOME
Yeah. The Silicon Valley ethos is that technology is expansive, we're reaching more people, and I'm always trying to figure out how to break that, how do I make Tech hyperlocal, like super local? It's by creating artifacts, creating physical objects that people have to come to or physically share with each other. I'm interested in how Tech can call, or ask, or require someone to meet in person.

EMANUEL
But it also seems like you're interested in the mistranslations, the fact that this postcard didn't make it to your grandmother, but it is potentially sitting in someone else's living room somewhere in Ethiopia.

SALOME
It's strangely beautiful that my glitched, pixelated image of my grandfather is somewhere in the world, with a love note to my grandmother. It could easily be found, which is also a funny thing. If it has landed in someone else's home, all it takes is a Facebook search, you know, to be like: "Yo, I have your postcard." It's just funny that mail and radio are still these things that have transmissions, but the receiving part is difficult. Things go out, but you never really know if they have been received.

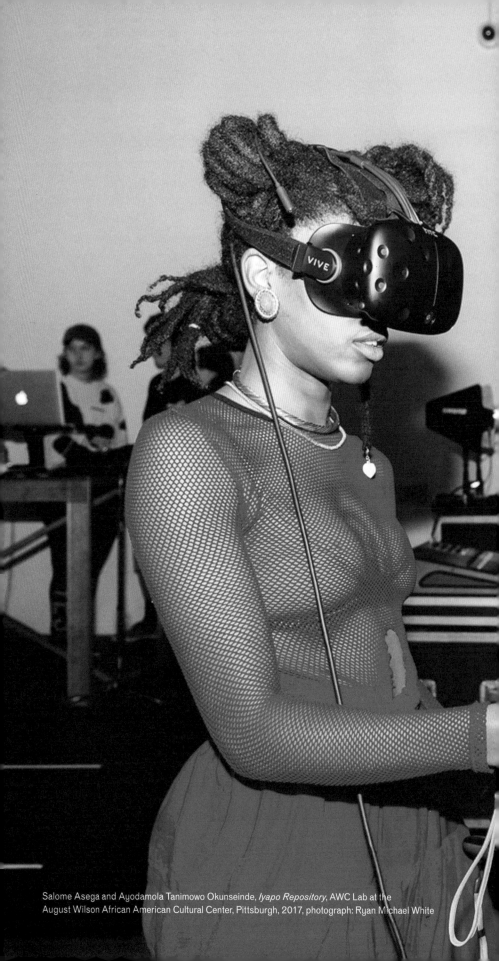

Salome Asega and Ayodamola Tanimowo Okunseinde, *Iyapo Repository*, AWC Lab at the
August Wilson African American Cultural Center, Pittsburgh, 2017, photograph: Ryan Michael White

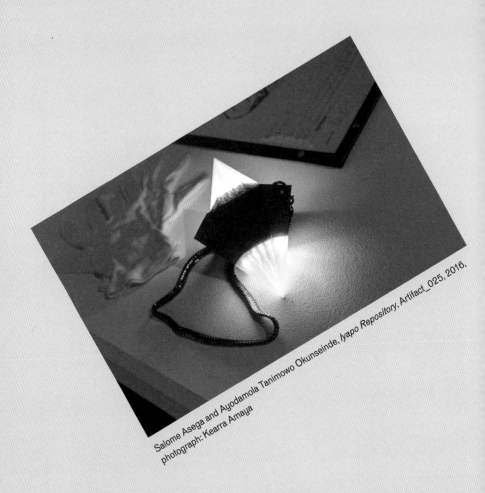

Salome Asega and Ayodamola Tanimowo Okunseinde, *Iyapo Repository, Artifact_025, 2016,*
photograph: Kearra Amaya

EMANUEL

We could potentially relate this to the goals of *Iyapo Repository*, in which partici-
pants become archivists of a future history they envision. And the ambition is to col-
lect African technological artifacts. In doing so you are facilitating a transformation:
an individual that was walking down the sidewalk, all of a sudden, becomes the
producer of an archive. And this seems to be a common thread across your practice.
How does the conflation of different temporalities affect the circulation of images
and artifacts?

SALOME

This project is thinking collectively about a past and coming up with a collective
narrative. Documenting the present and designing a future together is something

our diaspora does very well. We're able to time-hop simultaneously, we're able to be in both the present and the future at the same time, i.e. Drexciya or Betty Davis. *Iyapo Repository* provides some tools and design strategies to ask: what do you want to see for your future? And I've learned that in our workshops, we're not exactly designing concrete plans for a future — maybe in terms of aesthetics and style — but for the most part, I'm hearing about a past that hasn't been recorded and a present issue. When we started the project in 2014, a majority of the sketches and artifact ideas that were coming out of our workshops were about police brutality or unjust policing in the US. In 2015, a lot of the things coming out of our workshops were around clean food, access to clean water. It's the same year we started seeing things in South Dakota and specific land rights issues, we were also seeing more Flint media reporting in 2015. In 2016 there was anxiety about documentation, a lot of anxiety around voting and representation. And, you know, these are futurist design thinking workshops...

EMANUEL
But what they're really documenting is the present.

SALOME
The present!

EMANUEL
It's also interesting that these ideas from the *Repository* serve as points of departure for pieces that were further developed by you and your collaborator, Ayo [Ayodamola Okunseinde]. You mentioned in your presentation that the work is not necessarily futurist, but quite simply a design thinking workshop. Is it safe to say that you are interested in giving value to ideas and sketches that would often be discarded by cultural gatekeepers?

SALOME
Absolutely. I think design as a practice seems to require a certain type of literacy that claims, if you don't have the education or professional experience, you're not a designer. But we design every day. Everyone does that sort of thinking and you don't need institutional paper to recognize that type of work, that type of labor. So, we just wanted to design things collectively.

EMANUEL
You're expanding what it means to be a designer?

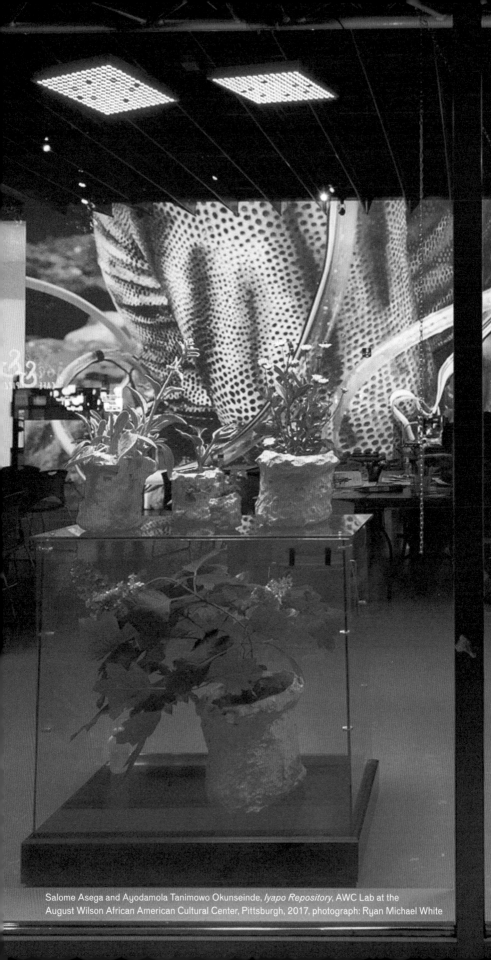

Salome Asega and Ayodamola Tanimowo Okunseinde, *Iyapo Repository*, AWC Lab at the
August Wilson African American Cultural Center, Pittsburgh, 2017, photograph: Ryan Michael White

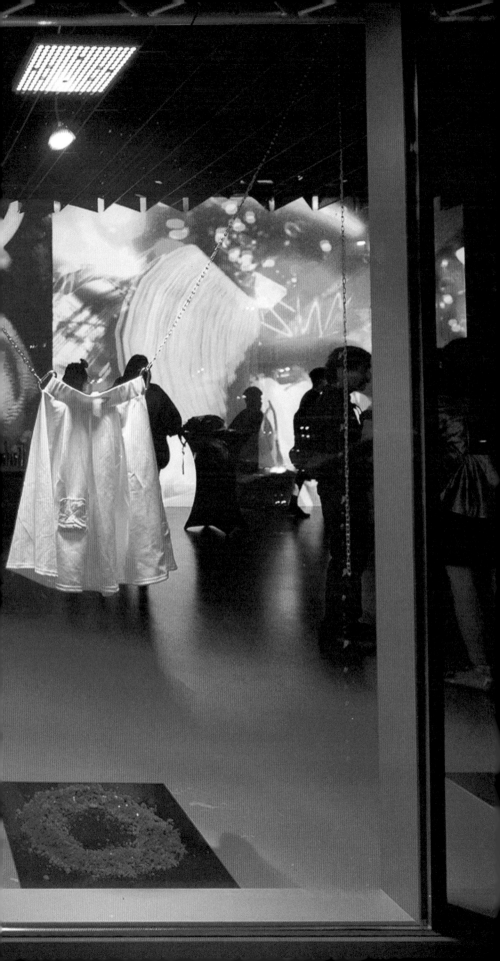

SALOME

Yeah. Because I think we do that all the time like: did your mom or grandmother save bags after grocery shopping to use as trash bags?

EMANUEL

Yeah.

SALOME

That's a system, she designed a system that's centered on sustainability, I want these tiny practices that we do every day to survive and be recognized as design. The other thing is, as a Black person who works with technology, the minute I touch a computer I'm an Afrofuturist.

EMANUEL

Ha!

SALOME

It doesn't have to be all that, it should be very contemporary for me to be working in this way. I want to see more Black folks acknowledged for using emerging technologies; my work through the *Iyapo Repository* allows me to do that. We have a fun futurist narrative, but my goal is to leverage the access I have to these resources and spaces so that our workshop participants become familiar and have a say in how the technologies develop.

EMANUEL

In the same vein, *Iyapo Repository* explores the tension between the historical and the futuristic, the real and the imagined. Can you talk about science fiction as a methodology for understanding Black subjectivity? Diasporic experiences? African experiences?

SALOME

I think the science fiction narrative just allowed us a lightness, a playfulness for people to explore. This is something I learned when I was doing a residency at Recess, which was in partnership with Brooklyn Justice Initiatives, so we were working with a group of young people who were entering an arts diversion program. So, for small crimes they committed, instead of going to Rikers [Island Correctional Center] or going into the system, they were put in this arts diversion program where we worked with them to develop artifacts. Their record was cleared if they completed the

program. And so, we were hosting design thinking workshops with them. Someone very explicitly said: "Yo man, I don't have space to think about the future, imagination is a privilege." And he said it so clearly that I was like, you're right, having space and time to think about tomorrow is a privilege because a lot of folks are just trying to get through today, get through the next hour. The science fiction narrative is a play-ful landscape for us to sit in and carve out space and time. This enabled us to bring in whatever we all were carrying with us that day and make it generative.

EMANUEL
Similarly, your VR work also relies on notions of spatial indeterminacy. Do you think that the dislocation of the body reflects historical conditions of displacement for people of the diaspora?

SALOME
That's interesting, I think that's a really beautiful interaction to design for: to think about the dislocation of our bodies, and separation from our families and commu-nities. But I've been making VR work around spirit possession and thinking about the ways the experience of entering a new realm has been described thoroughly in West African and Caribbean spiritual traditions. And so, when you look at statues from like Santería or Candomblé, you see practitioner figures holding something over their heads. They're holding a deity, an Orisha that's about to mount them and they go into spirit possession and a trance state. They are seeing the world through this deity. And so, I've just been interested in the actual imagery of it. It's a person holding an object above them, about to mount and enter a new dimension. There's a connection to a virtual! So, I've just been doing these research-like exercises where I create VR worlds based on different deities and their signifiers. I made one for Mami Wata where you put on the headset and go into her underwater palace. You see her symbols, her mirror, the gold, the lavish underwater experience. It's a seductive woman...

EMANUEL
So, you're researching specific deities?

SALOME
Yeah. I've shown the work a couple times, but I really do think of it as research because I want that perspective in VR because right now it's a lot of 3D rendering. So much is centered in aesthetics, it's very visual...

EMANUEL

But it's typically very apolitical and ahistorical...

SALOME

It's a lot about grabbing your attention. I'm really into the exploration. What happens when you put on the headset and just look around?

EMANUEL

You use technology in *Level Up* to understand and archive choreographed movements. In your opinion, what is the relationship between digital media and the representation of bodies acting in space? Even the performative piece you developed for your thesis, especially the performance that took place in the general store, seems to be in line with this vision and interest in really positioning people in their own spaces, in order to produce new performances...

SALOME

Yeah, I think it's important to bring Tech to where people already are. I really like creating experiences where people are kind of forced to act within a public or show up for each other in public. Creating these moments for people to demonstrate who they are or what they are into. In my pirate radio project *Crown Heights Mic*, Fahid is someone who had his musical instrument underneath his register. A huge part of what he loves to do was under his register and I'd only known him as a person who runs a general store and cashes you out for socks. That performance was a brief moment where he was able to bring his full self to me because I gave him a radio transmitter, you know? In the same way *Level Up* was for people who felt like they couldn't be their full selves in a museum space. You're not supposed to be loud; you're not supposed to dance. There's an understood and sometimes performative distance in which you engage with the work. Here, people were dancing at a museum, trying to win a game [laughter]. It's funny, I saved an email from one of the security guards at the New Museum who basically told me he had the best time watching people dance all day. All kinds of people. A little Austrian girl and an older Black woman were in a Harlem Shake battle. That's the kind of experience I want, where you break the rules of a space a little bit.

EMANUEL

You also seem to prioritize collaborative efforts over the idea of the individual producer. It seems to relate to your interests in multiplicity and dissensus. Is there

HOW DO FAILURES IN TECHNOLOGY PRODUCE NEW WAYS OF IMAGING BLACK LIFE?

a clear genealogy of creative practices that serve as precedents for this approach? And also, how does this relate to contemporary notions of authorship?

SALOME

I definitely like to work collaboratively because I don't have all the answers. I don't know everything. I like to leave a lot of room for other people to contribute to something I maybe instigated. The methodology I use is participatory action research, and the framework is cooperative. Whenever I have an idea, I work with people who are in that field. For example, with the *Level Up* project, I didn't know it was going to be a game. My collaborators Ali Rosa-Salas, Chrybaby Cozie, and I had some conceptual questions. We brought these ideas to other dancers and then we came up with the idea of a game together. I would never come and say: "I want to make a game, can you help me?" I don't even know if that's the right interaction for the ideas I have. I never start with the Tech or concept. I have questions, I bring those questions to people and they add more questions. Or they have answers and I have answers, then we decide together. This is what the process should be. That's important because I need it to be messy and I need it to speak to a volume of people. I just want it to be multivocal. I would never want to say I'm doing something *for* a community or a group of people. I want to say I'm doing it *with* someone. And it's hard. When you talk about authorship, I have to navigate that all the time because there's more value in a singular author or sole artist, partly because I think it's easier to digest and also because it perpetuates "the genius." I have to constantly insist on the need to put all these people's names in credits. Even with the *Iyapo Repository*, when people submit sketches, we build out a fully functioning thing. But the person's name needs to be on placards and wall tags because she submitted the idea. I don't need to be the celebrity artist. That's not why I'm in it. I'm in it to learn with the people I'm working with.

EMANUEL

But it also seems like your intervention starts at the level of the credit line. That's a critical moment where you say, these are the co-authors that are usually left out.

SALOME

It's not easy. I've worked with galleries and folks in museums who are like: "Really?" It requires a certain amount of labor from everyone, but I also required a certain level of engagement: don't fall off at any point in this process, we've got to do this right.

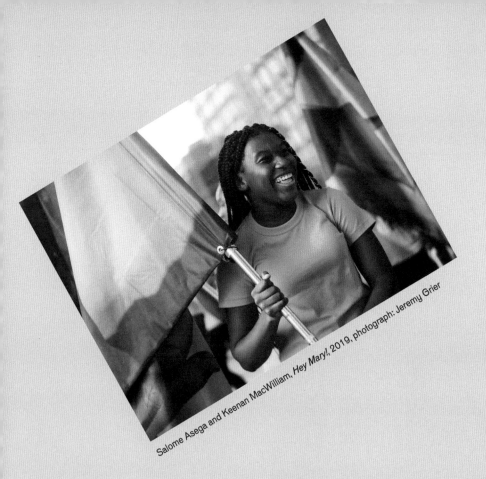

Salome Asega and Keenan MacWilliam, *Hey Mary!*, 2019, photograph: Jeremy Grier

EMANUEL

But isn't that frustrating? I'm assuming there are moments when you expect people to give more to the project, but they disengage.

SALOME

Yeah, I get frustrated. I'm being really nice right now [laughter]. When you're in reflection mode, it's always great but the process is tough. You're dealing with people! I'm sure I'm annoying at some points. But I'm into these moments where we butt heads and are forced to have a conversation and make decisions. We have to ask why people are annoyed with doing a certain level of work, or why they are disappearing, not participating. I like having those conversations. The process is a major part of the work for me. But we're human. We're not going to get along all the time [laughter].

EMANUEL

In one of your presentations, you suggested that the most radical work in imagining alternate futures is not taking place in the mainstream, but rather, on the margins. What are your thoughts about this idea of producing work in separatist spaces? Is

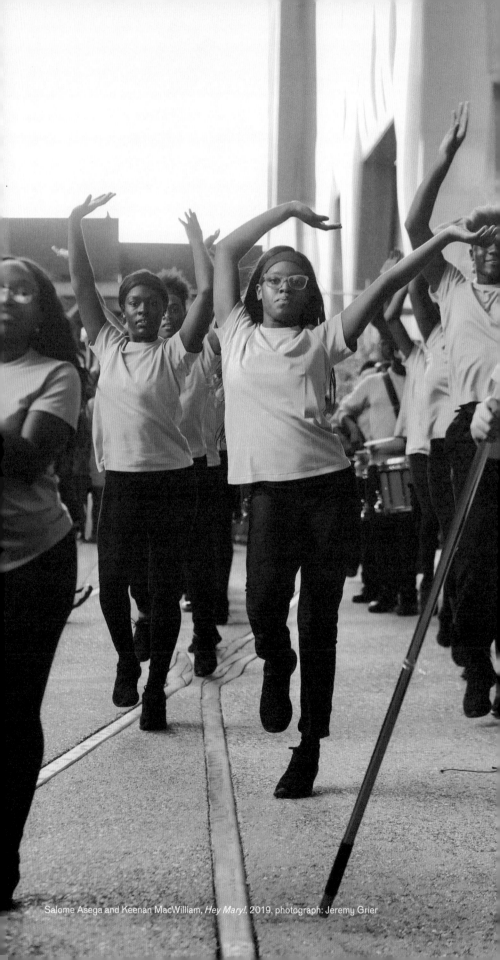

Salome Asega and Keenan MacWilliam, *Hey Mary!*, 2019, photograph: Jeremy Grier

that the most productive way to decenter dominant narratives around contemporary African art, narratives that are being developed by museums and art institutions?

SALOME

I go in and out of being in separatist spaces, because I currently work for a major institution [laughter]. But I really find value in organizing and producing in separatist spaces, because otherwise it's easy to slip into seeking validation from a mainstream that has never really included you. That's the type of work I'm just not interested in doing. I find value in the things I make. I value the things my friends make — it's a community of practice where we show up for each other. When there's a lot of energy concentrated over here, people in the center begin to notice. Then they come and scoop you, and that's what I'm seeing happen now. We've always been over here working together, now I'm seeing people look over here and scoop us into the main, slowly. So, I just don't want to put effort in trying to measure my work against something I think it should be. I want to have my own indicators for success that are measured by my community.

EMANUEL

It's a micro value system that is specific to that community.

SALOME

Yes, a system defined by a community of practice that is amorphously driven by the same motivations.

EMANUEL

What is the current focus of your practice? Is it *Hyperopia*? Your art practice? Teaching?

SALOME

That's the Million Dollar Question.

EMANUEL

That's why I saved it for last [laughter].

SALOME

I don't think I have a central focus, but I have buckets. I really love teaching, so that's one bucket. An independent studio practice is another, and then, radio. I love

conversation. It doesn't have to necessarily be radio, but I like creating spaces for people to share ideas. So, those are my buckets right now.

EMANUEL
We didn't talk about *Hyperopia: 20/30 Vision*. What was the ambition behind that project and how has it evolved over time?

SALOME
The project was started by me and Carl Chen. We were just talking about how the people around us were on a glow-up. They'll be shaping a field in the next fifteen or twenty years. We wanted to talk with them about what they were forecasting — as potential leaders in their fields by simply asking: "What do you think your discipline will look like in fifteen years?" Because we both love music, we also decided to find DJs to create mixes inspired by our conversations. We've been doing this for a year and a half...

EMANUEL
How frequent is it?

SALOME
It should be every other Tuesday, but we're actually thinking about making it a live show. My peers are taking up more space and I want them to speak out as people who will be shaping their respective fields. We've had people from the public and private sector, from reproductive health to architecture. Folks are moving in their fields. I just want to get them on record now. I will have this beautiful archive, twenty years from now, and I will look back and say: "You are now the director of this human rights organization, remember when you said this?"

EMANUEL
So, both of you are still involved?

SALOME
Yeah. Carl went to the Bay for a bit, but we got him back. Thank God! [laughter]

EMANUEL
Cool. Do you have any additional comments about where AFRICA or the diaspora is, and where you would like it to go?

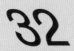

Salome Asega, *on the line*, 2015

Salome Asega, *on the line*, 2016

33

SALOME

I would like to be part of more conversations about where the Arab diaspora and African diaspora intersect. Because of where Ethiopia is situated, historically, there has been a lot of mixing.

EMANUEL

You're probably like thirty percent.

SALOME

Right. So, I'm interested in learning more about the overlaps and digging into that richness.

INTERVIEW WITH

ANTHONY
BOGUES

EMANUEL ADMASSU
Could you briefly describe the interrelationships and overlaps between your different titles and positions? We are interested in positioning your relationship to research, teaching, writing, editing, and curatorial practices.

ANTHONY BOGUES
My official academic position is that I'm a Professor of Humanities and Critical Theory, the inaugural Director of The Center for the Study of Slavery and Justice, and a Professor of Africana Studies, African and African Diaspora Art. That's the official university position at Brown University. The other things, writer and curator, are not official university positions, but rather descriptions of the ways in which I conceptualize critical intellectual work around questions of AFRICA or African diasporic intellectual history, political thought and theory as well as art. For me, the question of writing is about engaging in practices that will allow one to intervene in a set of debates, challenging a set of discourses, frameworks, and conceptions about what constitutes AFRICA and African diaspora thought and art. It's not just about being a writer in the conventional sense. Writing is an integral part of what I understand to be my own work as a *critical intellectual*. I make a distinction between that kind of intellectual work and academic practice. I'm an academic, that's how I earn my living, so I write scholarly books and articles as well and participate generally in what is called the academy. But, these scholarly writings are not driven by any one disciplinary protocol; rather they are driven by a series

37

of questions I am engaged with. I generally think that writing is a certain kind of practice of intervention for those of us who are Black, critical intellectuals. That does not necessarily mean a certain disciplinary approach, which tends to be organized around the protocols of a specific discipline. Writing for me is a practice of reflection and critical intervention. Indeed, over the last few years as I think about my writing projects, whether they have to do with writing about the political thought of Michael Manley or with the body of ideas that I am now calling "Black Critique," I am writing to intervene, to shift the axis of debate and discussion, if possible, and to contribute to a radical Black intellectual tradition.

My curatorial work is related to the ways in which I think those of us who are critical intellectuals need to engage in publics outside of academia. I curate shows, particularly shows on Haitian art because I think it's important to have a relationship to people or to publics through what people call public humanities. But I'm also doing that work as a part of a critical intervention practice. In my curatorial work I'm trying to think about exhibitions and curatorial practices, ways to reframe a set of questions that are oftentimes extensions of what I write — for example, the 2018 show I curated on Haiti at the Colorado Fine Arts Museum. It was called *The Art of Haiti: Loas, History, and Memory* and was in part about trying to reframe Haitian art.[1] The show was also about positing a categorical argument that Haitian art was not naive, exotic, neoprimitivistic, or non-Western surrealist art. The show attempted to illustrate that there is an internal discussion in Haitian art, Haitian culture, and intellectual literary tradition, which sometimes centers around questions of "Marvelous Realism," or the Marvelous, or around issues of history and memory. In thinking about this work of reframing, I have worked a great deal with the Haitian artist Edouard Duval-Carrié.[2] Since we met in 2011, we have worked together on many shows, and I have written numerous articles about his work and Haitian art in general. Duval-Carrié is, in my view, one of the most significant Haitian artists working today. There are many others, of course, and the works of artists associated with the Grand Rue are of exceptional importance, as is the work of Ralph Allen, Mario Benjamin, Philippe Dodard, and younger generations, artists like Tessa Mars and Renold Laurent. All of this points to the fact that there are various schools of Haitian art, which these conventional art categories do not take into account. Now often elided in the conventional history of

1 For a discussion of this exhibition, see Anthony Bogues, ed., *Art of Haiti: Loas, History, and Memory* (Colorado Springs: Fine Arts Center at Colorado College, 2019) Also see the newspaper article, Alissa Smith, "New Fine Arts Center exhibition dismantles Haitian stereotypes" *Colorado Springs Independent*, February 9, 2018.
2 For a catalogue that pays attention to Duval-Carrié's work as well the history of Haitian art see Anthony Bogues, ed., *From Revolution in the Tropics to Imagined Landscape: The Art of Edouard Duval-Carrié* (Miami: Pérez Art Museum Miami, 2014).

art is the discussion and the debates around the conception of the Marvelous.[3] The phrase "marvelous realism" was coined in 1956 at the Congress of Black Writers and Artists in Paris by Jacques Stephen Alexis, a Haitian intellectual, novelist, and medical doctor.[4] In the speech he delivered to the Congress, he was thinking about Haitian art from the *inside out*, suggesting a different genealogy to the categories in which Haitian art was at that time conventionally examined. Alexis had attended the 1956 conference with [Aimé] Césaire, [Frantz] Fanon, [George] Lamming, [Léopold Sédar] Senghor, Richard Wright, and all these folks, and in the debate about Black culture at the conference, he had posited this conception of Haitian art. In reframing Haitian art, one is not operating in a narrow nationalistic sense, but rather trying to think about it on its own terms — as a form of Black diasporic art. Of course one does this and then categorizes Haitian art in opposition to the colonial anthropological gaze, as folk art or a form of non-Western surrealism. The other question I've worked on as a curator is around the issue of racial slavery and how can one tell the story of racial slavery as a central foundation of the emergence of the modern world.

I'm part of a project called the Global Curatorial Project, in which we work with museums in Amsterdam, the National Museum of African American History and Culture [in the United States], the Natural History Museum of Nantes in France, the Iziko Slave Lodge in South AFRICA, the IFAN Museum of African Arts in Dakar, International Slavery Museum in the United Kingdom, Royal Museum for Central AFRICA in Brussels. The work of this project is to reframe the curatorial practices of the exhibitions of slavery and colonialism. We've been meeting for a couple of years and plan tentatively to hold a major exhibition in 2023 — an international traveling exhibition. Again, here the issues are about reframing questions of representation; about trying to find ways in which we can tell these catastrophic histories of slavery and colonialism in terms of the human experience. Here a key question is: how do you represent racial slavery and colonialism recognizing that all representation is in fact a failure because there's no full representation particularly of the past? So you always have to be going back over the same thing, not as a form of repetition, but rather to find new ways to tell the story as a different glimpse of the past emerges and entangles with the present. How do you tell that story from the perspective of the enslaved and the "colonized"? This is what we are trying to do in the project and to tell these histories in ways that will not only challenge conventional curatorial

3 For a discussion of the Marvelous, see articles by Suzanne Césaire and René Ménil in *Refusal of the Shadow: Surrealism and the Caribbean*, ed. Michael Richardson (London: Verso, 1996).

4 Alexis was murdered by the Duvalier regime in 1961. There is a painting by the Haitian-American artist Edouard Duval-Carrié that depicts this murder. See *The Sad End of Jacques Stephen Alexis* (1992).

practices but will also present new knowledge of the enslaved and the colonized themselves. My third art project is a recent one. Working with the Visual Identities in Art and Design Research Centre (VIAD) at the University of Johannesburg, I convened a project titled "The Imagined New, or What Happens When History Is a Catastrophe." This project is an interdisciplinary platform for critical exchange and research around AFRICA and African diasporic art practices. If you wish to sum up what I do in a nutshell: my writing and curatorial work is really about reframing questions of representation, questions of knowledge, questions of history, and the present. Obviously, in relationship to colonialism, slavery and what I like to call, the catastrophic history of the Black diaspora.

EMANUEL
Do you consider yourself an African and/or Jamaican intellectual and curator?

ANTHONY
In 2006, I spent eight months — two semesters — in South AFRICA as a visiting professor. Myself and Professor Geri Augusto were there to work at the Centre for African Studies at UCT [University of Cape Town], and to jointly plan a conference called *Thinking AFRICA Differently*. When I arrived I had to fill out forms: the usual bureaucratic things. Now, I don't like to fill out forms and wear badges, but on one of the forms I saw a particular box that said "International Person of Color." I immediately checked it. I hadn't thought of that [before], but that's what I actually consider myself. That is, a person who was born in Jamaica, grew up there, went to London and spent some time there, returned to Jamaica and then came to the United States. I now spend a lot of time between AFRICA, here [the United States] and South AFRICA. And presently, I'm a Visiting Professor and curator at the University of Johannesburg. I also, obviously, spend time in the Caribbean where I was born. I'm part of the African diaspora, but I like the sound of an "International Person of Color." I'm not sure where they got that phrase, but I like it a great deal. It sums up, I think, my diasporic locations and the ways in which I think about and practice diaspora. You should note that more recently over the past two years or so I have spent time in Europe, in Amsterdam, and here I have learnt a great deal about the African diaspora that now resides in Europe. One of the most important things I have done over those last two years is work with a group in Amsterdam that call themselves The Black Archives. So, if you think about my work and travel: born and grew up in Jamaica; went to London and edited the radical Black newspaper, *Flame*, while working as a journalist; returned home and worked as a TV journalist and then became a scholar and came to live in the US. From there, working extensively in South

AFRICA and now having some understanding of Black life in Europe, you will see why I like the International Person of Color designation; however, I think it should be clear that a great deal of what I am, I have learned in Jamaica and the Caribbean. In the 1970s, first as a high school and university student and then as an activist, I learned a great deal both from the Caribbean intellectual tradition, particularly C. L. R. James, Sylvia Wynter, and of course Frantz Fanon. But secondly, and very importantly, I have learned from ordinary Jamaican people. It was my grandmother who lived in deep rural Jamaica who was the most influential person in my life, facilitating the creation of deep commitment to grappling with all the complexities of Black life.

ANITA BATEMAN
In Chapter four of *Black Heretics, Black Prophets: Radical Political Intellectuals*, focusing on Julius Nyerere, you write, "Western political thought examines African political thought, not as theory but as ideology. From this position, African political thought might be studied for what it can tell us about the relationships between institutions, ideas, policies, and politics in AFRICA, but is of no relevance to the larger questions of political knowledge and the complex problems of political life."[5] Here you seem to be responding against "the epistemic narrowness of Western thought."[6] What drove your interest in looking at the political thought of Julius Nyerere?

ANTHONY
A couple of things: firstly, I came of age in the 1970s in Jamaica, which was a period in modern Jamaican history now called politically Democratic Socialism. This political project was led by the late Michael Manley. The most important international ally of Manley was Julius Nyerere. Those of us who were youngsters at the time, interested in AFRICA and trying to understand the African national liberation movements, learned a great deal about Nyerere. Secondly, once I became interested in activism and politics, Nyerere's conception of *Ujamaa* was deeply interesting to me. So, I spent a lot of time studying him and reading about *Ujamaa* because I thought it was one possibility for Jamaica. It was not, but I was a young person searching for political ideas that would grapple with decolonizing Jamaica. Thirdly, and very importantly, what drew me to Nyerere [when I was] coming of age in a postcolonial Jamaica was this: in the early 1970s, I had not yet read Fanon's *Wretched of the Earth*, although I had read *Black Skin, White Masks* in high school. So, drawn to AFRICA and

5 Anthony Bogues, "Julius Nyerere: Radical African Humanism, Equality, and Decolonization," in *Black Heretics, Black Prophets: Radical Political Intellectuals* (New York: Taylor and Francis, 2015), 100.
6 Ibid.

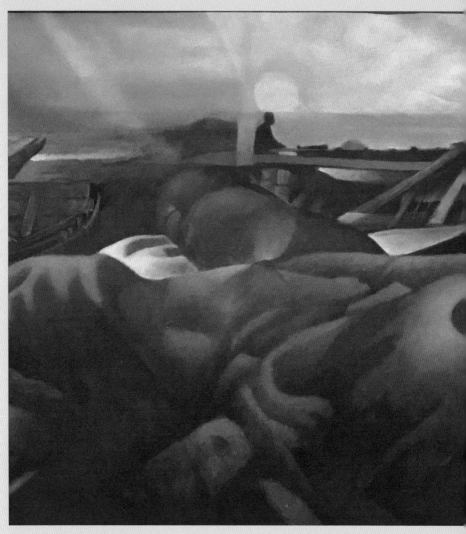

Ralph Allen, *Jeremie Town Martyr*, 2017

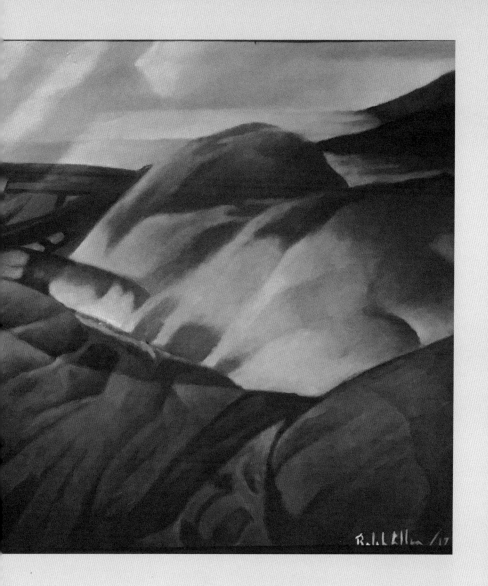

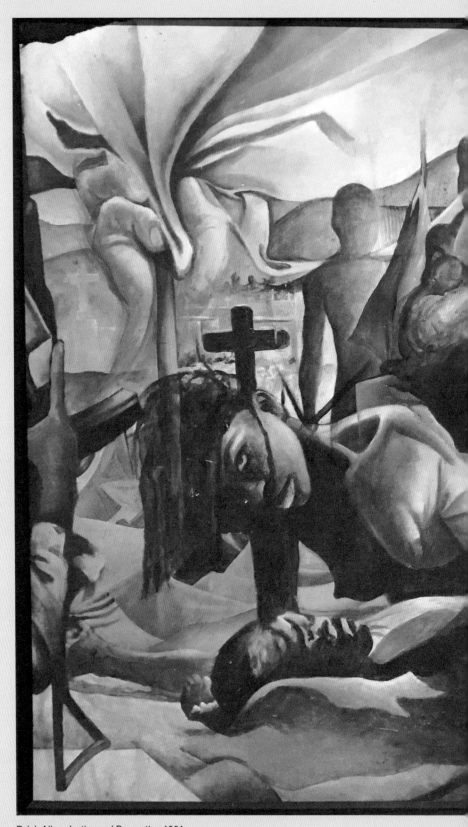

Ralph Allen, *Justice and Reparation*, 1991

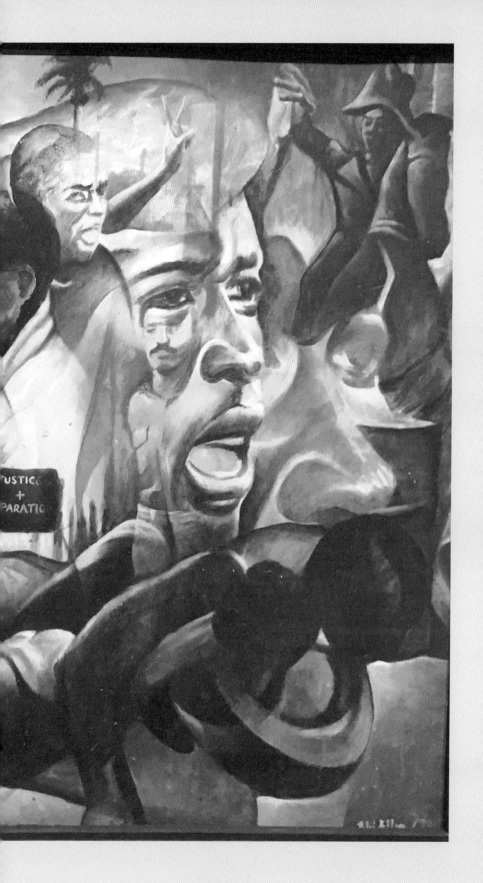

hearing about Tanzania in public political discourse and coming across the writings of Nyerere, one of things that struck me and stayed with me was how in Nyerere's political thought he was concerned about establishing systems in which the new post-independence elite would not be able to personally use the resources of the state for capital accumulation. With the Arusha Declaration, Nyerere was trying to think about how postcolonial politics should operate and the role of politicians and political individuals. His advocacy of modesty and the ways in which he talked about certain principles were focused on keeping the postcolonial elite from using the State as their checkbook. I thought that was really very important, growing up in a postcolonial state. That was my interest in Nyerere. My PhD was on the political thought of C. L. R. James. What became clear to me as I was studying James's thought was that Western political theory and philosophy did not have the categories to explain the African and African diasporic experience over the last five hundred years. Therefore, one had to find different ways. My return to Nyerere with this book [*Black Heretics, Black Prophets: Radical Political Intellectuals*] was an elaboration of something that I've been working on since 1994 — thinking about the African and African diaspora intellectual tradition in all its complexities. What this means is that a great deal of my critical intellectual work has been about reframing and rethinking African and African diasporic intellectual, political and cultural history. In other words, what I've been arguing is that the African and African diaspora intellectual tradition gives us intellectual resources in which we can begin to understand and grapple with life in the twenty-first century. It doesn't offer a master key. No system of thought offers any master keys. There are no master keys to the complexity of life, but an intellectual tradition gives us resources that help us to think about the present. I think this tradition does give us those resources. If you ask me further, I think the Western archive is exhausted. It doesn't mean that it is of no use to us. I would never say you do not need to study Foucault, Marx, or Gramsci. I would never say that — I myself do that — but what I am saying is that the Western archive does not have the capacity to give us a set of resources that may allow us to grapple with life today.

EMANUEL

You seem to be interested in the ways in which Nyerere and [Kwame] Nkrumah developed political thought and theory in direct relation to the practices of decolonization, simultaneously questioning the precolonial orthodoxy while representing their own societies in their own terms. How can we maintain a critical stance within societies that have both macro and micro fragmentations? In other words, how do we determine the boundary between ideas that should be exported versus ideas that should remain within specific cultural and linguistic boundaries?

ANTHONY

For me, ideas travel. Edward Said makes this point and I think he's absolutely correct. The question is always, what happens when ideas land? Even though ideas travel, given the nature of power and the way that the world is constructed today, the ideas that seem to travel are imperial ideas or Western ideas. There is also a way in which African and African diasporic political ideas also circulate and travel. Also, there is the circulation of African diasporic and African culture and cultural practices like music, dance, etc. These practices I would argue also embody ideas. However, if you talk about different frameworks for thinking, for conceptions that can grapple with categories, then it seems that AFRICA and the African diaspora are not seen as a site of ideas. The West is seen as the primary site of ideas. One leg of my general argument is that when these ideas travel and they land, they are reworked. Black ideas that travel: African, Caribbean, African American, also get reworked when they land. So, for example, if you think about Nkrumah, you think about his relationship to UNIA [United Negro Improvement Association] and [Marcus] Garvey's ideas and his invitation to [W. E. B.] Du Bois to spend his last days [in Ghana]. There are Black ideas from the diaspora that travel. I don't like to think of ideas as static positions. There's a certain fluidity and porousness in how you work through concepts; to me, that becomes important. What you discard is also important. I always bear in mind Fanon's injunction in *Black Skin, White Masks*: that to learn a language is to learn a civilization. Therefore, as a Black person, one has to be very careful about ideas and where they're coming from, their provenance and their histories, realizing that all ideas, whether they come from AFRICA or China, actually have histories and that these histories are also freighted with forms of representations.

EMANUEL

I'm wondering if there are ideas that don't necessarily translate across...

ANTHONY

Oh yes, I think so. I think there are ideas that don't translate at all. Since ideas emerge out of human experience, some human experiences do not necessarily become translatable to every single [context]. The idea, for example, of racial slavery is not necessarily translatable, say, if you go to China and you're trying to [talk about] racial slavery; people [might] look at you in a strange way, although anti-Black racism exists there. So, in many cases you have to explain it over and over again because that idea is not necessarily translatable.

47

EMANUEL
Also in certain parts of AFRICA, right?

ANTHONY
Well, certain parts of AFRICA. I pause at that one because the question of slavery in AFRICA is a vexed one. A group of us met with a number of African scholars at end of May 2017 in Joburg and part of what we were trying to discuss is the question of slavery in AFRICA, precolonial slavery in AFRICA. It's a vexed issue. There's a way in which some of us on the continent like to reclaim a precolonial past that is pristine. But no past is unproblematic and pristine. There were deep social problems that were not about racial slavery [because] I think racial slavery is a phenomenon that comes out of the Atlantic — the North Atlantic and South Atlantic slave trade. Now of course the question of race that appears in AFRICA as colonialism wreaks havoc on African social structures, sometimes creating new ethnicities and racial categories. Therefore, people understand what racism is about. There was no colonialism in AFRICA without anti-Black racism. The construction of the Negro, of the native Negro, is a construction around questions of race. However, I think that while some of my African colleagues will say: "Yeah but we didn't have racism in the way you have it, and the Black experience in the Americas was distinctive and should not be conflated with the African experience under colonialism." My response to this is that of course there are differences and nuances, there is no generative singularity common among human experiences, and to that end one historical unified Black human experience cannot stand in for all the complexities of Black experiences. Yet as I say this, I look at the ways in which shades of skin color operate in Ethiopia and how racial categorizations were deployed to talk about the Tutsi and Hutu in Rwanda prior to and during the genocide.

EMANUEL
I am from Ethiopia [laughter].

ANTHONY
I spent some time over the last few years teaching at Addis Ababa University in a summer program. One thing that struck me was the conflict between the Oromo people and other ethnic groups. It was a conflict constructed around ethnicity. But you can't escape that there were racial considerations around it, about who is darker than whom. Ethiopia was not colonized, but once you have colonial ideas and ideas of difference through race, which is part of what colonialism and the human

hierarchical classification system established, then people re-inscribe and rework their hierarchies through that [lens].

EMANUEL
Going back to *Ujamaa* or this notion of "familyhood" in contemporary African political thought—do you think there's room for *Ujamaa* today?

ANTHONY
I think in the twenty-first century we are in deep trouble. Not just AFRICA, we're [all] in a mess right now. The way I think about this question is not in *Ujamaa*'s familyhood terms, nor its relevance for today as a form. I think we have to be careful about models as frames for our critical thought. We have to do the hard work of thinking through every historical moment. One of the things that *Ujamaa* suggests to me is this matter that is at the core of politics—how shall we live together, what I have called forms of common association, what Rastafari might call forms of *livity*. In thinking about common association, I am working through this idea with an eye to plurality and difference. *Ujamaa* is a very specific historical idea; it comes out of Nyerere's thinking, it comes out of Tanzania, it comes out of Nyerere trying to figure out what to do with one hundred and twenty-one ethnic groups that the colonial powers had left behind. For him, *Ujamaa* was one way to think about how you tackle this question of difference and potential conflict. However, I would argue that today in thinking about this question of political forms, a different set of questions are posed. The residues of the colonial and the afterlives of slavery remain, but there are other questions about human life today, gender domination and how we live with and on the Earth. It is in this regard I suggest that there need to be forms of what I have called a politics of common association. In that common association, I go back to Fanon at the end of *Black Skin, White Masks*, where he makes the point: "Was my freedom not given to me to build the world of you?" So, again I am taking a particular set of ideas and reworking them. Common association, though, is not an abstract political idea. It is linked to practices of how we construct politics and economics in which issues of inequality are not subordinated. How can we begin to really construct the world in a different way, a much more humane way, both for ourselves and, quite frankly, for the planet we live on? If we continue to live the same way, we're not going to have a livable planet and AFRICA will be deeply and adversely impacted, as you both know. The question of the biosphere is an important issue today. Historically, I do not think we can separate this issue from the ways in which European colonial empires organized historical processes of dispossession, how forms of life were created on the planet, and how we began to see Earth as

a resource to be possessed, mastered, for economic profit and gain. So on the matter of the biosphere, while I think all the technical solutions are important, I want to argue for a total reorientation of how humans relate to this planet. With regards to politics within the practices of a common association, we need to create a politics of radical equality, and a politics in which we can begin to think about questions of freedom, but never freedom in relationship just to an "I." But recognizing freedom is always about the relationship that creates A-N-O-T-H-E-R, not just the other. It's about us having relationships with each other that are much more humane and if you ask me, that's one of the intellectual gifts of African and African diasporic thinking. To always think around this question of what Fanon calls "YOU," of another. That's certainly different from Western capitalism, its conception of life and the logic of the market fundamentalism that we now live in.

ANITA
Going back to the construction of common association, do you think Pan-Africanism becomes reductive now in some senses, or is it the foundation of thinking about what you call "another"?

ANTHONY
I think Pan-Africanism is a very important political, ideological framework for questions of continental unity in AFRICA and for a relationship between AFRICA and the diaspora, but I'm also concerned about the world we live in. I also think that now, in the twenty-first century — while I'm obviously very preoccupied, and while I work primarily, in AFRICA or African diasporic critical history, culture, thought, and art — I am focused on thinking about Black life internationally, so that, in some ways we can say that my work operates within a tradition of Black Internationalism.[7] My stance comes out of a certain history that is about AFRICA and the African diaspora, but it is my stance upon the world in which we live. The world is constructed in such a way where we can't just say: "OK, let me just go off and set up my own continental thing and then I'm alright." It doesn't work that way, not in the twenty-first century. Five hundred years ago, the Columbian voyages brought genocide and colonialism to the Americas. It has also created the actual links for a globalized world; so a globalized world is not just a recent phenomenon. Therefore, I start from AFRICA, African diasporic thought and art; but I start from there to think about the world. I understand Pan-Africanism, I support it as an ideology of continental African unity, but I am also

7 Black Internationalism is a way of thinking of Black life that cuts across the nation-states of Africa and the Caribbean. It seeks to go beyond the organized nation-state and works through forms of solidarity with Black life everywhere. One of its foci is the ordinary not on elite politics and culture.

very mindful that Pan-Africanism, like all political concepts, has historical meanings. I would suggest in this regard that Walter Rodney's speech at the sixth Pan-African Congress in 1974 is an important analysis of Pan-Africanism that is different from that of George Padmore's analysis in his book *Pan-Africanism or Communism?* (1956), or the debates and discussions held at the Manchester 1945 conference.[8] [All of this is to say] I think through the African and African diasporic radical intellectual tradition, but from there I also think about the world we live in and how we can transform this world into a more humane space.

ANITA

In the same vein, conceptualizing alternative narratives in the imaginary/imagination, can you talk about Caliban as a metaphor or figure for Black heretics or radical intellectualism?

ANTHONY

That's a really good question. A lot of us who were colonized by the British learned Shakespeare deeply. There's a Caribbean writer who I've written a book about, George Lamming, and one of the things he said to me — he's now ninety-odd years old — was that for those of us who come out of British colonialism in AFRICA and the Caribbean, Shakespeare and literature was like philosophy. For those in Francophone AFRICA, it was philosophy, it was the work of Jean-Paul Sartre and others. Because of this particular preoccupation with literature and Shakespeare being the greatest — if you wish — English playwright, all of us learned and understood Shakespeare. You know, I recalled going to an elite high school and during lunch break, we competed on who could memorize and cite different parts of Shakespeare, and who could do it the longest [laughter]. Therefore it was not surprising that in the British colonies, *The Tempest* became a key text. If you recall the play. It's a play about a shipwreck in Bermuda, a British colony, in the 1500s, and in it Caliban emerges as this "native" figure. A lot of us have worked on that figure, including Ngũgĩ wa Thiong'o, from Kenya. However, the person who breaks that thralldom we had with Caliban is Aimé Césaire. In his play, *The Tempest*, there is a section in which Prospero calls Caliban, calls him by his name, the name he has given him, and Caliban says: "Don't call me by that name, that's a name you have given me. You have given me language and now I use that language to curse you."

8 See Walter Rodney, "Pan-Africanism in Neocolonial Africa," in *Black Liberator* 2, no 3 (June 1974/January 1975). One of Rodney's main points is how classes became crucial in post-independence Africa and the role that the now native elite would play. He was making the same point that Fanon was making about national consciousness and the emergence of a native elite.

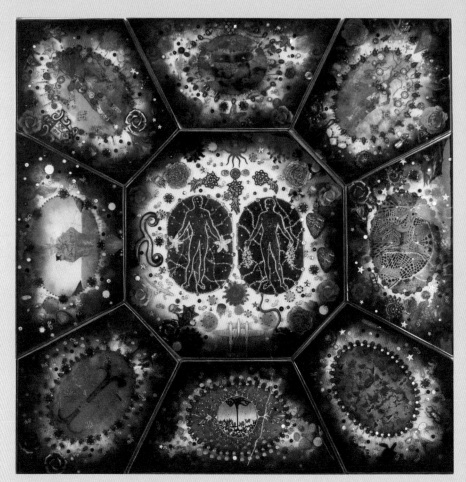

Edouard Duval-Carrié, *Memory Window*, 2017

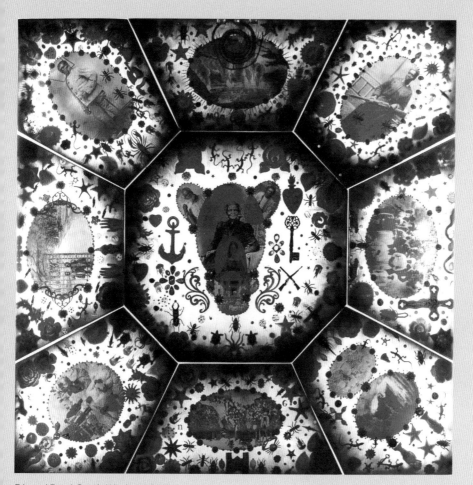

Edouard Duval-Carrié, *Window 4*, 2017

I think that this is a decisive moment in AFRICA and African diasporic thought, where Caliban is no longer the figure that we can use to think through the question of "the native" in relation to central questions about colonialism. We have to find another figure, or if you're a literary critic, you have to do something else. But if you're like myself, which means moving into the direction of art while thinking carefully about the AFRICA and African diasporic critical history of thought, then you have to begin to think about the figure of the "native" on his or her own terms. I also think you have to do this in literature as well. Who is this native that is no longer Caliban but is attempting to negotiate and rework his or her own subjectivity in relationship to the colonial, in relationship to the neocolonial? It is at that moment, I think, that art is really extraordinarily powerful as a way to begin to allow that figure to emerge.

EMANUEL

In investigating post-independence, again in the Tanzanian context at least, you demonstrate that an important political objective of the movement was to capture the colonial state and use its structures and practices to govern. For example, how Haile Selassie did this by appropriating certain structures that the Italians left behind. Can you elaborate — with the privilege of hindsight — on what the extended, long-term legacy of this strategy might have been?

ANTHONY

It doesn't work. One of the difficulties of independence movements was that once they got into power, they sometimes had a state that captured them, not the other way around. At the same time, the independent states had no major resources or infrastructure. In this regard I keep remembering Angola at independence: they had two doctors. One doctor was the head of the government MPLA [People's Movement for the Liberation of Angola], Agostinho Neto; he was a medical doctor. The other doctor was killed in an air raid. So typically, the independence movement gets into office and contrary to all the propaganda, the colonial state has not left an infrastructure for the vast majority of the people; instead, they have left an infrastructure for the elite and for the political economy of extraction, because that's the character of the colonial project. The roads are there to pull the cocoa — or whatever it is — to the port. It is not an internal network, it is all connecting economic activity to the outside. You're growing sugar in the Caribbean, that's all you're growing. You're growing the cane, the sugar is made elsewhere. They grow cocoa in Ghana, the chocolate is made elsewhere. You won't find what they call backward and forward linkages within the colonial economy. The infrastructure is essentially constructed and determined by colonialism. That's the colonial "balance sheet,"

no real infrastructure, high illiteracy, no hospitals, no real public schools. So the independence movement takes state power and says: "OK, let me see what I can do with this thing." I think that our experience has shown that one of the things that happens is that these state formations themselves have a certain logic. One of these logics is that "Might is Right"—that's the heart of colonial logic. Therefore, many times the independence movement takes over and the state then begins to do things it never thought it would do, in part because it is trapped. My assessment about independence, or takeover after the colonial state, is that it is not a good one. Things have happened, people are going through literacy programs, many hospitals have been built, etc. I'm not saying this is a zero-sum game, but if you're thinking about independence and if it has been able to meet the aspirations of the ordinary person, that simply has not happened. The question that one faces is the question that was raised by Amílcar Cabral. It is this: when you take over the state, you then have to transform the state. However, that transformation itself is difficult and problematic because you're doing it in a world where you're not going to get support for that act. You are embattled and encircled in many ways, so you find yourself in a position where even if you're trying to transform the state, you are doing things and negotiating with a world that is not supportive of a decolonized project. For us in Jamaica, an example I know best, when we were trying to democratize part of the state in the 1970s, it was part of a project in which we were also trying to transform the economy, but we got caught up in Cold War politics, got caught up in CIA interventions, got caught up in violence. You get caught up in all those things, so that your desire to try to transform [the state gets compromised]. Those in progressive politics get up in the morning instead of thinking about: "OK, how do I democratize?" They think about fending off the latest violence that has been enacted by those who are against these changes. Again, those are some of the questions that one wrestles with, and in this context you make decisions and political judgment calls that do not focus on your strategic political and social aim, which was about transformation and decolonization. This is the way I think of it: that in many African and Caribbean postcolonial states, what Nkrumah would call neocolonialism, would be the order of the day as the new native elites take over the colonial state without any fundamental change. And that in other cases where there are attempts for change, there are serious external forces working to stymie that change. Sometimes in AFRICA, I think it might be useful for us to begin to do an examination of what Amílcar Cabral called "Liberated Territories." In other words, if you follow the guerrilla war in Guinea-Bissau, you will see that the PAIGC [African Party for the Independence of Guinea and Cape Verde] established assemblies and forms of rule in each of the places they liberated from Portuguese rule. In our examination we might want to ask: what was happening in these liberated

zones? What were the forms of rule? What were their preoccupations? How did they develop forms of common associations? Those [questions], to me, become important because one of the features of many national liberation movements was once people got into power and became Marxists, but a kind of Marxism that was tied to Stalinist practices of the then Soviet Union, when this happened there was a negation of what was being experimented with in these zones. Many movements began to think of a certain kind of state that drew from their understanding of the Soviet Union — and we know that collapsed. It was not a good model and there were other intellectual and political resources that they could have drawn from. Though again, I want to make a caveat: you can't say what people should do or should not do because often these movements were in the middle of Cold War politics. Think of the folks in Angola. They had the South Africans breathing down their necks, trying to make sure that they were not victorious, so they had to invite the Cubans. These are the kinds of political realities that people experience. And I think in politics, we should take account of people's specific realities. However, I am also saying that when we can begin to examine these things by asking the question about political knowledge in the past and from what experiences we draw from, today we need to ask: "Where are the intellectual and philosophical resources we can draw from that are important for us in the twenty-first century?" To think about the present and the future. This is the way I like to think of it: Western thought draws from the Greek city-states, but the Greek city-states collapsed and failed. Nobody critiques the Greek city-states and how they collapsed. It is taken as part of the historical record. And so, the West draws [from them] and points to them. So why is it that we can't then say: "OK, this and that went wrong and that didn't quite work? We are human beings, we are not perfect, but in our attempts in the wake of colonialism, were there new ideas and practices that we need to account for? In what ways are we able to draw from and incorporate these ideas in trying to think about the present going forward?"

ANITA

You've written on postcoloniality or specifically the collapse of the anticolonial project in relation to African liberation movements. A type of intellectual recuperation seems possible in understanding the construction of knowledge as a means in which colonial ideologies were disseminated. You suggest quoting Nyerere: "reeducation is a call for the decolonization of the political mind," and that "what is important is that this political statement establishes two grounds for a polity of equality. The first is intellectual decolonization and the second is the relationship between the individual and the community."[9] Decolonizing the museum or exposing its imperial foundations has been theorized as a way to recover oppressed

9 Bogues, "Julius Nyerere: Radical African Humanism, Equality, and Decolonization," 104.

HOW DO YOU
REPRESENT
RACIAL
SLAVERY
AND
COLONIALISM
RECOGNIZING
THAT ALL
REPRESEN-
TATION
IS IN FACT
A FAILURE?

narratives and critique the exclusivity of the museum space. How do you think the intellectual decolonization of museums affects the Black community? And do you think radical intellectualism can contribute to ethical constructions of knowledge within Western institutions?

ANTHONY

The question of decolonization—really following Ngũgĩ wa Thiong'o on this—begins by trying to grapple with the internal contours of African and African diaspora art. Trying to understand it on its own terms—not in a narrow way because, as I said, thought always has a certain relationship to other things or other sorts of ideas. There is no thought that is just fixed and frozen. For me, the question of intellectual decolonization is [about] beginning to understand African history, African diasporic history. On its own terms, on its own internal motion, the ways in which human experience has been thought about through art, through religion, music, and history, by people of African descent. Not simply a question of color. Rather, in other words, how do you understand African and African diaspora human experience as a slice of human experience on this planet? How do you understand it from the inside out, not from the outside in? That's the question of intellectual decolonization. From that understanding of the inside out, you can begin to develop categories of thought and ways of thinking that emerge out of that human experience. When it comes to the matter of the museums in the West, there is a problem. I work with some museums in the West and I think the jury is out because I think there are a couple of things: there's the ethnographic museum in the West, which is the previous colonial museum; this museum has all these material objects, dioramas, and all these things that they took from different colonies. What do you do with those things? Do you return them—questions of repatriating those things to your previous "colonies"? Can you reframe them? Because many of these Western countries in Europe have an African and African diasporic population that currently lives there but comes from the previous "colonies"; there is the issue as well about notions of belonging and citizenship in Europe. But oftentimes there is also the necessity of thinking about these issues in relation to [the objects] in the museum. So, do you send back the stuff the colonial power stole or do you engage the population that's there who live the daily life of anti-Black racism? I think that you have to do both. Stolen objects need to be repatriated but this discussion should not be separate from the necessary discussions about the forms of politics and life that shape the new African diasporic communities in the former nations that constituted the European colonial empires. Therefore, the question of decolonizing the museum in the West is a very complicated one. It requires reframing. It requires questions of repatriation. It requires

deciding what to do with human remains in Berlin and Vienna. Those are some huge questions. Then, when you put aside the ethnographic and the colonial museum, there is a question of what to show in the new museums. The question of decolonization in the contemporary museum is also about what you show in those rooms. How are you going to represent both your colonies and other parts of the world? And how do you engage the African diasporic population that now resides in these sites. This means that your curatorial staff has to be re-educated. If you look at the curatorial staff in many of these museums, a lot of them don't know much about African diasporic art, so they don't even think about putting stuff there. There is a museum that has the second largest collections of Vincent van Gogh paintings in the world and some really amazing fifteenth-century Renaissance paintings, which they have preserved very well. Then they have one or two pieces that are clearly African — one from Ethiopia. But they have no idea where they came from or what kind of wall text might frame the pieces. The question of decolonizing the museum is not just about the ethnographic museum. It is about the present: what are you going to show in the contemporary museum? How does the RISD Museum pick from its collection? How does it think about its own collections and its collection's history? How does it present African and African diasporic art — not just the big names, not just because Kara Walker went to RISD. How does it do that? The Victoria and Albert Museum has an extraordinary collection of design objects from AFRICA and from India, but it doesn't show them. It is somewhere in the [basement] of the museum. One of the things that has to happen with this decolonization is also asking: what is your inventory? If your museum was formed during the colonial period you are likely to have art pieces from the formerly colonized world. Some would be stolen and should be returned, others might not be. So, for example, I know of an art museum that in the 1940s or '50s established a buying practice of Haitian art. In the latter case the question becomes: "How do you turn your collections into a set of exhibitions that reframe these collections?" Part of the answer, in my view, means you have to employ some Black people — you have to employ some more Black curators who are able to do this work.

EMANUEL
But how does decolonization as a practice address or confront issues around object repatriation?

ANTHONY
I have made some reference to this, but let us probe this question more.[10] To my mind, in addressing this question you have to work out a relationship between the

10 This interview was conducted before French President Emmanuel Macron's statement after the report written by Bénédicte Savoy and Felwine Sarr that announced the plan to return African art objects from French museums would be a priority.

ex-colony and the museum itself as to what it means to go back. Now the question of repatriation [is usually answered by saying:] "OK, let me give it back to you." No! I also think that the question of repatriation means that the West has to confront the issue about why it did not develop museums of a certain kind in the colony. If art objects are going back, I would also like to see a conversation about funds that can construct new museums with all the necessary infrastructural conditions. Of course, there are sacred art objects that when they return they should not be placed in a museum, but rather the community of their origin should decide what to do with them. In the end, then, the question of decolonization is about reframing the inventory that you have. It is also about reframing your national history. If you go to the Rijksmuseum, the Dutch have something called the "Golden Age." I searched in 2017 in that museum to find anything to do with colonialism. During that so called "Golden Age" the Dutch – from that small place – were the second largest slave traders and one of the biggest owners of colonies around the world. But the "Golden Age" just has about four or five [Albert] Eckhout paintings from when the Dutch controlled Brazil.[11] It would seem to me that decolonization is about reframing entire collections because the question of the colonial is not a small question. It is the question that dominated the world for five hundred years. It is the way in which the world we inhabit was shaped — colonialism and racial slavery. That means that art and knowledge formations were shaped by these practices. If you're going to talk about decolonization, you have to think about reframing it as a contemporary issue. If you're reframing your history and reframing your art, you also have to think about reframing your politics. How do I reframe questions of citizenship and belonging? How do I reframe questions of equality? Decolonization is a really large project and it's a project that would help us move from questions of the colonial to something else and facilitates us creating a more humane world.

11 The Rijksmuseum has now undertaken a major project to tell the story of Dutch slavery as a crucial element of Dutch history.

INTERVIEW WITH

JAY SIMPLE

ANITA BATEMAN

First question. Your name is Jay Zuberi but you also go by Jay Simple. This division of personality is intentional. Can you talk about your creative persona and why that division is necessary?

JAY SIMPLE

It started before a lot of the creative or artistic things that I've been interested in really kind of got underway. I did it when I moved to New York. I was working in the commercial art industry, doing headshots for actors and for models who were trying to get more publicity. I was sending my work out to ad agencies and modeling agencies and I wouldn't ever hear back from them. I used to go by my full name, Jabari Zuberi, and I had read this article about how you're more likely to get hired for a job if your name doesn't sound too "ethnic" or if you're of some type of diversity and so, it was sort of a social experiment for myself to see how true that was within my own field. So I picked Jay Simple. It's sort of a pun off of a Langston Hughes character, Jesse B. Semple. There were a series of novels about the Black experience; they were both funny but then also painfully ironic in ways, and I thought that was very fitting. It made a joke that other people weren't totally aware of. And so, I did that and I actually started receiving contacts back pretty regularly. It was always funny because I never changed my work, so it always had a lot of African Americans or people of color inside of it, then they would send people to me, and even when they arrived, they'd be like: "Oh, wow, I didn't know you were...you're Black." So that's how I arrived there. I've kind of just kept it going as this persona that plays

63

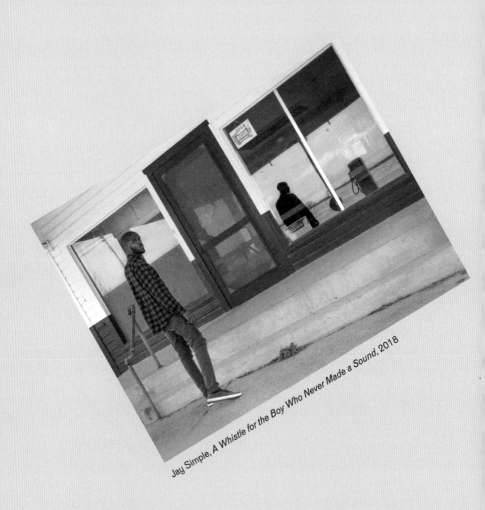

Jay Simple, *A Whistle for the Boy Who Never Made a Sound*, 2018

with people's perception of who I should be, which is often what's engaged inside of my work.

ANITA
Does Jay Simple only make photographs or is Jabari interspersed in that process? Or do you think that's not an accurate way to describe the process?

JAY
Sometimes. It depends on what I'm doing. Prior to coming to RISD [Rhode Island School of Design], I was working as a cinematographer, doing mostly documentary films. In all that work, for whatever reason, I use Jabari Zuberi.

EMANUEL ADMASSU
So it's not an alter ego.

JAY
In a way, sometimes it is. I mean it does allow me to have some type of separation from my personal life and myself so I feel like I can very freely make work under this alias. It creates a separation from any type of obligations of not going so far with something. So definitely it is, for sure.

EMANUEL
How are you working through the decolonization of racist imagery? Are you interested in educating your audience or in other words is it about the production of knowledge?

JAY
Well, I would say that the ideology [and concepts] I put into my work are already out in the world. I use a lot of theory by Frantz Fanon and it is bringing narratives to the surface that are already there which act as counters to this larger colonial ideology.

EMANUEL
So I was wondering, do you feel like the work you're producing is also potentially educating some audience out there?

ANITA
Is that the point of the work? Is it more of a cathartic thing? Is it something that is meant to center the Black experience rather than educating a particular audience?

JAY
My purposes for making the work and then sometimes what it does in the world can be sort of separate. Sometimes I make the work for selfish reasons because I want to figure out where there are like-minded individuals who can meet me in this sort of ground where we can stop using the colonial and European or white supremacist ideology to think about the people who are considered Black or just humans in general. I think through the act of doing that there are some people who haven't even imagined those possibilities. I've been showing work with my cohort and some people walked up to me after a year of sort of repeatedly showing my work, and were like: "You know, I never really considered that Blackness was a constructed ideology, that it was raised as this huge construct." Right, so in that sense, it becomes an

educational tool. Then also the act of making it was super cathartic because I tackle issues that are very personal to my experience and to other people's experiences. So by reenacting those things I work out some of the frustrations and tensions that I have with living in this country.

ANITA

Relatedly, what was the impetus for the series *Ti(d)es That Bind Us* and who would you say is "Us"?

JAY

The *Ti(d)es That Bind Us* is a sort of double entendre. One of it is tides, like water, and then, ties, like something you can tie to your wrist or a way of confining you. I was interested in this duality of how there are certain ideologies that came by way of sea vis-à-vis European colonization and how these ideologies tie both us and all these different places together, but those ties are sometimes solely based on our connection with colonial powers and how those things have disrupted our social, political and economic stability. This project is a culmination of that, in trying to look at, historically, how notions of race have come into play within the United States, and how those legacies continue on today: so, constantly juxtaposing past and present to try to disrupt the sanctity of these ideologies that we think are innately true about people and trying to show that there is a certain time period that you can really track back where these notions were not even applicable. In the eleventh century, if you asked somebody what race they were, they were probably going to tell you human, right? Which is totally different than now, and it's solidified, like you're one of these categories that we know are totally constructed. What was the second part?

ANITA

Who's "Us"?

JAY

It's all of us; it's a global "Us" in a sense. The impact and legacy of colonization, even for those places not directly colonized originally, is felt everywhere as it is the ideology of colonization that still affects us all; so it's everybody.

ANITA

You often use narrative devices that suggest violence against Black subjects. *Lynch Station*, nails in *For Those Who Loved Us*, etc. There are also more subtle instances of this violence, if you will, in your images of blackface minstrelsy or photographs

that depict signage with racially imbued language or racially motivated language, however you want to call it. We know there's a fine line between perpetuating and critiquing violence. How do you think your images subvert or expose white supremacy in America or is there something more confrontational about that? Is there a message to white America or to America in general?

JAY

There's always a thin line between critiquing it and perpetuating the very same thing. I make more images of that type of violence than I actually end up showing for that very reason. Even when I show it I'm sometimes unsure, but I try to look at what I'm attempting to do within very particular images that use those techniques. For example, in *He Died for Our Sins*, there is a picture of a man, me, being lynched inside of the RISD Museum in the gallery with classical paintings on the fifth floor. In that image, there are two women and they're pointing up at this picture of the crucifixion of Jesus and in between them and the picture is the full image of the lynching of me. I picked that to use because I felt that it talks about violence against the Black body. But then it also disentangles this notion of the Black body being any different than any other body, in comparing the lynching and murder of Jesus as similar to the constant crucifixion of Black bodies in America during that period. But they are seen as two different things. So, a society that can say: "You know it's horrible what they did to the innocent Jesus" but is also simultaneously lynching innocent people all the time. Then you have this moment of the viewer: these two white women who are looking up at the painting of Jesus and we know that that lynched body is not really occurring inside of the RISD Museum. There is this ambiguity on whether or not they actually see the other hanging body which is what perpetually happens. Black death is viewed as almost more of a spectacle than an actual event of atrocity. When I use that sort of imagery, I'm trying to disrupt the way that we view things. In another piece, *For Those Worn Black Bodies Used to Build This Country Without a Thanks*, there are wood cutouts, nailed onto a post and I usually show this with another image: a street sign called the *Lynching Station* in which there are all of these body parts which are jumbled on top of each other, making an abstraction of the body. They're nailed onto the post and then I take branding irons and I brand in *For Those Who Loved and Toiled and Strove for Thee in Other Years.* When you look at the piece and you read it out, through the message, it sounds like this is a piece to commemorate and give thanks to people who have done some form of service and struggled for us in the past through all the things that you can think of in history as it connects to the Black struggle. But the only way that you can read the *Thanks* is through the bruises on the body.

I'm interested in how the *Thanks* is often only the infliction of pain, or the healing of, or the presence of, a wound. In those instances, I'm on that thin line, but I'm trying more so to disrupt how we view Black death than to try and make a spectacle of it. Hopefully I'm successful. It's a tricky line.

EMANUEL

You seem to be interested in using photography as a discipline that could potentially destabilize the construction of specific racial ideologies. Do you believe that the discipline of photography could actually be separated from the "problem" of race? If so, then, how can we move away from this historic contribution to the construction of racial heritage?

JAY

I don't know if photography alone can; in part I think about the history of photography being very much ingrained in the creation of racial ideologies. I think it is a good tool to try to disrupt notions of race that are intrinsically built into how photography functions. All of racial ideology is based on visuality and so if there is a way to use photography to disrupt that, it can be quite powerful. You read about race. Using words is different than visualizing it: it creates a different emotional effect of being able to see how ridiculous our notions of these things are. It triggers something inside of us a little bit differently than reading about it. It connects more to the experience of actually dealing with those issues. But at the same time, it's a double-edged sword in a way. I want to use photography in a way to disrupt those things by expanding the conversations or the types of imagery that are being made, but then also because it is a purely visual medium, it's hard for people to then disentangle what they already see, or know, or think they know about people who look like this, look like that, from the imagery. I was talking about being interested in the ideology of Frantz Fanon, and this idea of how constructed race is … even the usage of racial terminology to define yourself is owned. Defining yourself — even if it's self empowering — only reinforces the ideology that race can be real. But if I take a picture, I'm like: "That's not a Black guy." Right? It's hard to visually get that across to people because they're so ingrained in the ideology, so I can cause some disruption to that. There is also a need for there to be something else that goes along with the photographs. I make this work because it hints at these other things, and it allows me to try to find people who are doing like-minded work in a lot of expansive ways. Through percolating within those circles, you can identify different ways of approaching work; but also the dialogue that your work creates can supplement the places where perhaps the photography alone doesn't work yet. Also, having some

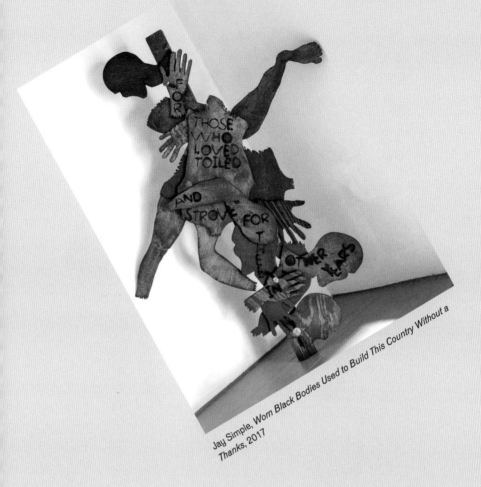

Jay Simple, *Worn Black Bodies Used to Build This Country Without a Thanks*, 2017

written aspect is necessary for my work to get into the deeper things that I haven't yet found a way to expose through the photographs.

ANITA

So what do you think your intervention as a Black photographer is in dismantling colonial structures of seeing? Do you consider yourself an artist? A Black artist? Someone who happens to be Black? I'm wondering if you put power in that term based on what you just said. And is "art" the right word for your body of work?

JAY

This idea of what the colonial view is and how I disrupt it is an interesting question because the colonial view is also about hiding things and concealing things, right? The hiding, concealing, and contorting of things. The colonial view will see something and figure out ways that it can manipulate what it sees to become exactly what they want, for their benefit, to hide that manipulation. My work is about exposing the

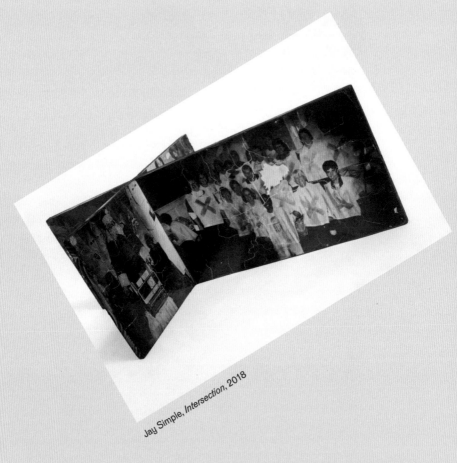

Jay Simple, *Intersection*, 2018

manipulation and the facts that have been hidden and quite often lied about. A strong portion of the body of work is exposing and changing how we can view historical facts or things that happened in the past, and then how we can create a very valid and true alternative narrative to what the colonial ideology says. Am I a Black photographer? I don't know. Am I Black in the sense that I was born into all the things that are Black culture? Yeah, for sure. But I'm simply about the power of words and terminology. There needs to be a way of talking about ourselves that doesn't hinge on racial ideology. I'm not saying that I'm not a part of a particular social or cultural group or anything like that. If you look at the work, it's obvious that I was acculturated within the "Black Culture of America." But I just don't think it's useful to use that terminology because it constantly refers back to degrading ideologies that we are continuously revamping like, what exactly it is we can be called, from Negro to colored to Black to African American to all these other ways of us trying to move away from the hinging of our identity game based on degrading ideology. But even

70

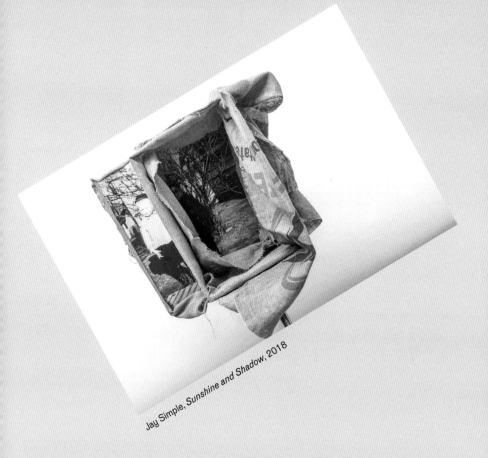

Jay Simple, *Sunshine and Shadow*, 2018

in each one of those steps it still includes some type of notion which was created by white supremacy. Even "African American." AFRICA was a term that was created by Europeans. America was a term that was created by Europeans. There needs to be a dis-hinging of our identity from those terms.

ANITA
Can terms ever be reclaimed? Is the impetus to make new terms or to abolish terms in general?

JAY
Can terms be reclaimed? I'm not sure. I think certain terms maybe not. I often wonder: "OK, should we reclaim it and try to fix it or just abandon it and start anew?" Starting anew seems like a shorter process than trying to reconfigure centuries of brainwashing. Sometimes washing away things that are going on seems like it could be a lot better than trying to work through them. That being said, you can't wash away everything that easily. It doesn't work in all instances. So, I think that at least how we identify ourselves is a place that we could say whatever. Like any type of term to sort of group ourselves together. Do I think we need to get rid of groupings and all those types of things? I don't think so. I don't think we've ever been organized as humans like that. I mean, we kind of group ourselves together in different ways

that historically have always been sort of good and bad. We just need to reassess how we group people together, and start grouping based on things that actually matter. Many of the ways that we're grouped together now are just according to physical attributes, which don't contribute too much to how people might actually, really be connected. You can be very far away from the thinking of someone the same color as you and even be closer to someone who is from China and who doesn't resemble you in a way and who has a totally different cultural background.

EMANUEL

That's a great segue to the next question. First, I want to ask, does this moving away risk the possibility of being read as a form of ambivalence? I feel like a lot of these identities and ideologies that you're talking about are linked with the need to belong. By fighting against that history, by fighting against that violence, how do you maintain that need to belong to a specific culture or a specific heritage? Or is that frivolous?

JAY

I don't think it creates a sense of ambivalence, but it does create a more expansive way of orienting identity and ideology which isn't centered on the colonial mindset. If we don't center our identity on our physicality but center it on our thought process, for example, we might find connections which encompass more of who we are. Much of it is hinged on the way that white supremacy and Europeans decided how we should think about those groupings of people together. It does put me in a space where people are like: "What are you talking about, dude?" That's not to say I don't find connections with people — I find connections with people who consider themselves Black all the time. They're my friends, my family. What's interesting is that as soon as I say that, I just don't want to be Black. Everything that has to do with Blackness, OK, I'm with that, but the terminology of it needs to change and people are very, very set on that terminology. I have a friend here and I say: "Instead of calling me Black, say a man with dark melanin and see how everything that you say next sounds ridiculous." We do that for like, a week and then we just kind of fall back to what feels normal. It does point to how attached we get to that term and, actually, it holds more weight than things that are far more important in our culture. Our resilience, our knowledge base. I mean, we built this entire world in a way. The descendants of AFRICA were some of the most ingenious people in agriculture and medicine and science and all these things; people think that they just picked some guys up and then showed them how to build a nation. That's not what happened. Those things should inform the terminology that we use.

EMANUEL
It's really fascinating because it seems that, intellectually, you want to be a nomad. You want to be able to move around and not get pinned down. But there's also this other side that is linked to maybe issues of pride and maybe love and association of pleasant experiences that you have with your identity as a Black man, as part of the diaspora. Following that, how does your physical location in the northeast of the United States influence the pictures you make? Or your process, for that matter? Would you make the same pictures if you were in Haiti, Nigeria, Egypt, etc.?

JAY
Being in Rhode Island definitely affects a lot of the pictures. I mean, the history of Rhode Island is so weird. The majority of voyages into the west coast of AFRICA left from Rhode Island, which is like the tiniest little space. It is an interesting place to talk about the colonial view and the history of colonization and all the subsequent historical events. Because while simultaneously Rhode Island is this hub of enslavement, it is also the hub of... what's the name? I want to say Yankee, but the new white view during the Civil War of... it is also a part of the New England Yankee ideology. New England was known as a liberal area of anti-southern ideas, but that history is far more complicated.

ANITA
Abolitionists?

JAY
Yeah, but there's another term for white people who decided not to be confederates.

ANITA
Unionists?

JAY
Yeah, but there's something else. I'll remember it. But it's basically the birthplace of...

ANITA
Dissonance?

JAY
Yeah, removal from the history of slavery... New England starts to abolish slavery far before the Civil War and so they create this national narrative that enslavement

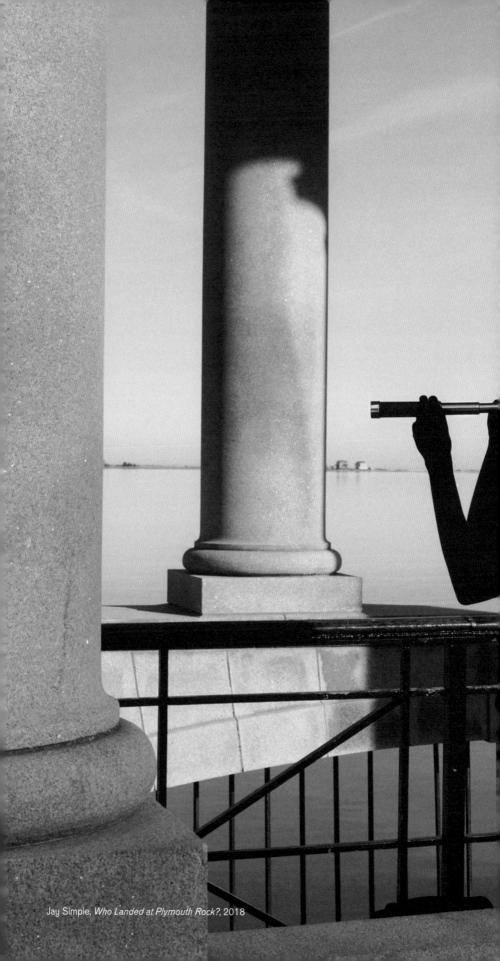

Jay Simple, *Who Landed at Plymouth Rock?*, 2018

wasn't ever really a factor in the history of New England. That creates separation, which is the political grounds for the Civil War, a perceived undertaking against Southern enslavement. When, in actuality, the way that New England manipulates their laws that abolish slavery, if you're unemployed, you're seen as a vagrant of the state and, if you're a vagrant, then you're jailed and then to get out of jail you're put into these apprenticeships with the same people who were the enslavers, where you're forced to work for them for a particular period of time. They basically distanced themselves from a form of enslavement, created a new one, and then vilified someone else for basically the same history that they are a part of. We see this rotation happen: the end of the Civil War and then the passing of the Thirteenth Amendment and the legalization of being able to incarcerate people and being the only point in time where they can be forced to enact labor against their will. There's this cycle that happens that is very apparent in the history of New England, which becomes a national thing. That really informs my work. I think that if I was making work in other places there would be some similarities, but it would be different. If I were making work in Haiti, I would be engaged with a different history. After having spent some time with this, that's where I'm headed to — starting to say: "OK, now where are these constructs [elsewhere]? Where are they in other places, and how have other regions disrupted those narratives of who someone can be and what they can do and how do they respond to colonial powers and how is that creating different constructs in the present time?"

ANITA

I'm interested in where constructs end for you. If you're saying race in some instances makes you think that colonial powers have infiltrated and manipulated in order to forefront their own agenda, then which constructs *are* useful, if any? Why not make work in Haiti? In other words, if everything is subject to the colonial construct, then it wouldn't matter that you aren't in Haiti necessarily. So, where is it that constructs come in handy?

JAY

I'm saying I'd make different work in Haiti, not because Haiti is different, but because I'd probably be constantly thinking about what happened historically in Haiti and their ability to overthrow colonial powers. I can be constantly thinking about that, and make that work, but just physically being in the space does something for me emotionally when I'm making the work. But where are useful constructs? I don't think there are a lot of social constructs that are highly beneficial. I just don't think they often work. Colonialism spread a particular ideology that has not been beneficial

WHAT
IS THE LINE
BETWEEN
CRITIQUING
AND
PERPETUATING
RACIAL
LOGICS?

for a majority of the world. But if you go back prior to that, I mean, it wasn't like the world was just cotton candy... [Europeans] weren't the first to enslave people, they weren't the first people to create genocide and atrocities all around the world. Not only thinking about how the constructs that came out of colonialism are bad, but how as humans, we always construct these boundaries and these forms that bind us into the situations where it's "us against them" and it's horrible. But it is also something about human nature. It's the way — at least from documentation of the past — we've always done these sorts of things. And I think that that's a problem. But also, how do you get away from that? How do you live in a sort of ambivalent, non-construct zone? It sounds dope to me, but it's actually very impractical. I think that you can live in that space within your mind and there's something powerful in being able to take a step back and see the ridiculousness of it all. But day to day, you have to some- how or another make some type of social connection with people. You could move out into the woods and do that lifestyle, but that's not going to be the lifestyle that a majority of us is able to ascertain. So, you have to, you have to make connections. And when you get into those constructs, they can be very good, but then also most constructs are just not idealistic places, so there's always a bad side to it as well.

EMANUEL

The construction of race, as you mentioned, relies on the exploitation of labor but also the accumulation of capital. Are you concerned that your civic mindedness could be co-opted by different forms of consumption? Especially at a moment when identity politics is being absorbed by market forces? Are you also interested in offering resistance to this increasing commodification of "Blackness"?

JAY

Yes it will be co-opted. I'm one hundred percent sure that if I want to have a career making artwork, it's going to get co-opted. If we're saying the career is RISD, the museums, and galleries, it's going to be co-opted — it's currently popular to be socially conscious, to be talking about these issues. I show my work and no one's lying to me about it. They're like: "Oh, it's hot right now. You need to get that out there...this is the time." It's cool to care.

ANITA

Isn't that a good thing for you? The point is that you want the idea of constructs to go away, and you really want to be ideally a global citizen. You can't necessarily co-opt something that isn't real. If you're saying that the point is to level all playing fields, if someone does co-opt your Blackness, does that become a problem for you?

78

Jay Simple, *The Body of Nesim (Rhode Island School of Design)*, 2017

JAY

If I show my stuff in a pretty gallery in SoHo and somebody buys it to match their furniture because they think it's nice and they don't really care about the message in it, they're just buying it because someone else told them it was the thing to buy: at that moment it becomes just an object that's not actually doing the work that it's supposed to. That's what I think co-opting is: instances where the work is getting shown by those people and they're like: "Oh my god, I didn't know that there were such atrocities happening all around the world and we want to do something about it!" There's some power in that, but maybe it's my cynical nature that I'm more inclined to believe that a lot of those things may not be at the forefront of elitist, white people's minds because, let's be honest, what I'm talking about is nothing new or revolutionary and it's what's been said in the past. Those circles may not be the place for radical change in the way that identity is considered and thought of, because they benefit very much from these systems being where they're at. The co-opting happens because if you can have a hand in the narrative and how they're contextualized then you can take something that has power and disarm it. Having those works in those spaces and then the context and narrative that's given to the work is in a way then controlled by the people whose space it's in. That can possibly create moments where the work is de-armed or not as useful. But at the same time,

though, we live in a capitalist society, capitalism is a global issue. There is a need for capital in some form for change to occur, being aware of this being the moment for capital gain based on your political views is OK. If you need to, go ahead and make your money from your sales of images or whatnot, but what are you going to use that money for? If you're just going to go pump that right back into some nice things...what are you going to actually use that capital for? That becomes the important question.

ANITA

So, returning to the concept of "spectacle," there's a situation in which you directly reference AFRICA. You are using the iconography of Anubis, then talking about Nesmin in the museum [Nesmin is the mummified person in the RISD Museum's collection]. So, what is that work doing? Where is that work going?

JAY

I'm interested in Egyptology in the sense that it's often a reference point for Black culture of the past. I was also thinking about how people use terminology to try to uplift themselves and to think of themselves as: "We come from kings and queens who built pyramids." We need to think of ourselves in better terminology than the visuals that are given about us, like in pop culture and things like that. I started making these images of Anubis and he's in street scenes and there's a pyramid behind them, and a young Black man is basically dying or reaching the point of death and he's usually being comforted by a family member who's usually also a woman. And it's about this moment, when Anubis, the God that takes the soul from this life to safety by transforming or taking it to the afterlife. So, placing this Egyptian ideology a little bit further, taking it and putting it in association with moments of Black death. And creating both this ideology that's already there about people seeing themselves as kings and queens and being like: "OK, really what does that mean if we connected directly to that ideology and looked at it?" This was years ago. I had made those and kind of let it sit. I hadn't even really thought about them again until I came to the Museum and I was thinking about doing the thing with Nesmin. It wasn't even until a few weeks before I did the presentation where I was like: "Oh yeah, I did shoot something like that." And I went back to it. This one [image] was a little bit more of a progression of actually thinking about that idea, so, I was interested in how there's a spectacle of Black death that has a track in all these different areas. In cultural institutions, war/military institutions, those types of settings and normalcy, even in the scientific community, there's this comfort with viewing Black death. Within the Museum, you can have a body of an Egyptian

[Nesmin] and during that same time there they are robbing the graves of enslaved and free Black people to use their bodies for scientific purposes throughout the United States without people giving permission. You go to the Tuskegee project [the "Tuskegee Study of Untreated Syphilis in the Negro Male"] and you see people's bodies being unknowingly injected with syphilis and scientists are watching the effects of that. Even after they find a cure, they continue it. So, this idea of ease and comfort with Black death — and how that ease comes through its infusion within so many aspects of our life in very mundane ways — and then thinking about: "Well then what responsibility does a place like the RISD Museum have in perpetuating an ease with Black death?" That's a question that should be asked. It often seems so peripheral and unconnected. Nesmin and the Egyptian collection, you wouldn't think of that in direct association with Black Lives Matter. But there is historically a heavy connection with it.

EMANUEL
That's a great place to end. Thank you.

INTERVIEW WITH
WITH

TAU
TAVENGWA

EMANUEL ADMASSU

You describe yourself as a "curator/coordinator and designer/editor" at the African Centre for Cities [University of Cape Town]. Could you briefly describe the interrelationship between these titles? Is there one that you most identify with?

TAU TAVENGWA

I just came from having lunch with somebody and I was saying that by the end of my year I will perhaps have one that I am most comfortable with; for me, it's a continuum of things. I always say my approach to editing, especially the magazine, which has become the main thing, and my approach to an exhibition is the same process. I always joke that when we finish an issue of the magazine, it's exhibition-ready. For me the various practices just weave together. If we were putting together an event, the same preparation and the same amount of work and the same sensibility goes into it as if we are preparing an issue of the magazine. I'm very much interested in a hybrid kind of practice. At any given time, if it becomes a problem, I will identify with any one of those titles, sometimes two, sometimes it's all at the same time. That's actually been a very conscious decision for me after struggling to get an identity I was comfortable with for a while. I got to it accidentally maybe ten years ago. Since then, hybridity has become something that I've embraced. In all of my various activities and approaches, there are different questions and results that ultimately add to something whole.

EMANUEL

So, do you have a clear definition for this notion of hybridity? Is it productive?

TAU

Oh, completely. That's been the most productive space for me to inhabit. There are times when I have a singular role and someone working with me occupies the other. They might be stronger in one thing at that particular moment, and I might be stronger in something else, or I might not know what the fuck I'm talking about. I like the idea that I can step aside and have the clearest person come forward. It's a mix. For me, those boxes — Architect, Curator, or whatever else — actually confine a kind of productivity that we all need to be working towards. We should not be limited to those narrow stretches. So, it's very conscious.

EMANUEL

Issue #6 of *Cityscapes Magazine* tells the story of ten Capetonians. There seems to be an ambition to provide — through this biographical investigation — an incredibly diverse understanding of various African subjectivities. You seem to be responding against the pristine, sanitized images that we typically associate with Cape Town by shifting the focus onto notions of neo-apartheid and the spatial conditions it produces. What drove your interest in looking at the city through these atomized experiences?

TAU

Two things actually. One, there was a census in 2011 in South AFRICA. As the results were coming out, everybody was talking about it and making declarations that were not reflected in a lot of what I was seeing in the city. At the same time, the African Centre for Cities ran these research labs that were focused on Cape Town. They were looking at everything incuding housing, cultural practice in the city, and climate change, etc. The lab research findings began to come out about a year before the census results. And so, what became an interest to myself and to Edgar Pieterse, who is my main collaborator on most things, was the fact that we had a unique opportunity to look at the data that was coming out of the census and compare them to some years-worth of research that was coming out of the city labs and see if we could build something. I'm relatively literate but was struggling like most people to understand the census numbers as they tend to be very complicated. So initially it was always that research speaking to the census. Then we started asking how the census was actually speaking to real people's lives. As important as they

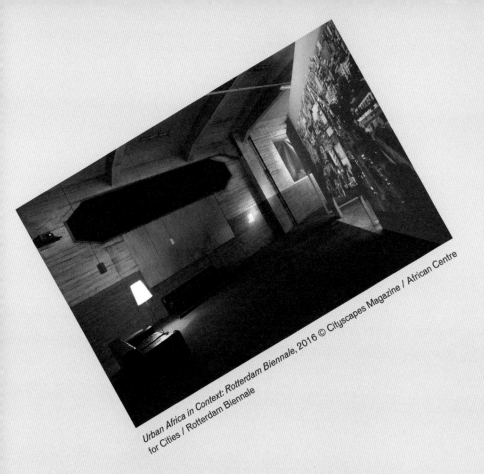

are, census data tends to sometimes reduce people into numbers and this approach can leave you thinking you understand something. Understanding numbers is not the final stop. In the end, we took the approach of the labs, which were thematic, and the key findings of the census and meshed them together. We then went through a process of working with different journalists and writers to identify particular individuals that we thought were representative of the racial profile of the city and of the economic inequalities and differences that define the city. The spatial spread of Cape Town is very problematic. I don't know if you've been there.

EMANUEL
I haven't.

TAU
It's this super beautiful city, but it's also a really ugly city that's defined by the same thing...

EMANUEL
The beautiful part is what we get, usually.

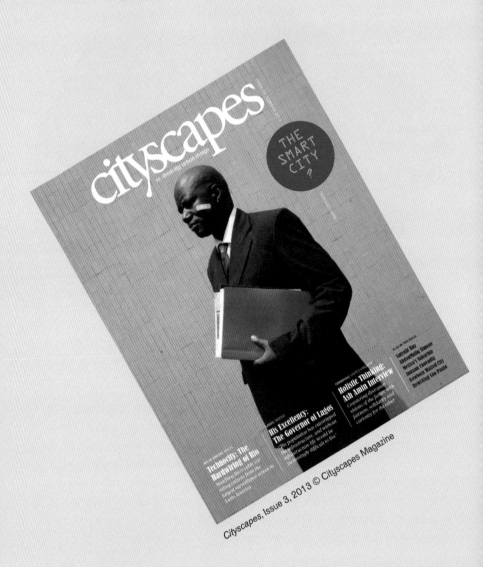

Cityscapes, Issue 3, 2013 © Cityscapes Magazine

TAU

Yes, and the beautiful part you see from everywhere. You know, you see the moun-
tain from every part of the city and you have a different relationship with it. Our
main question became: how do you understand people and what "their city" was?
Through their stories, we tried to see if the census was saying something that you
can actually relate to. So, we went through an almost three-year process of building
both an exhibition and the issue of the magazine as well as a series of other activities
that ranged from debates to lectures and even some public engagement activities.
We wanted to provide people with a way of entering into this big data set. A huge
number, about 22,000 people, visited the exhibition.

EMANUEL
The exhibition was primarily about...?

TAU
It was primarily about these ten people. It allowed you to dig into their lives, down into the census data and upward. What we did was super interactive. You could see how each of our protagonists lived and occupied the city and get a deeper understanding of the key challenges they faced through interactive short documentary films, sound pieces, maps, and interactive graphics. You could even see if you could try to find the point of convergence between them. Cape Town is such a spatially spread-out city but also very divided, so we wanted to figure out where people's contact points might be across race, economic status, education levels, etc. It was quite an interesting exercise.

EMANUEL
I was interested in your idea of an atomized city and how that can offer a productive curatorial framework.

TAU
"Atomized" — that's perhaps a more elegant way to say what I'm trying to articulate. More than the geography and looking at the city as separated space, we were interested in the diversity of the city. It ended up on some level becoming an investigation into whether or not people have more in common than not. Cape Town's narrative is very much around difference. This was a way of trying to explore if there were convergences and some ways in which the big apartheid spatial divides that were intentionally put in place and still define the character of the city are being breached. And they were. At the end, we had these ten people and their respective stories, which they were very generous to share. We brought all ten people together for a dinner in the exhibition hall, with everything setup a night before the opening, and they couldn't have been more different. The psychologist surfer dude found that he was actually working on the same problem as this ex-gangster who worked against violence in one of the craziest neighborhoods in the city, in the Cape Flats. It was really interesting. So those human stories, at the end, revealed much more than the data implied.

EMANUEL
Similarly, I would like to hear more about *Urban AFRICA in Context*, the ten-minute remix film you produced for *Cityscapes Magazine*. In this case, you seem to be

interested in identifying commonalities across the continent and in using found images and film clips to question and maybe destabilize certain representations of the continent.

TAU

I was one of the guest curators for the Rotterdam Biennale in 2016. I ended up sort of leading on the AFRICA bit. So, the theme was the "Next Economy." We could have ticked a bunch of boxes, told a series of nice stories about, you know, Africans on mobile phones — the typical thing. Shown pictures of a Maasai warrior in traditional garb, standing cross-legged with their Nokia [laughter] or some cheap smartphone knock off. And we had to say: "We can't do that," because this stuff requires context. Instead, we proposed a pavilion, which was supposed to be a standalone. We wanted to define the context and complexity in which things across AFRICA are happening. What is AFRICA anyway? Those were the questions that we threw back at them. You can't talk about AFRICA and the "next economy." Living in South AFRICA, the difference between Cape Town and Johannesburg, Cape Town and Durban, Durban and Pietermaritzburg — just that alone is insane. So, to take this brush and say the continent... it wouldn't work. We proposed this pavilion that was about going right back to history. Understand the history, the colonial and the postcolonial history. Understand the legacy of the colonial history but also understand the legacy of the postcolonial history. And really, honestly pin down the mistakes, and then try to see if there is a way of explaining the current state of things. We had come up with four or five formats; I can't even remember them all, but we thought we were being very clever. The idea was to look at what responses people come up with to address some of the challenges they face and then try to be projective into what might be possible going forward. Then the budget of the project was cut... So that's when the fight started.

EMANUEL

So, they started cherry picking.

TAU

Yeah, but then we said we would select a bunch of projects that we think are pushing things forward, but we insisted that those projects would not make any sense without the context. So, the film format allowed us to do a projection as the main piece and the other stuff, for me, became peripheral. So the aim was to inject this loud, confident, almost defiant sensibility and reality into this very ordered exercise. We're producing a lot of stuff about the continent on the continent. But no one is

City Desired, 2015 © Cityscapes Magazine

City Desired, 2015 © Cityscapes Magazine

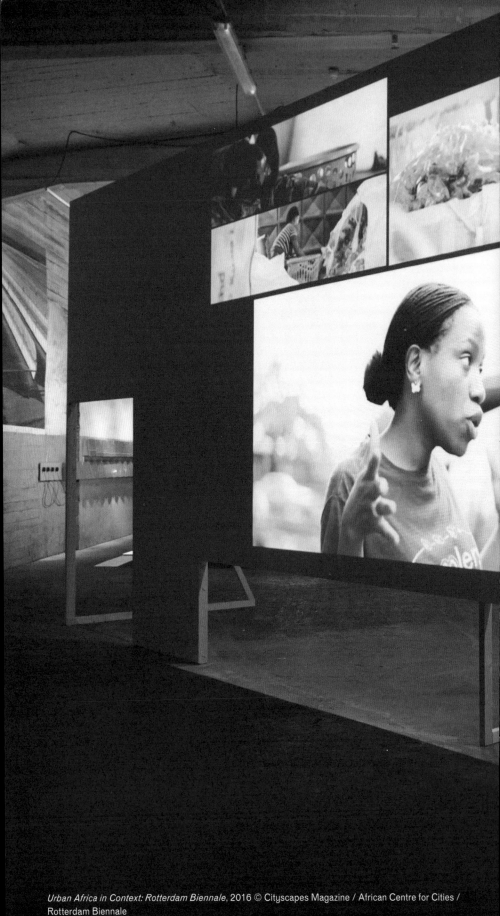

doing the job of going into it and trying to tap into what it means, codifying it and providing context — curating it so to speak. So that film was an experiment where we looked for all this "found footage" and voices. We literally spent months going in and just listening to speeches, interviews, street sounds, whatever. We contacted filmmakers and assembled visuals that we thought would enable us to tell this story about complexity. Of all the voices, not a single one was recorded for the video as we were just stitching things together. That was a very nice experiment, and something that I would like to continue, which is why I'm very excited about what you're doing because I think the spirit is the same. There is a lot of great stuff, but without contextualization — or without people that are trying to curate it into a form that starts pulling out what the patterns are — it's noise. It's a billion hours of video that no one will ever watch. But what is it that you can take out and use to show exactly what's happening? That's what we were trying to do. I feel we didn't really succeed, because we did it with very little time.

EMANUEL
I found it really fascinating. Primarily because I'm really interested in post-production and what that means nowadays. I think that's very much in line with a contemporary African aesthetic. There's an idea that you can give value to things that have been discarded.

TAU
Yeah, absolutely. The remix culture. I like that idea of remix culture and I think it's something that we need to adopt more in the sort of work we do.

EMANUEL
Yes!

TAU
But how do you think about that in your work, as an architect? Where are those ideas landing in your practice?

EMANUEL
Both in my teaching and my design practice almost every project starts with a series of samples: we identify a series of architectural concepts, then we begin to pinpoint their failures. It's a constant attempt to both correct those historical ideas but also remix them so we can produce new spatial conditions.

TAU

I like that idea of starting at failures. Because you know this idea that precedents are only the things that have succeeded ...

EMANUEL

... It's outdated ...

TAU

... It makes no sense ...

EMANUEL

We have to move beyond that. There are so many canonical figures in architecture, especially in modern architectural history, that are idolized to a point where questioning their work becomes blasphemous. I find it really unproductive. We're trying to shake that up.

TAU

Cool.

EMANUEL

With the incredible work you have been doing at African Centre for Cities [ACC], specifically with the work you've been doing through publications and exhibitions, have you noticed major shifts with the global visibility of African art or urbanism over the past ten years? What are some new currents and commonalities that can be identified between creative practices that have been actively representing the continent?

TAU

I have. And I'm in a crisis because of the shift. I remember talking to Edgar maybe eleven years ago. When the ACC started, no one was talking about African urbanism or the continent's cities. It was new, it was interesting, and then it became sexy very quickly and everybody became an "Urbanist." We suddenly had many Urbanists but very little productivity. What I have noticed is there's this wonderful spread of stuff and people speaking to some of these issues around urbanism, but a lot of the work is performed to talk to people in other places, it's geared outward when we should be talking to each other. You know, those other places (Europe and North America) are addressing themselves too. For me that's kind of the change. I celebrate the fact that we started this project called *Urban* AFRICA,

but I have many reservations about it now. It was a website. The idea was to have a space where people could easily access what was going on in all these different cities. It was an aggregator; this is from ages back. When we launched, you could never find the material you wanted on what was going on in different cities from all angles. Now there's a lot of it. A lot of it is bad quality. I don't know what it's trying to achieve — content for the sake of content, I guess. At the same time, it's a good thing that we've got this diversity of voices that are popping up. What we need to start worrying about is quality. And I think what we need to start talking about is: "Who are we doing this dance for? Are we dancing for ourselves and practicing, getting better? Or are we just performing?" It's a question, it's a discomfort I have and that's what I've noticed. If a lot of people are interested because it's fashionable, what happens when it's not so sexy? I think this is long-term work, so it needs people that are committed to perhaps not being fashionable today, but to creating these bigger bodies of work that maybe need ten years or longer to look back and say: "OK, there's a canon of sorts." It's uncomfortable, but I'm also very happy to go online and find a million things and sift through them and re-think them and sometimes even dare to remix and make something new.

EMANUEL
To extend that conversation a little further: what would you say is the relationship between contemporary forms of globalization and African urbanism for you?

TAU
I guess one is the consequence of the other and vice versa, right?

EMANUEL
Because it seems like a lot of the funding for the research for these projects is coming from cultural institutions based in Europe.

TAU
Absolutely. That's one thing that we need to seriously consider. I am sometimes ashamed that most of the funds we have and can access are coming from the States. AFRICA has got a huge number of wealthy billionaires and businesses that should be investing in research. They're not investing in knowledge production. I think that means we're not investing in ourselves and that perhaps explains why we are producing work that is to be consumed by others, because that's where the money is coming from. Until the money comes from within the continent or we find

governments funding research at different capacities, not just university but also other practices, I think we will continue in the same way. That's a problem.

EMANUEL
It's a tough situation.

TAU
Yeah, because you want to do the work. You're not going to stop and wait until you get a moment where you have all these resources that are coming from where you are comfortable. So, it's a weird situation.

EMANUEL
I mean part of why we named this whole project *Where Is AFRICA* is because we really need to understand where the funding is coming from. We also need to understand where these "Africans" are positioned geographically.

TAU
With *Cityscapes*, we have very consciously located ourselves in the Global South conversation more than anywhere else. We are trying to partner up and work with people from South Asia and South America, countries like Brazil, Argentina, India, etc. In those places, they have managed to cultivate some measure of local funding. We've been trying to look at alternative places for collaboration that are more relevant to our work. But also, as ways to learn how people are strategizing and funding work internally.

EMANUEL
Counter Currents starts with a critique of current urban permutations in Cape Town driven by real estate speculation, on the assumption that such speculation is completely reformatting the city. And if it is, then how can we position ourselves against our immediate geopolitical context? There's an understanding of what the immediate context is and how you can gain agency by positioning yourself against those patterns and tendencies.

TAU
We started working very much at Cape Town scale. And then that's when *Counter Currents* came out in 2009. It was really a mapping exercise to locate all these ideas that, on paper, made a big difference and had this capacity or potential to be quite transformative within South AFRICA. Everything from public space to arts

Counter Currents, 2009 © Cityscapes Magazine / African Centre for Cities / Jacana

interventions. I think that was the first compendium of those kinds of projects. We just tried to see exactly where they succeeded and where they failed. It was that interest in failure you mentioned. At the end we had maybe twenty good projects and twenty very honest self-critiques from the people that had been initiators or that had been really leading those projects. At the end we had a very candid dinner. We got a whole bunch of people that contributed to the project down at one dinner table and we said: "We're going to record this conversation and let's have a chat about why innovation fails in Cape Town." You know, we are lucky in South AFRICA that we've got a few more resources than most other countries.

EMANUEL

Absolutely, especially on the continent.

TAU

It's a middle-income country, so you can do stuff. There are lots of people that have got skill, we've got good infrastructure. The question is how do you make that infrastructure accessible to everybody? Even with those advantages, a lot of stuff doesn't quite have the impact that's intended. We had a conversation with these guys about why they're failing. It was interesting. I will send you the essay. It was a mixed bag — government and civic society, business people, academics and they were essentially saying the system is geared towards making sure that the status quo is maintained. While we did that project, what was interesting was that simultaneously, we were working on *Rogue Urbanism* — Edgar, myself and AbdouMaliq Simone. So that was an interesting contrast. It was immediate: we're living there and dealing with different issues and having conversations about failure. At the same time, we were working on *Rogue Urbanism*, which was a struggle. It was three years late because it was too big of an experiment.

EMANUEL

You were trying to find things that have been overlooked.

TAU

It was literally assembling: putting in the same room, artists, historians, economists, film people, photographers, there was even a DJ or two — a whole bunch of people from all over, from across the continent. The idea was to get them to just meet and know each other, and that over time, we would have a series of meetings. There was one in Cape Town and there was another one about two years later in Cairo.

EMANUEL

All of that was for *Rogue Urbanism*?

TAU

Yes. That was all for *Rogue Urbanism*. The idea was that those guys would love each other and find resonance and start collaborating, but even the best laid plans didn't work. In the end, we put the book together as a way to close and document it. So that contrast of working on those two projects was fascinating.

EMANUEL

Was it productive to work at the scale of the city and the continent simultaneously?

TAU

Yes. That was very interesting and challenging. The perspective is very different. That's when I really began to learn and be interested in complexity. I realized for the first time that sometimes our practices can limit us. That people could have the same intentions but have the practice they are embedded in and very different ways of talking and approaching their work. In many cases, this means they are unable to immediately see the same things in each other. I learnt that before you can even get to talk about collaboration, you have to bridge these differences and that can prove quite foundational. What an architect expects of an artist and an artist expects of a filmmaker is very different. That was a big lesson, and that exercise is what led to starting *Cityscapes*. Just the realization that we weren't speaking the same language across practices that were ultimately trying to address the same challenges and injustices, practices that could each substantially benefit from interacting with others, both at the scale of Cape Town right through to the continent, was a big moment for me. So, could we do something that would mix it up and challenge people to break out of the box? That's when we also started

HOW DO WE NARRATIVIZE THE RAPID TRANS-FORMATIONS OF AFRICAN CITIES?

very substantively to engage with people in India, with people in South America, with the understanding that if we cannot get that conversation just from people across the continent, and we want to engage with a wider geography, then we need to find a device of our own that would at least be a demonstration of what it is that we are talking about. Once you layer all these conversations together, there was a very steep learning curve and I still keep coming back to some notes from that experience.

EMANUEL

It's interesting because it seems like there are some clear dualities in your work.

TAU

Schizophrenia perhaps. By the way, have you met Edgar Pieterse?

EMANUEL

No.

TAU

You need to be connected. I mean for all intents and purposes I can very proudly call myself Edgar's protégé of sorts. He's got a way of thinking that's both at a granular level but also very big picture. Constantly playing that tension and trying to see what you are doing, what that means here and what that means at the global scale. I think it's something that's has naturally become built into our collective practice. You can have a conversation about a street vendor here, but what does that mean at the local level? What does that mean at state, national, regional levels? If you look at the graph, it explains how the ACC work is built like that. What is our work within the university, within the city, within the region, within the national/regional and global scale? Thinking at those scales has been drummed into my practice over the last ten years — something I didn't quite appreciate until recently.

EMANUEL

How do you think AFRICA perceives the world? As an African creative individual living in AFRICA? Are you still living in AFRICA?

TAU

Yeah, totally. I live everywhere, but I live in AFRICA.

EMANUEL

How do you perceive the world outside of the continent? Is it more about creating these networks with the Global South that you were mentioning earlier?

TAU

Oh, for me that's what I've actually become very committed to. Over the last few years, I've been lucky to spend quite a bit of time in South America, South Asia, and on some level Southeast Asia too. Our recent issue of *Cityscapes* was on South Asia.

EMANUEL

We should talk about that.

TAU

It was revealing. I spent a lot of time in India, particularly working out of India, but the entire region, working with South Asian writers and photographers and academics etc. I sort of went in to that place with my own perceptions. Ironically, that is exactly

what we accuse people coming from Europe of doing. There is also the problem and hang up of coming out of South AFRICA. I think we did something really special and I got educated on a lot of things in the process. I am super excited about that.

I am becoming more interested in what AFRICA has to say to the world more than what the world has to say to AFRICA. And not in that bullshit, "there's-an-old-African-saying," wisdom, imparting stuff, but just in terms of what we have in our own conditions and how we correct them sometimes outside of the frame of what's considered "the right way." We are learning some stuff about ourselves and the spaces we inhabit that can speak to other places too. We can't just be receiving knowledge. The ideas that are going to solve our problems are going to have to come from within the continent and if they are good enough, will travel and show how to think through the same problems elsewhere. We have to have the confidence in our own ability to create and disseminate new knowledge too. I'm not an Africanist in that old school sense but believe that the continent has new ideas and perspectives which are multiple and diverse to share with the world. These ideas also exist in a very located global/historical and contemporary context that is important to work with. I've become very invested in that idea. With *Cityscapes*, we are beginning to work with a whole bunch of partners in India, in Egypt, in Brazil, Colombia, Nigeria, and South AFRICA to reflect on what is it exactly that we are trying to say and what we can do if we choose to think outside of what is standard and normal. To ourselves, primarily.

PAN-AFRICAN
MULTIPORT

OLALEKAN
JEYIFOUS

The Pan-African Multiport [PAM] is a global network of massive low-impact travel complexes located off the coasts of major port cities throughout the continent and African Diaspora:

· PAM: Lagos, Mombasa, Port Said, Dar es Salaam, Durban, São Paulo, New York, Los Angeles, Port-au-Prince, Barranquilla, Havana, Montego Bay

The network's provenance is rooted in the legacies of the Pan-African Movement and the decolonization of AFRICA. The subsequent rapid dissolution of colonial infrastructures designed for economic exploitation and resource extraction coincided with an equally rapid consolidation of the many local Indigenous environmental movements into what is now a unified African Conservation Effort (ACE) that was founded in 1967.

With an ardent and unrelenting eye toward undoing the impact that economic and political exploitation had on the continent's ecosystems, it wasn't long before ACE had not only reversed much of the havoc wrought by the erstwhile colonial powers, but also proceeded to develop considerably advanced innovations in green technologies that radically transformed almost every sector of life on the continent. The most globally coveted of these being their comprehensive system for renewable and sustainable energy production, which simultaneously accommodates rapid air, land, and sea travel; an innovation that quickly became the ACE pièce de résistance due to its implications, not only for continent-wide solidarity, but for the African Diaspora.

It is 1978 and the latest PAM iteration has just been completed. The complex deviates from its coastal counterparts to embed in a remote area of the Barotse Floodplain in the Western Province of Zambia, where a newly developed hybrid network of tidal, solar, and algal production sustains the local ecology while supporting the five PAM proprietary travel systems:

· SubOrbital Shuttle: Non-Rocket Launch System
· MagLev Passenger Pod: Rapid over-ground Transport
· Coastal/Floodplain EcoCruiser: Riverine Research/EcoTourism Vessel
· Intracontinental WingShip: Zero-Emissions Electric Jetliner
· Amphibious FlightLiners: Air and Sea Cargo Transport

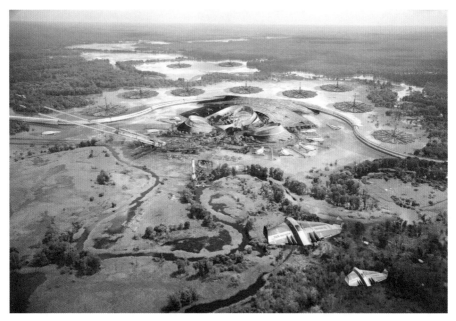

Two WingShips cruise above the PAM: Barotse, a low-impact eco-travel complex in the Western Province of Zambia. In the distance a series of circular solar arrays convert the algal floodplain into electricity which powers the complex and its many systems including the surface to orbit, MagLev Launch track at left and the gleaming metallic Transport tube which snakes across the landscape.

The "Departures Roundabout" is a busy yet tightly coordinated roadway that shuttles passengers, via driverless hover pods, between the SubOrbital Concourse, MagLev Transport Stations, and Aqua-Terra Docks where EcoCruisers can be boarded for short or long-term research/eco-tour residencies and WingShips wait to carry passengers to and from neighboring countries. Amphibious FlightLiners coast along a separate riverine canal, ferrying goods across the continent.

The smell of fried *ifinkubala* (caterpillars) wafts through the air of the SubOrbital Covered Concourse, an open-air market and departures terminal where passengers wait to board one of two types of SubOrbital Shuttle. Lush and verdant gardenscapes are intersected by long rows of bench seating, and "Boarding Bots" weave throughout the waiting throngs, providing info on everything from flight schedules to checked bags* and current weather conditions. *Checked baggage is pre-boarded via "Baggage Bots" upon arrival to the terminal.*

Two classes of SubOrbital Shuttle await take-off in an algal drift-pool that will guide each one to the MagLev Launch Track: a non-rocket, magnetic propulsion system that catapults the shuttles into a low earth orbit, allowing for a travel time between Lagos and Los Angeles of roughly two and a half hours. The huge Observation/Control Drone, which hovers at the horizon, is responsible for coordinating the Air/Aqua/Terra travel and transport for the entire complex.

INTERVIEW WITH

MPHO
MATSIPA

EMANUEL ADMASSU

You were initially trained as an architect at the University of Cape Town and at the University of California, Berkeley, prior to completing your PhD. Was your decision to pursue a PhD in architecture and to continue working as a researcher, educator, and curator driven by a certain frustration with the limited agency of a designer in cities like Johannesburg?

MPHO MATSIPA

[Laughter] I did my professional degree in architecture in South AFRICA. All of my later education was in research at Berkeley. I actually was accepted to Berkeley to do an MArch, but when I got there, it seemed like a more productive use of my time to expand into areas I have always been interested in but couldn't pursue, in a professional degree. The shift into research was more about finding approaches to some of the questions that I had confronted in my professional training, but that none of my previous education had prepared me to answer or to make sense of. I had no way of understanding informality, for instance, or geopolitics, or how development discourse emerges. There was nothing in my professional training that helped me to understand how African urban environments are actually produced.

EMANUEL

It was an attempt to expand the agency of architecture?

111

MPHO

It was more about expanding the vocabulary that's available to us, to make sense of the world, because architectural language and formal language can only get you so far when you are trying to actually make sense of an urban environment that is incredibly complex and where things can't be easily measured using traditional architectural tools. The tools that we had, as professionals, were completely inadequate for speaking to questions of rapid transformation, rapid urban growth, and even macro/micro economies. It just wasn't part of our vocabulary at the time. Most of the conversation was around questions of modernism and the difference between critical regionalism or orthodox modernism. That was the extent of the architectural discourse at the time, and postmodernism.

EMANUEL

In a PBS *NewsHour* special about colonial monuments, you talk about the concept of spatial justice. You state that the City of Johannesburg remains a monument to apartheid spatial planning and apartheid spatial thinking. How does the subversive role of spatial appropriation and unexpected use patterns destabilize spaces that have been embedded with violence and painful history? In other words, accepting the relative permanence of architecture — how can we inscribe new meaning to spaces that we inherit from oppressive regimes?

MPHO

If one looks at downtown Johannesburg, the land use patterns in the inner city have changed quite dramatically. There's an intensification of use, a diversification of use. A lot of the kind of 1950s, 1960s zoning technologies are largely irrelevant in the face the changing nature of business and the changing scale and speed at which the urban environment has changed. One of the things that's interesting about Johannesburg: in the 1920s you had politicians, like Barry Hertzog, basically talking about the city as the fulcrum of white civilization in these "barbaric lands." In the colonial imagination, the city was always imagined as white. Even though, historically, the city was never fully "white," the city was always mixed. But that kind of seeped into a lot of mainstream architecture and urban discourse where a lot of planners, as late as the 1990s and early 2000s, were talking about the graying of the inner city, which was basically shorthand, for them, about the entry of African bodies into the inner-city space. I think that, for me, Johannesburg is a city where a lot of the colonial and apartheid-era segregation has disintegrated while the city has transformed and you have uncontrolled urban sprawl. But there are also other kinds of technologies and spaces that persist and that are remnants of the apartheid

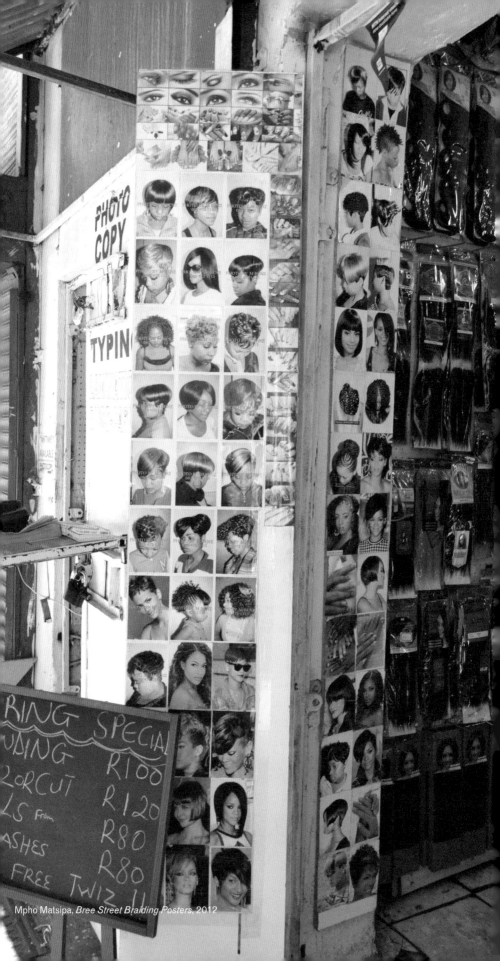

Mpho Matsipa, *Bree Street Braiding Posters*, 2012

and colonial era, like the way in which apartheid city planners used infrastructure as a technology of segregation and sociotechnical control. You see this in the way the city is largely unwalkable. It's a very automobile-oriented city even though about seventy percent of the urban population don't own cars. You have these vast strips of barren, unused, unprogrammed land that were basically designed to function as a multiplication of borders amongst different communities while city governments of Johannesburg have not really done enough in the last twenty years to rethink that geography, including reworking the sort of public transport infrastructure in the city. A lot of the historical patterns of segregation, with poor communities living in the south and wealthy people living in the north, remains, and the city grows away from what was once the center. You also have patterns of urban development where we have a capital-driven land market that governs how real estate operates, so low-income people are still the furthest away from spaces of opportunity. This, for me, is really a re-inscription of the apartheid ideology of segregation and separation. It also imposes a curfew because low income people have to leave the city after dark. The city is unnavigable without a private car after dark and it becomes unsafe for everyone.

EMANUEL

In this incredibly complex scenario, how do you begin to define spatial justice and how does this definition fit into the idea of a "Mobile AFRICA"?

MPHO

I think that architects need to ask deeper questions about the way in which inequality is structured. Questions of inequality cannot be addressed simply at the level of architectural form. We have to ask questions about policy, we have to innovate, experiment with different financial models to produce different kinds of architectural typologies, we need to map and ask questions around real estate markets and where land is free and what land is not free. What land belongs to the city, what land belongs to the state, and what land is privately owned. Questions of spatial justice cannot be disarticulated from questions of the economy, questions of land ownership, questions of the regulation of publicly owned land and its distribution. So beyond formal training, what's required is a political and spatial consciousness where one begins to ask questions about political economy and ownership and economic policy because these things have everything to do with the shape of the city. I also don't think that it's fair to burden low-income communities with the task of transforming the city and making it equitable. I think that architects and professional bodies are very well equipped to ask these kinds of questions too, but they

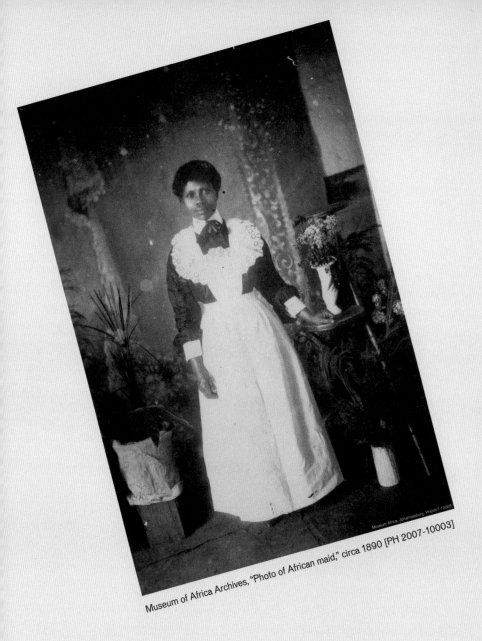

Museum of Africa Archives, "Photo of African maid," circa 1890 [PH 2007-10003]

Museum Africa, Johannesburg, PH2007-10003

need the political will in order to frame them, in order to pose them as members of the public and within our institutions.

EMANUEL
Absolutely.

MPHO
I wouldn't say that the encouragement of informality is enough to transform the city. I think that they need to be much bigger structural changes.

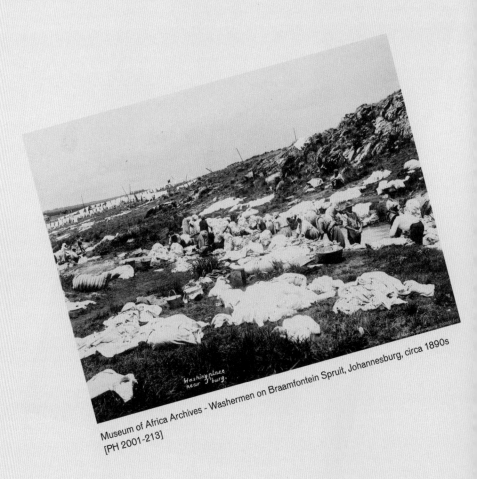

Museum of Africa Archives - Washermen on Braamfontein Spruit, Johannesburg, circa 1890s
[PH 2001-213]

EMANUEL

Following up with that, in your current project, *African Mobilities*, you're aiming to rethink the geography of African migration and the challenges and opportunities they pose for doing architecture and urbanism differently, through, and I'm quoting you, "an exploration of architectures at the intersection of migration, displacement, and digital technology." Can you talk a little bit about cartography as disruption? This was a concept that was mentioned at the Munich Exchange Conference.

MPHO

One of the conversations that I had, specifically with Ntone Edjabe (Chimurenga), was this idea of counter-cartographies. As it's understood cartographic work has its roots in a kind of colonial practice of mapping territories in order to master them. It also makes certain kinds of things visible in order for them to be controlled and

owned. However, when one begins to set out a counter-cartography, you're also delineating certain relationships of power that can indicate alternative trajectories. It's like, the sixteenth-century etching of Timbuktu, where you have the sedentary city and also a mobile city that can inhabit the same space simultaneously. One of the things that mapping out different cartographies and trajectories of the African cities can do is expand the vocabularies that we have around space. If you work exclusively through a Western industrial paradigm of the city, it's a city where people are actually fixed in place. Whereas there are other models of city-ness where populations move: people don't have to be permanently pinned down in a physical location in order to be able to participate in that culture or in that space. One of the things that is really important to do, not just for architects, but for policy makers and people making decisions about cities, is to expand our frame of reference for thinking "city." One of the limitations, for me, around cities in AFRICA, is that we've limited our imagination to a kind of Western industrial city ideal, which is not necessarily the future of where cities in AFRICA, or elsewhere, are headed. Our futures could be very different and we need to free our imaginations and our points of reference in order to take into account the complexity of future possibilities. It's really about openings rather than definitive proposals.

EMANUEL

In your dissertation, you write about a specific concern for legibility or what you call "anxieties generated by a city that has become opaque and unknowable." Do you think there's an anti-gentrification strategy that could potentially benefit from making the city more opaque? In a way, a resistance against the current trend within architectural schools to make guidebooks for African cities.

MPHO

That's so interesting because I think that opacity is actually the generalized condition of most cities in AFRICA and that legibility and transparency is a kind of modernist wet dream for what the city could become. Which is also desire for control. Also, one of the difficulties with transparency, or the demand for transparency, is that it's a violent desire and is tied very much to a capitalist economy where everything needs to be enumerated and calculated. It's not tangible and that speaks to a very particular kind of calculus of what city space is. In other cities like Nairobi, or even Johannesburg, there are zones of the city that are not that easily calculable, but where they've made allowance for a certain kind of opacity or a certain porosity that privileges use rights. It's not only property owners or the rule of private property that should govern the future of the city, but also the people who actually use the

Laura Trumpp, *African Mobilities — This Is Not a Refugee Camp Exhibition*, 2018, designed by Wolff Architects. Courtesy of Architekturmuseum, at the Pinakothek der Moderne, Munich

city on a daily basis but don't necessarily "own" it. Their voices are not accounted for adequately in those sorts of calculations.

EMANUEL
How would you say your project *African Mobilities — This Is Not a Refugee Camp Exhibition* addresses issues of access and dissemination? How can we make sure that the knowledge that continues to be produced about African spaces is accessible to future generations of African students, designers, and academics?

MPHO
It has to happen on multiple levels. We've produced an online catalogue, which is open source that's available for anybody who wishes to engage with that material or to access the conversations that happened in the eight cities. All of that information is freely available online — if people can get online. The second component of it is really having these public exchanges in the different cities which is about growing

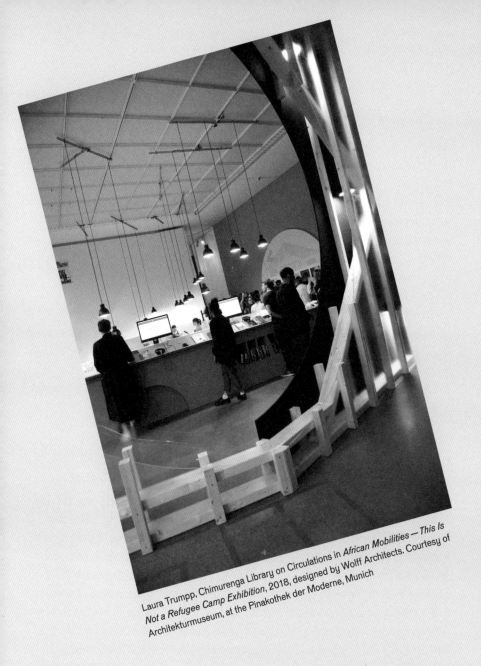

Laura Trumpp, Chimurenga Library on Circulations in *African Mobilities — This Is Not a Refugee Camp Exhibition*, 2018, designed by Wolff Architects. Courtesy of Architekturmuseum, at the Pinakothek der Moderne, Munich

the art public or growing the audience for architectural conversations in different locations. In some instances, student groups have actually organized themselves beyond the *African Mobilities* framework in order to have discussions amongst themselves without me being present or curating or determining what the priority will be. The third component is having a traveling exhibition that further disseminates the outputs from the exhibition in the cities where some of this knowledge is produced. This has a lot to do with the ethics of research where it's very easy to have an extractive model of research where one moves into locations that one does not come from and communities that one does not belong to, and go off and put on shows in

119

distant lands where it promotes your profile, your professional career, without any kind of feedback from the communities that one has worked with. So one of the things that I'm really looking forward to doing next year is returning to Lagos and sharing the output of our exchange with students from the University of Lagos and with community members from Makoko who inspired the graphic novel and the animated film. It's a very small gesture but it's the beginnings of me thinking about the ethics of research and the responsibilities that one has towards communities whom one engages, even at the level of fiction or speculative thinking.

EMANUEL

As someone who studies urban design, how do "transnational spaces" like museums, work towards fostering or challenging what you call the "larger geopolitical realignments?" In a way, how does design culture via biennials, global art fairs, international cultural exchanges, etc., dovetail with the specific spaces where culture is enacted and produced, i.e. the city.

MPHO

I'm not sure that it does. One of the conversations I'm having with my university is why South African universities tend to privilege European and American institutions over African institutions and part of that has to do with the fact that it's really difficult to actually have exchanges, transnational exchanges, on the continent and that they're very difficult to sustain, again, because of geopolitics, because our institutions are under-resourced. In order to have meaningful conversations, somebody has to pay for it, and we haven't quite figured out what kind of models we need in order to have sustainable exchanges amongst African architecture institutions in order for these conversations to happen on the African continent. We do not have an African architecture biennale or triennial and there are maybe one or two architecture festivals that happen on the African continent. A lot of the intellectual work, while it's being produced by Africans, doesn't necessarily stay in AFRICA. There's an ongoing challenge to return and center the conversation on the African continent amongst Africans who lead the conversation as opposed to always being on the receiving end of expertise from elsewhere.

EMANUEL

In your PhD dissertation you write about regimes of representation. More specifically you write about a distinct regime of representation that was embedded in dual projects of nation building and the neoliberal reorganization of the city and its economy.

MPHO

In order to arrive at some sort of image of modernity, the aspiration is to arrive at it as a European or an American aesthetic. What does it mean to actually diversify the aesthetic or to think about aesthetic justice that takes account of different practices, different spatial practices, different bodily practices, different cultural practices, that will produce the city differently? I don't know if one can *a priori* arrive at a regime representation that is African, but rather adopt a sensibility that is open towards different kinds of practices that are not normally considered practice for what the city should become. There are so many things that happen in African cities, even in terms of your own research, Emanuel. When you talk about the Tera system in the Merkato for instance. It's a different organization of space and that produces its own aesthetic that you are finding a language for or struggling to find a language for. This is the challenge for the next generation of African architects: to actually imagine beyond Europe and America. I think that the challenge for us is to find methodologies and techniques that bring us closer to understanding the kind of dynamism that we're confronted with.

EMANUEL

What would you say are possible precedents, or are we suffering from a complete lack of imagination at the moment?

MPHO

I wouldn't say so. I don't think that your Merkato research suggests a lack of imagination. That was the whole point of *African Mobilities*, it was an invitation for practitioners and artists to come up with different approaches. You have artists like Nolan Oswald Dennis, Dana Whabira, and Thembinkosi Goniwe basically talking about using sound as the smallest possible unit to measure space and experience, and they've basically reconceptualized the entire "southern African" region as one sonic vector that reorients one's understanding of cultural linkages that override the territorial inscriptions following the Berlin Conference in the late nineteenth century. This is a conception of space that is actually about movement. The movement of sound and its transformation, as a region together. That is also an expression of its diversity. There's your work. There's the work of Olalekan Jeyifous and Wale Lawal with Lagos Exchange. Even Jean-Charles Tall tells us a lot about diasporic move-ments through his photographic mapping of architectural styles across Senegal, the Atlantic Ocean, and Mediterranean Sea. These are all indications of architects at different stages in their careers or their art careers who understand the necessity to produce a language for the transformations that are taking place. We're no longer

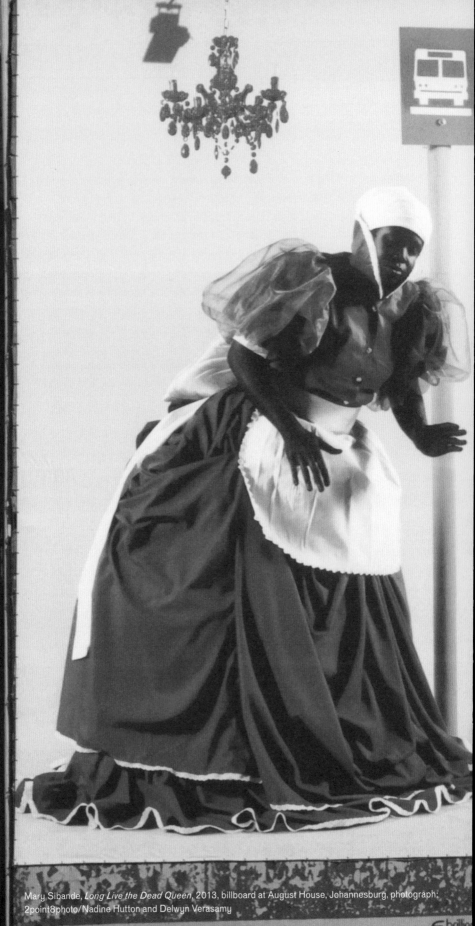

Mary Sibande, *Long Live the Dead Queen*, 2013, billboard at August House, Johannesburg, photograph: 2point8photo/Nadine Hutton and Delwyn Verasamy

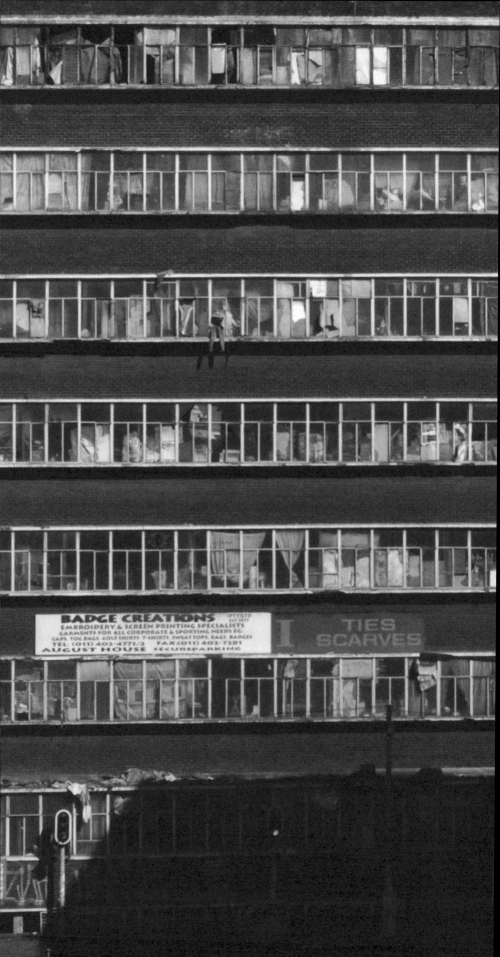

working within the old stale paradigms. This is a period of intense and creative searching for language, articulation, and invention, too. I think that we are entering a period of intense invention and imagination.

EMANUEL
I hope so.

MPHO
I think so! And nobody is asking for permission and there's no handbook for it.

EMANUEL
What would you say is the role of positioning in your work? Is there productive friction between disciplinary positioning and geographic positioning? Also how does your identity as an African intellectual, a Black woman, a global citizen, inflect the work?

MPHO
For me being Black, a woman, an African and South African is incredibly productive because I'm often on the outside (and inside) of so many different things. Even while I was training as an architect, I was on the edges of the discipline. As a Black woman in public space, I'm on the edges of public space. It's a kind of radical margin that allows me to understand a lot of the power dynamics as they play themselves out in the profession, in the field, and in space. It's sensitized me to questions of inequality, to questions of aesthetics, and to questions of representation, precisely because I've had to live through all these technologies of exclusion and work against them and find creative strategies to overcome them. For me, it's an incredibly productive space from which to imagine the world. And it's also a privileged space because I'm not mystified by what it means to be human. Whereas some people are born at the center of discourses and never have to be reflexive or to reflect critically on their own positionality, when you inhabit a world or you inhabit a profession that never imagined you occupying any meaningful space within it, then you're forced to be inventive, you're forced to assert yourself and to create space for yourself within and beyond that. For me, it makes me feel that I'm operating from a position of immense strength and insight. It's a privilege, in a way, to be able to occupy that space and to think about articulation. I think that after going through many years of graduate education and teaching at a South African university, there's been a lot of fuss made about representation and transformation and visibility. I've arrived at a point where I absolutely find questions of representation alone quite meaningless — or tokenism or being made visible. I think in order to really be meaningful, to be effective at what

WHAT ARE THE "COUNTER-CARTOGRAPHIES" OF AFRICAN CITIES?

you do, you can't just instrumentalize this part of somebody else's diversity project. Institutions have to create spaces of articulation and as an actor within that institution I have to work hard to create, maintain, produce spaces of articulation for myself and with other people. It's not enough to just be visible, we actually have to have spaces that enable us to do the work that we should be doing, or that we want to do, rather than meant to be doing.

INTERVIEW WITH

ERIC GOTTESMAN

ANITA BATEMAN
As an undergraduate at Duke, you were a Hart Leadership fellow. The Hart Leadership program supports "worthy purposes that have both a 'me' and 'we' dimension." It also proposes that "Students...learn that leadership and formal authority are not the same thing. Leadership is not handed over with a promotion or a title; it is a demanding art that requires attention, courage, and experimentation." Can you speak more about your early interests in finding a personal and artistic purpose? How do you define leadership and authority, and what has that differentiation meant for your artistic trajectory?

ERIC GOTTESMAN
It's interesting to revisit that because I haven't thought about the Hart Leadership program in a long time. [When it first started] it wasn't really a program, it was like a fellowship that Alex Harris, who was a professor at the Center for Documentary Studies, and Kirk Felsman, who has since passed but was a child psychologist, started at Duke as a combination of public policy and documentary work. In those days, they would partner with an NGO, and they would find a student that was interested in going [abroad] and doing a project. At that time, I had no interest in photography whatsoever. I didn't study photography. I didn't study art. I was actually working in Washington, DC at the Supreme Court in the Chief Justice's office when Alex Harris called me and asked if I wanted to be part of that fellowship. I didn't really know what I thought about leadership. I didn't even know what I thought about the kind of language that the Hart Leadership program used to describe itself, and

how that language gets formulated in sending out young college graduates from an American institution into these very complex situations.

When I think now about what leadership means and what authority means — well, I think one of the first things I ran up against when I made that initial trip to Ethiopia was how to understand and what to do with the dynamics of power. How was I, as a photographer, as an artist, as an American, as a white-ish looking man, supposed to negotiate and navigate the power relationships that I [also] create.

I think that the people who created the Hart Fellowship program were aware of the problems of sending young people out into complex situations. At the time, we, young students graduating from Duke, were like: "Yeah, I'll go to Ethiopia. I'll go to Rwanda a year after the genocide....." They knew our minds would be totally blown. I remember something that Kirk Felsman said before I went to Ethiopia for the first time. He told me: "You're going to feel these feelings about..." you know, I think he used the example of people on the street asking for money; "You're going to feel these feelings of not knowing what to do." And he said: "That's where we want you to remain: in this state of being unsure what the right thing to do is." These NGOs often have unassailable missions and names like "Save the Children," as though the inequality and suffering caused by human beings in the world is a simple thing that can be cleaned up by the same system that created it. Anyway, it's all to say that these issues of authority and power were things that became extremely complicated once I landed.

I'm conflicted about the kinds of programs that send eager, young, well-meaning people out into the world because on one hand they don't know — I didn't know — what the implications were going in. On the other hand, in some way I was primed to ask hard questions, and to dwell on those questions. Had I not gone, I don't think I would have been able to navigate how to participate in the world and be critical of my place in it as well. I think some of the work that I've done since then...I would have missed out on a lot [of opportunities].

ANITA
So, dwelling in that uncertain place troubles authority?

ERIC
Yeah.

ANITA
It sounds like those moments of discomfort were formative experiences. Do you think that dwelling in that discomfort shaped how you approach your work as an activist?

ERIC

I don't totally draw the line between my work as an activist and my work as an artist. But yes, I do think it shaped me because I pretty quickly realized what I knew and what I had learned was flawed, and who I was in those situations was complicated. I am made up of my experiences, my education but I am also made up of something else — as we all are. In my case, I wanted to know, why does this work like this? What were these things that I was witnessing as a photographer and as a human being? I got to Ethiopia, and I saw things I'd never seen before. For somebody who grew up relatively sheltered in New Hampshire — I had been to AFRICA once before — everything was new, and everything looked worthy of my taking a picture. But for some reason, I didn't photograph for the first five or six months. That experience of just trying to make sense of it all was something that led me to ask why and how I was seeing people and relationships. The systems that are set up to structure institutions and exchange are basically the same things that are set up to structure society. These very large systems are hard to visualize. Often, what we end up see-ing — especially through photography and as photographers, and more specifically, as foreign photographers in Ethiopia or other places around the world — the thing we see is kind of symbolic of much larger constructs. My critique of photojournalism and of documentary work is that what we see as a symbol is a set up in the lan-guage of a problem, as if we are seeing the root thing [instead of its symptoms]. For example, we're given an image of a starving child and the world is called to help. But why is that child starving in the first place? Why is that starving child *in that place* to begin with? It's not just about empathy, but about critical understanding. Why did a refugee child wash up on the shore in Turkey? What is the system and the history and the context that led to that situation? Those issues are way more complicated and much harder to see.

EMANUEL ADMASSU

So is the initial instinct to unlearn the preconceptions you might have as an American or as someone working as an artist?

ERIC

I'm conflicted about whether it was to unlearn that or to expand my learning of other things. When I first went to Ethiopia, I collected a lot of passport pictures because I was fascinated that people collected them because it meant something to them. When I first saw them, I saw the same picture over and over again with a different person in it, but once I started learning some of the context and history of those col-lection practices, I began to realize that a passport picture does a different thing for

131

me than say, photojournalism, which was the way that I had learned about Ethiopia and AFRICA as a kid growing up in the United States in the 1980s, so the question is: am I trying to unlearn what I saw, or am I trying to add layers upon it? I think it's the latter.

As an artist, I hadn't really "learned" art yet; I was sort of making it up as I went along. In college, I made up my own major. I was resistant to pre-existing definitions and categories, which is perhaps what led me to question authority — whether it's photographic authority or governmental power — in some of my projects. Then when I got my Master's from Bard, which is a very avant-garde type of program, a lot of people were telling me: "What you're doing isn't art, you're doing peda-gogy or sociological work or some sort of social work." My response to that was: "OK, but... why can't that be art?" I resisted the critique that you can't transgress boundaries. It's dangerous territory because you're constantly being told you're not supposed to be doing that.

EMANUEL

It seems like some of that resistance you had was both to disciplines and to insti-tutions, but to a certain extent, you've also received a lot of fellowships and grants through some of these massive institutions, like Fulbright, Light Work in Massachu-setts Cultural Council, etc. How have these sponsorships shaped your ideas about institutional support and the possibilities they provide? What are some of the compromises you've been forced to make while seeking funding for projects that have moral and ethical implications?

ERIC

We all have to figure out how to navigate, and ideally shift, the institutions that feed us. All money is dirty. The one that you didn't mention is the Open Society Foundations, which has a clear agenda in all these places. Some of these institutions are supporting me as an artist, and that comes with its own caveats. Some of them just support a specific agenda in the world. For the first fifteen years of my career, people would always ask me how I navigate grants and philanthropy, and my answer was kind of knee-jerk but also kind of true: I'd research the hell out of the granting institution, figure out how to write the proposal, get the money, and then rip up the proposal [laughter]. It was important for me to refigure each project. I could sit here and write a great proposal for how to produce a project in Syria or Mongolia or elsewhere, and it would sound really great to funders that also speak the same political, philanthropic, artistic, aesthetic language. Is that the project I would actually want to do if I were on the ground for a while? No.

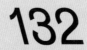

Another thing that I built into the work is hang out time. Time to just go some-where and be there, time to figure out what's interesting, what I have to unlearn or relearn or learn anew.

EMANUEL
You're approaching them as two separate projects then: there's the project of writing a grant and there's the photographic project, which might not be in line with the proposal. You're almost bifurcating the process.

ERIC
That's been my way of navigating, but there comes an end to that. You can only get so many grants. You can only "fake it" for so long. What's interesting is that I've said this to donors before. So long as I produce work that is within the realm of things I'm interested in, which is about participation and reconfiguring and challeng-ing existing structures ... I mean the work is always about that.

So in that sense, it's been rare that donors have been unhappy with what I've produced. But it is weird, and I'll just add one thing, which is especially [evident] with this *For Freedoms* (2016 –) project: I think that my way of operating has slowly started to change. I've been resistant to any other economic model allowing me to subsist. I've been resistant to engaging in a commercial market. I still don't have a gallery, and that's partly because I've been really conflicted about it and feel weird about how that whole system works. But, as I'm looking at certain friends of mine who are very commercially successful, it's interesting to see that they also have to navigate it because there is a whole calculation regarding the work they make for the gallery. The economy is not set up to do these sorts of experimental things. So then the question is: how do I figure out how to do it? Maybe academia is one route, but that is not necessarily cleaner either. You guys probably deal with this too.

ANITA
It is definitely a concern. That is, thinking about whether or not you have to peddle the artistic value of the project and hide its moral implications to people who may be offended or may not understand, just so a project can get funded. Do you feel like there's a trade-off, on one hand, to keep the integrity of your vision, and then, on the other hand, to have the political aspects come into play later once you actually have leeway to do the project?

133

ERIC

That is also something I've had to negotiate in a lot of different ways. What's interest-
ing, though, is that since I've started working on this stuff, foundations have gotten
much smarter about how they want to fund me — a foreigner — going into places to
do the kinds of work that I do. At the beginning, just my knowledge of a local scene
or situation would qualify me as somebody. Now there's a lot more sniffing out,
which I think is probably a good thing from the philanthropic side. On the political
side, it's a little bit of cloak and dagger because both in my project in Ethiopia [The
Oromaye Projects (2011–)] based on Baalu Girma's novel Oromay (1983) and in
For Freedoms, I'm often running up against places where politics isn't supposed
to happen, and then the question is how can I embed it within something else. So,
sometimes art is a Trojan Horse for me to accomplish the stuff I would want to do,
but without calling it what it is.

EMANUEL

Through the Hart Fellowship, you were able to collaborate with young people who
have lost their parents to AIDS-related illnesses. The resulting collective, Sudden
Flowers, was formed with the intention of centering the imaginative capabilities
of these uniquely affected youth. What do you value about that collaboration and
the relationships that developed between you and the members of the group? And,
has this first project shaped or set a standard for how you collaborate with other
artists and community members?

ERIC

The fact that photography is a medium where you stand there, and you take a pic-
ture of somebody and you're physically present with that person — that's one of the
reasons why I am interested in it. That relationship became a microcosm of all these
social and political dynamics that we're talking about. At first, I was really into doc-
umentary photography, but then I started asking questions that had already been
asked twenty years earlier about the critique of documentary photography; I just
didn't know about it because I hadn't read Martha Rosler, Abigail Solomon-Godeau,
Allan Sekula, etc. So then I wondered, if the photographer is the one controlling
the image, how can the subject have agency, autonomy, or some sort of authority
in the creation of an image that is representative of them? This is where I begin
to define collaboration: there's an uneven power dynamic. From some viewers'
perspectives, there's an expected way in which the power dynamic is supposed to
flow, and I wanted to mess with that. I wanted to make it messy. To decenter singular

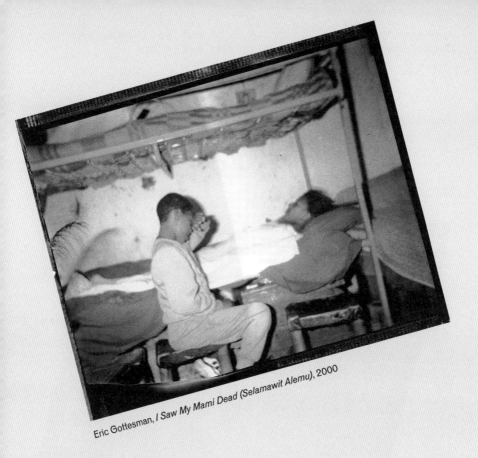

Eric Gottesman, *I Saw My Mami Dead (Selamawit Alemu)*, 2000

authorship. To take for granted that it didn't matter, or that it was a fuzzy gray area of who took the picture.

As I've gone along, there have been other collaborations that I've done in Labrador [Canada] with Wendy Ewald; in Jordan with Toleen Touq; with Hank Willis Thomas on *For Freedoms*; and others in eastern Kentucky, with a group of young people at Appalshop. In some cases, these are collaborations in the mold of: "Here is a power dynamic that produces a certain kind of image or a social situation. Let's mess with it, let's subvert it, and let's see what happens," because that in and of itself is going to lead to surprising results.

What drew me into Sudden Flowers is partly my relationship with these kids. Actually, at the beginning it was largely my relationship with these kids. From a personal level it's still my relationship with these people; they're no longer kids. As an artist, what drew me to the project — and drew me back again and again over fifteen years — was that the images we were making through this unique process were much more interesting than what I would have made about this community had I just been a photographer in the traditional sense. But in some of my projects collaboration takes a different starting point; it's not the power dynamic between subject and photographer or an unequal power dynamic. Rather, like with Hank [Willis Thomas] or with Wendy [Ewald], it's a situation where two artists are working together — sometimes in collaboration with other people, sometimes aligning their

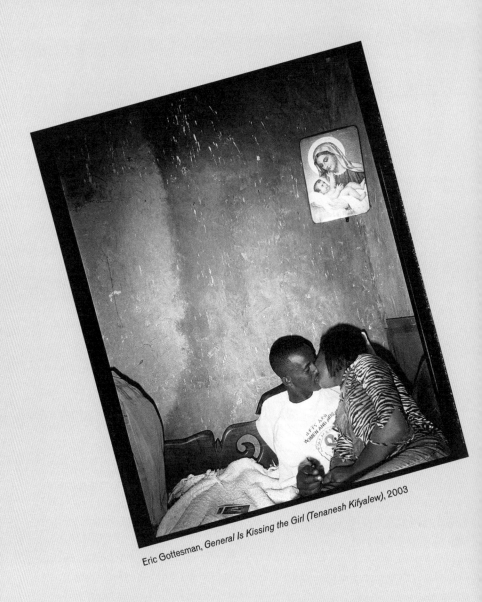

Eric Gottesman, *General Is Kissing the Girl (Tenanesh Kifyalew)*, 2003

visions with each other. Collaboration has become this kind of catch all term; I've become a watchdog for what collaboration means or what participation means. I hope I'm not too much of a bean counter about it, but it is important to be specific about what kind of collaboration we're talking about. So in some senses it's informed these other projects, but in other senses it's made me stricter about thinking about what collaboration means. For me collaboration, at least in *Sudden Flowers* (1999 – 2014), as a project, led to this idea of the possibility of surprise — that something new might come out of this process. It wasn't the artist coming in and

imposing a vision, but people coming together and generating something out of that relational experience. Since that time, other labels have been put on that kind of practice, like "social practice artwork," or "participatory art." In the 1990s, it was "relational aesthetics," which is not exactly a straight line, but even before that there was Fluxus, and before that, there was social sculpture. I see it in the same vein as these other art historical movements that are moving away from the art object and toward relational experience. But that's all to talk about it from my perspective now. [During] the project, it was very much about my friendships and the complex relationships that informed the photographs. These kids went through a lot of trauma, and we were processing together, so it was very personally meaningful.

ANITA

You've also talked about "collaboration" being an abused term and that you have viewed the relationship between you and the children as "a proxy for post-colonial power relations between individuals and also between institutions. Photographers often have had power over their subjects as colonizers have over the colonized, though obviously not to the same extent, and my approach was to blur the line between photographer and subject to confuse the concept of photographic authorship."[1] How do you resist or subvert these power dynamics if the medium itself reproduces and is sustained through the idea of the colonizing eye? And how do you draw attention to these issues, or convey your own critique of the medium if the point is to draw attention away from this idea of authorship?

ERIC

Now you're talking my language. I don't know is the short answer. As you know, photography is very much bound up in colonial ventures. I've thought a lot about that, and how to subvert it. I guess it comes back to the idea about drawing—about making marks, rendering, which is supposed to be a representational experience. The thing about photography—the trick of it, even though we know it's something that lies to us all the time—is that we still believe it on first instinct. There's something innate in that; it's maybe even physical or optical. Photographs look like the world that we see. It looks like the way our eyes register the world. It's really hard to trick your brain into deprogramming that. So ideology is inherently inserted into photographic practices, sometimes consciously and sometimes very subconsciously.

1 Amy Galpin, Abigail Ross Goodman, and Eric Gottesman, "Interview with Eric Gottesman," in *Fractured Narratives: A Strategy to Engage* (Winter Park, FL: George D. and Harriet W. Cornell Fine Arts Museum, Rollins College, 2014), 67–68.

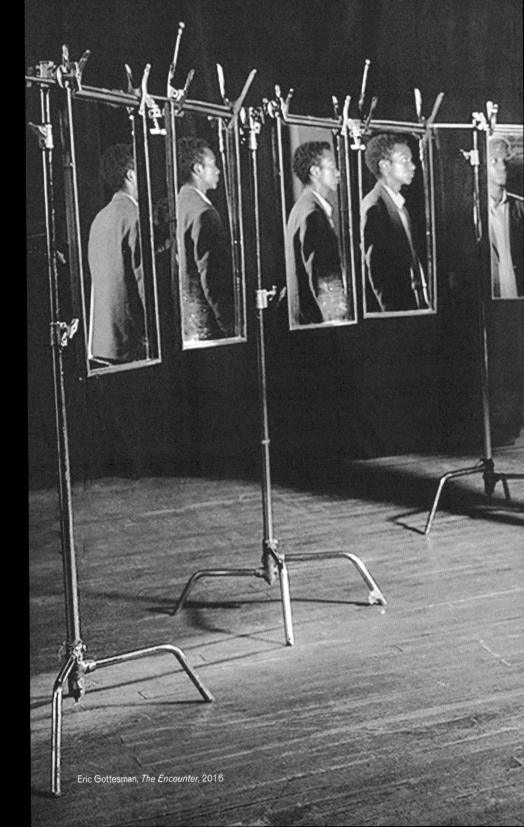

Eric Gottesman, *The Encounter*, 2016

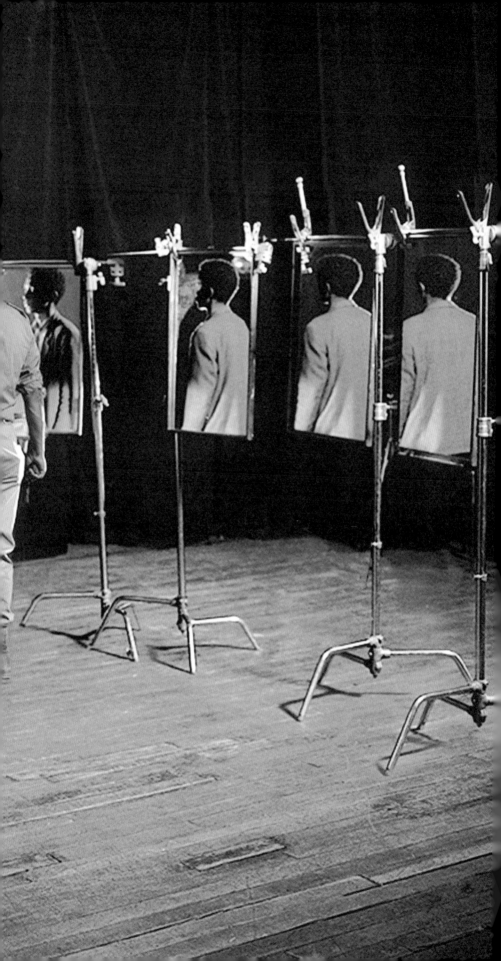

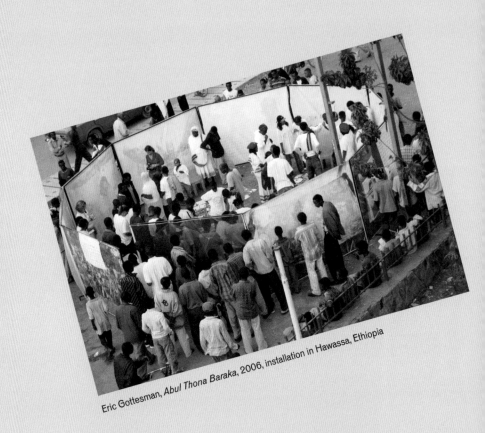

Eric Gottesman, *Abul Thona Baraka*, 2006, installation in Hawassa, Ethiopia

One of the things about photojournalism—I keep coming back to photojournalism because I think that's the ultimate representational practice where Orientalism embeds itself, and in colonial and anthropological photography as well—is that I'm sympathetic to the artist, or to the photographer because I feel behind that photographer or artist there's a much larger system that has geared their vision to be what it is. I'm sympathetic in the sense of their intentions. I often feel that people who are making problematic, oppressive imagery mean well, but that's not really enough because there is a methodology that links up with ideology—again sometimes consciously sometimes subconsciously—that basically gets in the way.

ANITA
Do you think it helps when the artist or photographer makes their intentions known, or is that limiting in some way?

ERIC
I think context always helps. Well, sometimes it helps. I mean it helps to determine

how to read it. Now that doesn't immunize us from what is going on in the images or how we perceive images.

Do I agree with the idea that the medium itself is part of the colonizing eye? Is it possible to decolonize photography? This is where I think Ariella Azoulay's work comes into play because I think there's inherently space for more agency in the image than Susan Sontag or others allowed.

Let me ask you: "How do you see the medium being part of the colonizing eye?" Are those my words or your words? [laughter]

ANITA

These are my words. Photography, at its core, is a medium for imagining the world. Photographers were indiscriminate in their subject matter; they went out, saw what they wanted to photograph, and that became a body of work. So you have this new way of imagining that is coterminous with the advent of the medium...

ERIC

Because it's descriptive?

ANITA

Right, it's descriptive, but photography also allows people to mass produce images in a way that was never possible before. Photography goes everywhere and does everything. So when I say the "colonizing eye" in relation to those early years, or even now perhaps with photojournalism, I mean that people are traveling to certain places and taking photos of everything because everything is interesting or com-modifiable. Also, photography allows for unrestrained access to people's spaces in a way akin to invasion.

ERIC

The more contemporary form of that is the surveillance and corporate imaging of our lives and probably this room.

ANITA

You're always being watched. There's always the chance a photographic event will occur, which means you're constantly being made vulnerable to the possibility of others inserting their wills on your image, your likeness, your environment. The colonizing eye creates consumable and disposable "objects."

141

ERIC

Right. Sister Souljah said: "You can be a bug on the end of a plant in the Amazon and there would be a white man pointing a camera at you."

ANITA

Exactly. There is this system that allows people with cameras to go in and document whatever they want, without any hesitation or apprehension as to how the images will circulate.

ERIC

My question is: "Is it the apparatus itself, is it the medium itself, or is it the ideology?"

ANITA

The medium sustains the ideology. Someone with a camera automatically assumes a type of authoritative license or purchase over what's being photographed because it's their way of seeing the world that can be manipulated or not afterward. You can read intentions or not into it, but there is an authoritativeness that goes into pointing, shooting, capturing, and all the other terminology that describes making these very surveillant things.

ERIC

It's definitely a tool that can be easily adapted to certain aims or agendas. But because colonialism took many different forms, it makes me think that photography was a kind of easy tool for *parts* of colonialism in terms of the production of race, the production of phrenology, and classification systems. Photography lent itself to the ways in which colonialism decidedly oppressed.

Was it the fact of the medium itself though? Azoulay suggests that there is a way to claim control without authorship. Photography is one of those colonial tools though it's not necessarily the driving force for why we see the way we see.

EMANUEL

The issue to me is not necessarily photography but the photographer. Usually — at least in the context that we're discussing — it's about the potential to disseminate an image. Africans have been photographing themselves for a long time. People from the Middle East have been documenting and drawing themselves. But the colonial arsenal allowed photography to disseminate globally in ways that it wasn't able to before. To a certain extent, that's what Napoleon did with Egypt; for example the moment he entered Egypt, all of a sudden Egypt became knowable, became

MERICA GREAT AGAIN

FORFREEDOMS

mitee.

LAMAR

HOW DO
ARTISTS
UNLEARN
INSTITUTIONAL
MARKERS
OF VALUE?

something you can actually draw, represent, and of course disseminate throughout the world. So I don't know if we can separate the two — the photograph from the photographer.

ERIC
Well, if you think of our current tools — Facebook, for instance, or social media in general — they are enabling access to an archive that goes well beyond the kinds of stereotypical images that inform the world about, say, what Ethiopia was before. So, now you're right: the photographer is controlling an image to a greater extent, and yet there are photographs being made that surveil, that regulate, that threaten, which often don't have a photographer attached — they're machines taking pictures. So, maybe this distinction between the photographer and the camera, or the photographer from photography itself, is a useful one because it does seem like this colonial impulse emerges when a human is imposing a vision upon an image. However, we don't actually know what's happening on social media right now, we don't know where it will lead. Maybe I'm being overly naive, but it may lead to a kind of upending of the ways in which photography has played into a colonial mentality, in the sense that the colonial mentality was a powerful nation-state going out and claiming another land, another people. Now, if the power to disseminate is distributed — highly distributed — that might change those dynamics. Or at least change the tools authority uses in order to claim other territories.

EMANUEL
Regarding *The Oromaye Project*, you have stated that Baalu Girma's "anti-Derg stance and his creative expression make this book a useful vehicle" for thinking about the resulting photography project in which actors are hired to play the characters in the book. I'm interested in the notion of interpretation and how this project perhaps differs from a project like *For Freedoms*, which re-interprets [President Franklin D.] Roosevelt's speech, but isn't confined by the limits of translation or imagining characters. Can you talk about the difference between these two projects?

ERIC
I think the similarity between *For Freedoms* and *The Oromaye Project* is in creating a kind of vehicle. In *For Freedoms*, the vehicle is the artist-run organization that can straddle the line between two worlds seamlessly; we can do things that organizations do because of our legal status, but we can also do things that organizations don't do because we're artists. So, the vehicle itself is the artwork in a way. Same thing with *Oromaye*. I'm producing videos and installations. I'm working with and overseeing

photographers and filmmakers who are making things in response to the project, but really the project is the vehicle, and on some level, the novel itself is the vehicle. The difference is that *For Freedoms* is set up as a national organization where we're doing political messaging across the country. We're broadcasting. We are appropriating tools of political campaigns and PR as a way of just getting our point out there. And our scale is large. The Baalu Girma project, *The Oromaye Project*, is more along the lines of my other projects, which have been discrete communities with which I'm collaborating, in this case the creative community within Addis Ababa, and also a little bit within the diaspora and hopefully in Asmara and in wider Eritrea where I've started to make inroads, but it's very challenging. So for the different models, one is kind of broadcast and one is absorbing the vehicle as a way of stimulating different productions. Maybe they're more similar than I think. As I'm talking about it, I've sort of talked myself into thinking that both of them are vehicles that allow certain forms of speech. With *For Freedoms*, for instance, with our billboard campaign, there was a lot of censorship from city governments and billboard companies that didn't want us to put up certain kinds of messages. Perhaps the difference is in the means of, and the publicness of, the distribution of those messages. With *Oromaye*, I'm much more careful about how we're approaching it. Both are definitely political projects, but with *Oromaye*, I'm really trying to approach it from the side — from an angle. *For Freedoms* is very earnest and frontal. We are registered with the FEC [Federal Election Commission] and the IRS [Internal Revenue Service]. *Oromaye* is a project where there are a bunch of different entry points and ways in.

EMANUEL

Would you say they're opposites? One possible reading of *The Oromaye Project* is to think of it as a way to update Baalu Girma's novel, framing it through a contemporary lens. Whereas many of the *For Freedoms* installations seem to be more about providing history to a contemporary moment, which tends to be relatively ahistorical.

ERIC

Well, in *For Freedoms* we're also trying to update what freedom means from a sort of Norman Rockwell version of it up until now. We did one thing [in *Oromaye*] where I hired an actor to play Baalu Girma and we went into Merkato, and he engaged with people as Baalu Girma. And it was really interesting because people were like: "Who's Baalu Girma?" Then we'd talk about it and all of a sudden they would get the sense that they could interact with this guy — this stranger — and talk about things that were happening politically. So in that sense, we are also using history, bringing history into contemporary conversations.

145

MAKE AMERI

Paid for by For Freedoms, www.forfreedoms.org,
not authorized by any candidate or candidate's commitee.

Eric Gottesman, *Make America Great Again (For Freedoms)*, 2016

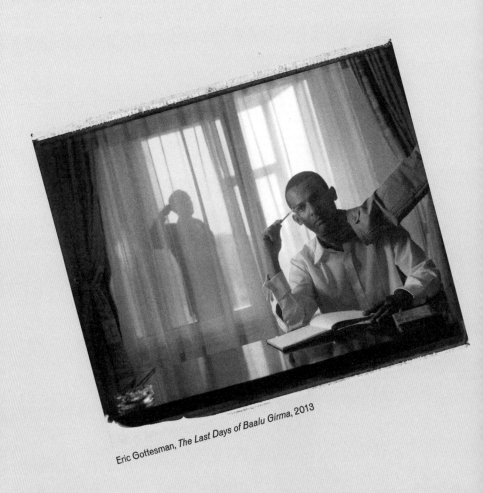

Eric Gottesman, *The Last Days of Baalu Girma*, 2013

ANITA

But is there added pressure to get Girma's story right because of his family's involvement? Maybe it's something that you really don't want to be too experimental with because it's someone's actual life history.

ERIC

This is tricky for me because I've been really excited to cooperate and work together with the family. On some level, just the achievement of translating part of the book into English and publishing it, which we did, is fantastic. There's not much Amharic literature translated into English, so that is a benchmark for the project, and that couldn't've been done without the family because it's his novel, it's his copyright, and they own the copyright. When it comes to the artistic interpretation of what the novel means in society today, we've now been talking together for the last six years about

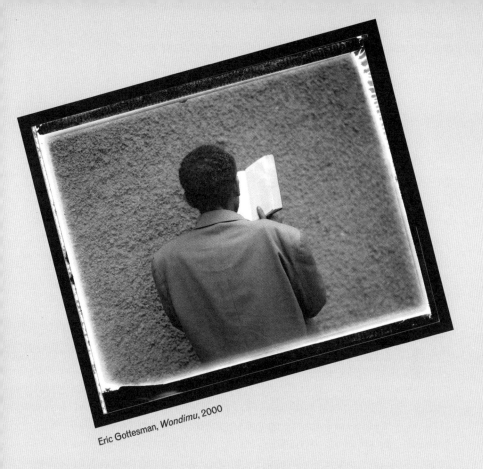

Eric Gottesman, *Wondimu*, 2000

the project and those conversations have been amazing, and his family is amazing and brilliant and really gets the potential of the project in the same way that I do. I would say they have a much more emotional connection to the book and to the story. So to do anything experimental, or to do something that doesn't represent it exactly as it was, is hard. Negotiating that relationship is part of the project for me, and fortunately, the conversations that we've had have led in the direction of where I kind of wanted to go in the first place, which is that the relevance of the project today — the updating of *Oromaye* for today's context in Ethiopia — is what I'm most interested in. Here's something that was written by a key Ethiopian modernist and that has a specific history within that context, [but] is not necessarily part of the public discourse about Ethiopian identity and Ethiopian nationalism today. To many people, what Baalu Girma stood for is respected: Ethiopian journalists all have pictures of him on their desks, but that element of it is not something that's widely valued. There are other things that are valued about him — his writing, his literature, but that element of his defying authority in a very creative way is something that people are doing today, but it's just a lot of *Qene*.[2]

2 *Qene*, or *sem-ena-worq* (wax and gold), is an Ethiopian linguistic strategy used in poetry, music, and daily language to share a hidden message.

EMANUEL

With most of your projects, a specific local condition or project serves as a point of departure for your intervention and it seems as if that point of departure can either be a sociopolitical issue or an aesthetic, artistic project. Is this driven by an interest to destabilize your sensibilities and preconceptions as an artist, or do you see this as the only way to engage creatively, especially based on the inherent asymmetries we've talked about: your being an American and operating within these African spaces?

ERIC

That's a really astute observation that I hadn't really considered because it goes beyond the American context or the Ethiopian context. My work in Jordan is very much about that; my work in Labrador is a response to a set of pictures that were made in the 1960s. You're probably onto something because the way that I conceive of my work is as a reworking of some sort of previous work. It has to do with an acknowledgement of my own identity, but maybe it also has to do with an inherent belief in change or resistance in that the present moment can learn a lot from times in history that I wish I were a part of, like the 1960s. I don't know where it comes from. I studied history in college, and I read Howard Zinn; we tell ourselves these stories, but they're just stories. And then getting into photography, I recognized that it's not only the stories, but it's also who's telling the stories and who's behind the camera. Ultimately that's my work: figuring out those questions. Each individual project ends up being a context-specific, site-specific exploration of those ideas.

EMANUEL

Do you think there is a common thread that unites them?

ERIC

I think so. I think it's about authority and how power operates; that's the essence of it.

EMANUEL

As you know, people are currently living through a precarious political moment in Ethiopia. You're interested in questioning power and authority through some sort of local lens...

ERIC

Is revolution a better option?

EMANUEL

...but also it seems like you are very explicitly critical towards, for example, the Derg regime. Why hasn't there been the same level of criticality directed towards the current regime?

ERIC

Or maybe there has been? [laughter]. In a precarious time, in a precarious society— from which, by the way, I do not exempt our own country—in that kind of context, is revolution a better option? In Ethiopia, I definitely think for a great number of people the answer is no. Regardless of your take on this current regime [now changed since this interview], a revolution as a method of change is going to be catastrophic. So then, the question must be: "Is it possible to build a new institution, society, government on the bones—on the foundations—of what currently exists?" That's part of the reason I wanted to choose a work [*Oromaye*] that alludes to another history in Ethiopia, to say: "This, too, is Ethiopia." There is space to expand upon and be experimental, it just takes a lot of *Qene*—working the angles, and figuring out who to talk to and how to talk. As you know, people navigate this effortlessly in Ethiopia: people will speak about certain things in a certain way in public, and they'll speak about them in a different way in private.

EMANUEL

Working these various angles is very much in line with your sensibilities as an artist. Are you fascinated with this approach of potentially being a "double agent"? From the way you even explained the grant funding process: there's kind of a way to deliver a story, and the way you follow through on a project.

ERIC

Would a double agent tell you if he wants to be a double agent?

EMANUEL

Probably not [laughter].

ERIC

Perhaps because I came to art late, maybe because my first inclination was to engage in politics—whatever the origin of it, that's what led me to become an artist with a certain set of extra-aesthetic goals. Questions about aesthetics are extremely intellectually stimulating and challenging, but they're also insufficient as a citizen or

151

as a participant—as a human being. So these other questions of ethics, power, and
political pragmatism—these are what I engage with. But to operate as an artist, you
don't often claim that's what you do. I'm comfortable calling myself an artist, but
I think I had come to terms with the fact that I was doing something other than just
making art...which is, I think, what double agents do [laughter].

INTERVIEW
WITH

REBECCA
COREY

EMANUEL ADMASSU
Can you tell us a little about your trajectory? Your journey from the University of Georgia to here at Nafasi Art Space?

REBECCA COREY
It's now more than ten years since I first came to Tanzania. When I was at the University of Georgia, I had a scholarship called the Foundation Fellowship, which came with a generous package that included the opportunity to travel in the summers for research or service. I was studying literature and cultural anthropology and working with a professor who was an expert on proverbs of the United States, but I had always had an interest in traveling outside of the Southeast, and so I asked friends and professors for recommendations on where I should travel for my research and I eventually settled on Tanzania. Having come from the US, where our education on AFRICA generally — and African art and culture, more specifically — is very limited, I came not knowing much when I first traveled here.

What drew me was this sense that the representations of AFRICA — or those that I was aware of — were so surface level that they were actually distortions, and I wanted to unpack that. I'm adopted from South Korea. My younger sister is adopted from Peru. Because of this, I had opportunities to spend a little bit of time outside the US and realized that, culturally speaking, there is an America-centrism that distorts and impoverishes our understanding of the world. But at the same time, we're constantly exporting culture, exporting a point of view that we take for granted. So that was what initially drew me to Tanzania. My plan was to research Tanzanian

proverbs and if and how they were changing or being influenced by global culture, from popular music to Hollywood and Bollywood movies.

I was very young. I got here and didn't really know much Swahili. I spent that first visit to Tanzania just learning and observing. After that summer, I went back to the States, finished my degree, and moved back to Dar es Salaam in 2009. I studied at the University of Dar es Salaam, in their Institute of Development Studies, and also worked for Kiva, an American organization that facilitates person-to-person micro-loans. I was also here as a Rotary Ambassadorial Scholar.

Studying at the University of Dar es Salaam had a huge impact on me, especially learning about Tanzania's early independence history, the various approaches to development taken in Tanzania and throughout the region. I was especially interested in cultural policy and how it could shape ideas of national identity as well as the role of art as a tool of resistance, or rather the assertion of culture as a site of resistance or resilience against oppressive or exploitative forces. I ended up getting in a motorcycle accident when I was halfway through my program and had to go back to the US to recover, but, before I left, a friend of mine gave me a bunch of old Tanzanian music from the 1960s and 1970s which I absolutely fell in love with.

EMANUEL
What artists?

REBECCA
Like DDC Mlimani Park Orchestra, Kiko Kids Jazz, NUTA Jazz, Urafiki Jazz — the music that characterized the early independence era. At the time, the different state institutions and state-run companies had bands and the musicians were given a salary, benefits, housing, healthcare, and all that. Many were workers in factories or soldiers or civil servants *and* musicians at the same time. The bands were like twenty to twenty-five people strong, with huge horn sections, lots of guitars, and a popular song format that had sections for both dancing and also to highlight lyrics that were very socially conscious. There was live music all over the city, and a lot of the songs were about independence or about building the nation, about the goals of African socialism. There was significant state involvement, which included both support for recording as well as censoring the work. I was fascinated by this whole story.

So in this office I have these reel-to-reel machines and tapes that I've been digitizing over the past few years. I started an initiative called the Tanzania Heritage Project to do this work. I wanted to make the leap from studying the political history of Tanzania to arts and culture and how cultural policy shaped the artistic scene. I later ended up applying for a job at Sauti za Busara in Zanzibar. It's an international

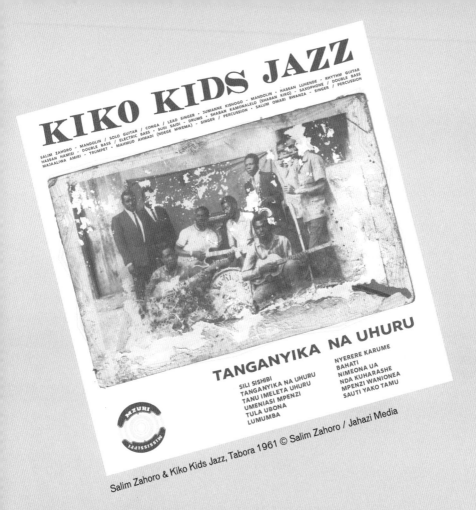

KIKO KIDS JAZZ

SALIM ZAHORO - MANDOLIN / SOLO GUITAR / CONGA / LEAD SINGER • JUMANNE KISHOGO - MANDOLIN • HASSAN LUHENDE - RHYTHM GUITAR
HASSAN HAMISI - DOUBLE BASS • ELECTRIC BASS - SUDI SAIDI - DRUMS • SHABAN KAMONALELO (SHABAN KIKO) - SAXOPHONE / DOUBLE BASS
MAJAALIWA AMIRI - TRUMPET • MAHMUD AHMADI (NDEGE MWEMA) - SINGER / PERCUSSION • SALUM OMARI BWANZA - SINGER / PERCUSSION

TANGANYIKA NA UHURU

SILI SISHIBI
TANGANYIKA NA UHURU
TANU IMELETA UHURU
UMENIASI MPENZI
TULA UBONA
LUMUMBA

NYERERE KARUME
BAHATI
NIMEONA UA
NDA KUHARASHE
MPENZI WANIONEA
SAUTI YAKO TAMU

Salim Zahoro & Kiko Kids Jazz, Tabora 1961 © Salim Zahoro / Jahazi Media

African music festival in Stone Town that happens annually. The founding director was taking a sabbatical so I came in as the Managing Director of the organization for a year and a half while he took a break. That was from 2012 to 2014.

During my time in Zanzibar, I went from thinking primarily about the historical importance of music and culture to wanting to become more involved in active contemporary expressions of Tanzanian music and Tanzanian identity. Through conversations with musicians and artists, I came to understand what a huge challenge it is in Tanzania to be an independent or non-commercial artist of any kind. Also, because of what at the time I saw as lack of access to the music of the past which meant that contemporary popular music was lacking continuity with previous generations of music. The music festival was really great for thinking about contemporary expressions and how to create new work that is rooted in an understanding of the past and trying to push it into the future. I came back to Dar wanting to go back to the heritage project, to digitization.

EMANUEL
Was this going to be a documentary?

157

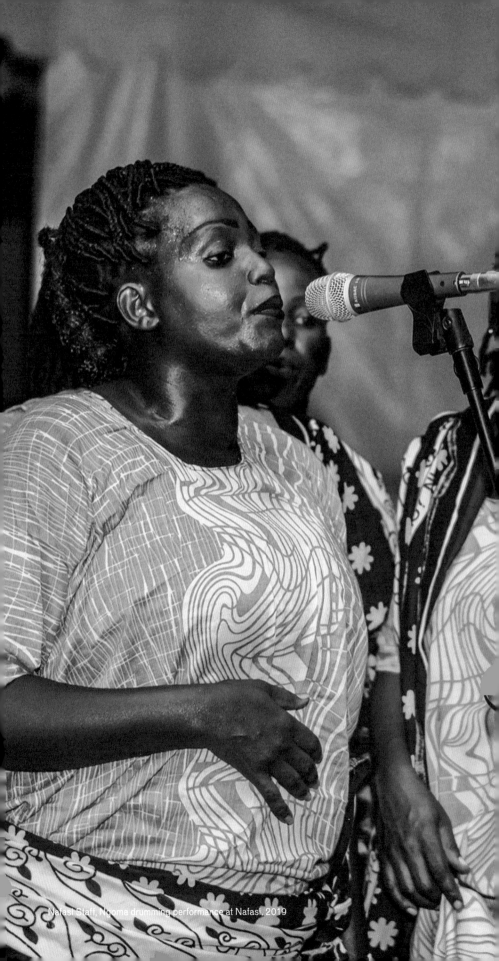

Nafasi Staff, Ngoma drumming performance at Nafasi, 2019

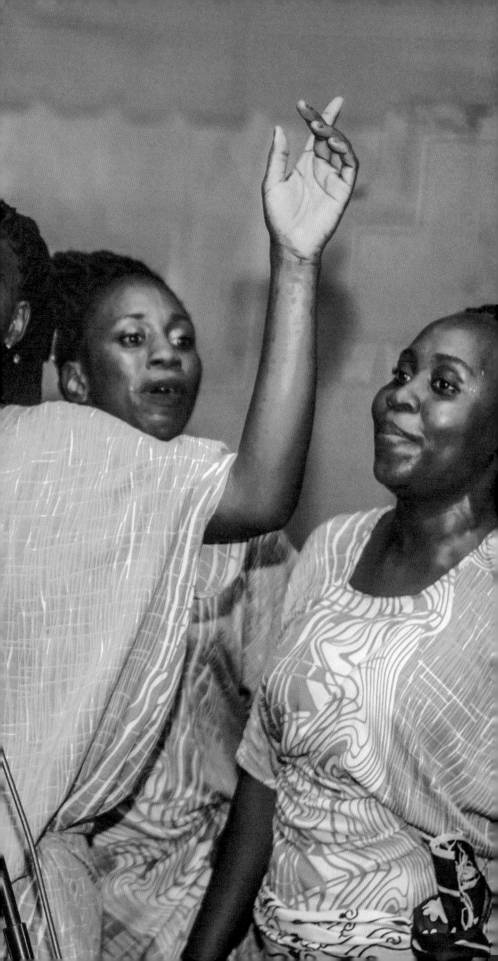

REBECCA

Yes, the documentary is called *Wahenga* (the Ancestors) and it came out in 2018, premiering at the Zanzibar International Film Festival then playing at several other festivals and venues, including Film AFRICA festival in London. The more I realized how many musicians are out there struggling to make a living, struggling to be able to play the music they want to play, the more I wanted to work with those musicians and artists and try to help in providing opportunities, spaces, and platforms for them. I met a musician called John Kitime who is a guitarist, songwriter, radio DJ, and something of a one-man phenomenon trying to preserve and archive the past.

He was obsessed with music from a very young age and followed the stories of the bands obsessively, even making scrapbooks full of every newspaper clipping and photo he could find. He learned to play music himself and has since been a guitarist with many bands. Right now, he plays with Kilimanjaro Band, who perform every Saturday night at Selander Bridge Club.

The background of the film is that Amil Shivji, a filmmaker friend of mine, and I started filming John and his efforts to put together a band to revive the sounds of the 1960s and 1970s. We got support from DOCUBOX East AFRICA. The film took three years to make because it was shot in an observational style over a long period of time. There was a lot of footage to go through! More than a hundred hours. The final result is a ninety-minute documentary that follows Kitime and the members of the band, weaving together their memories of the past, current lives and triumphs and struggles, and their hopes for the future. Through these personal stories, we're trying to show the influences — economic, political, cultural — that have led to the current state of things.

So that is the long path in terms of how I came to do this work. In 2016 the director of Nafasi Art Space, Jan van Esch, who had been the director for five years, supported us to put on a concert at Nafasi called *Urithi wa Leo — The New Heritage*, which was a range of traditional and contemporary musicians playing in one event, drawing connections between old and new.

That was my first time working at Nafasi and I saw what an incredible space this was. When Jan decided to leave, I applied for the job. What stood out to me about Nafasi was its atmosphere, which seemed quite different from the other cultural centers we have here that are anchored through an outside agenda. Often, I think in Dar we have this huge NGO industry that can end up swallowing and replacing a hollowed-out art scene. You end up with NGOs or embassies paying artists to create public awareness and behavior change campaigns. Sometimes the work is very good and sometimes it is not, but regardless, it's being instrumentalized by a third party, outside of the artist and the audience of the work. Sometimes the

Rebecca Corey, photo of Frank Massamba, John Kitime, and unknown, 2016

topics are important, but the structure and process that brings this work into being
is problematic from the perspective of a curator or gallery or arts institution that
is striving to create space for independent, original art to flourish.

EMANUEL
And it's geared towards...?

REBECCA
Yes, a crucial question that we ask ourselves and each other constantly is: "Who is
it for?" Buyers and funders tend to be mostly a set population, primarily expats.
So at Nafasi, the Tanzania Heritage Project, and Sauti za Busara, I came to realize

Nafasi Staff, Rebecca Mzengi Corey at *About Time* exhibition opening in Zanzibar, 2016

that unless you consciously resist and struggle against the systematic commodification of creative expression, culture and art can be treated primarily as an export, and artists themselves become a product. The model of success hinges on whether you can leave and make a living from your work outside of Tanzania. This seemed to me a very uneven equation — one that prevents art from being something that is of and from the community that it comes from.

ANITA BATEMAN

Can you talk about that further? Here at Nafasi you are the director with commitments. You have things that you have to get done. How do you balance having a managerial position and then focusing on helping artists to be the best that they can be?

REBECCA

I am aware of the irony that I am an American who has come here from outside and am now in a position of leadership and power to make decisions in the art

162

© Tupilike Mwakajumba

Rebecca Corey, Jesse Gerard, 2020

community here, even though the philosophy that I've developed since working here is antithetical to that. I do not believe there should be gatekeepers that come from the West and dictate. My hope is that my efforts in keeping the space open and funded have been worth it to create an opportunity for critical thought and analysis around these questions that further develops among the community here. I also think about internationalism, the idea that there can be meaningful and productive solidarities between locations, and if I can approach it with constant self-criticism and humility then I can contribute something of value in this space.

My primary goal is just to keep Nafasi open and running, and then to bring in and work with as many Tanzanian and African artists and curators as possible — people who can elevate the work of the space beyond that of a donor-funded nonprofit organisation and make it transcend that administrative category. I want to support artists to create the work they really want to, and to clear the air of all of the distracting and distorted signals of what art should be. At first, I thought of Nafasi as a place where we could expose Tanzanian art to a bigger audience to help it get more recognition and support. However, over the past couple of years, I've increasingly seen it as a space not of exposure but of protection. It's a place to develop audiences and give them experiences that fight against this idea of art as a commodity: not something that you just buy and consume, but something you

experience and participate in. Art as something that has always been here, and is part of a communal process.

EMANUEL
Are you working against the traditional gallery model?

REBECCA
There is definitely a tension — where we are trying to create access to markets and the chance for artists to make a living from their work, but at the same time, having discussions around the problem with art that is inaccessible and elitist. How do you simultaneously build the value of artwork in society while also fighting against unequal access to it? The way artworks are priced means that the only people who can afford it are living in a completely different stratosphere than those who it is about and perhaps meant for. I've started to think of each artwork as an object of magic and power, so that even when it is bought it is never really owned, it just moves into whatever space it is in and then influences that space.

There aren't really any strong galleries in Tanzania with an international presence. It makes it hard for artists to have access to the international market without leaving completely. So in a sense, we do want Nafasi to be able to help to fill that gap. At the same time, Nafasi is a place that protects artistic freedom and even obscures certain things. I believe that reminding people that there are things they don't know and don't have access to can be a powerful tool. It can help address the imbalance of power and lack of justice that characterize many social structures and systems.

ANITA
In a holistic sense, do you feel that you are recruiting people from different backgrounds for the artists-in-residence program in order to make the space more dynamic?

REBECCA
That's a fair way to put it. When the international residency program started, it was funded by the EU, and most of the artists in residence were from Europe or America. Those early artists in residence contributed a lot to the education of many artists here. Many of the Nafasi artists began their careers as illustrators or sign-writers, so they had strong technical abilities but not much conceptual or theoretical training. Over the years, though, we have become more focused on bringing artists from the continent to Nafasi for exchanges and collaboration.

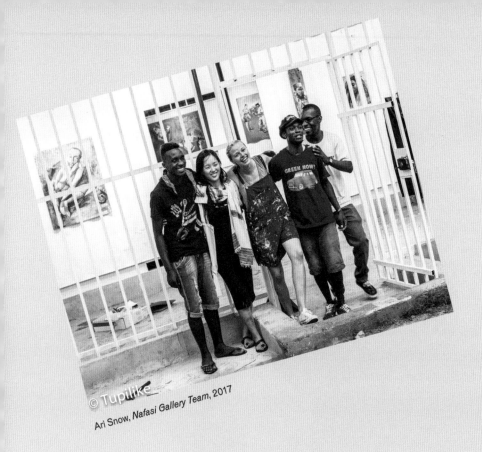

© Tupilike

Ari Snow, *Nafasi Gallery Team*, 2017

EMANUEL

In light of that, what is the ambition of Nafasi within the continent? When we're discussing African art, obviously there's a lot of visibility for artists from South AFRICA or Nigeria, for example. Where does Tanzania fit within that conversation, and are you trying to establish a new kind of model here that doesn't exist elsewhere?

REBECCA

Yes, I think we are trying to establish a different model, but we also have a very different context because we don't have the market that places like Nigeria have — middle classes that are looking to buy expensive art. I don't want to sound negative or critical of people who are trying to develop the high-end market for art, because I think it is important. Here at Nafasi we just have limited resources and limited time, so I have made a conscious decision not to focus on international visibility at the expense of local inclusivity and access. It's difficult because I wish we could do it all, and we have tried to do a bit of everything. We've built a little gallery here, but that takes loads of time and resources and there's only so much we can do. There needs to be a multiplicity of people who are doing this kind of work as well — just as you wouldn't want the art to all be dominated by one style of art or one curatorial approach. On the art direction and management side of things, you also need people with different approaches and ideas, so we try to support that as well. Nafasi

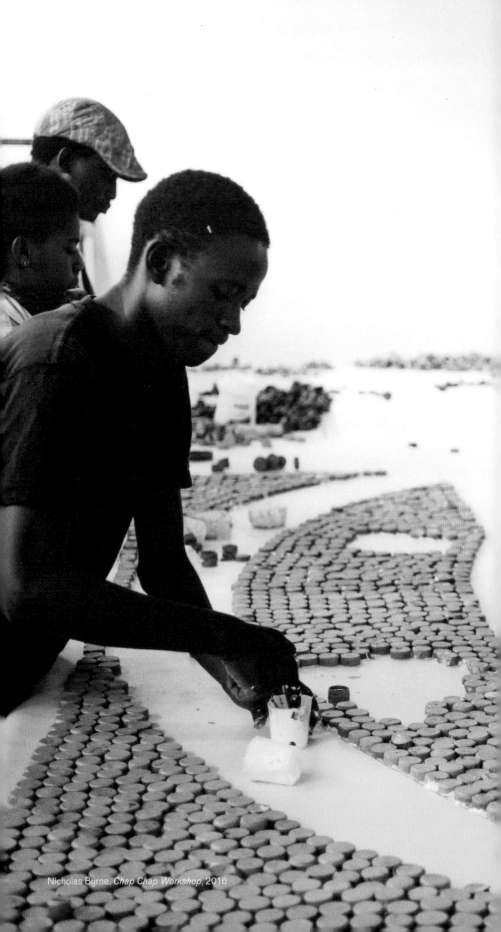

Nicholas Byrne, *Chap Chap Workshop*, 2016

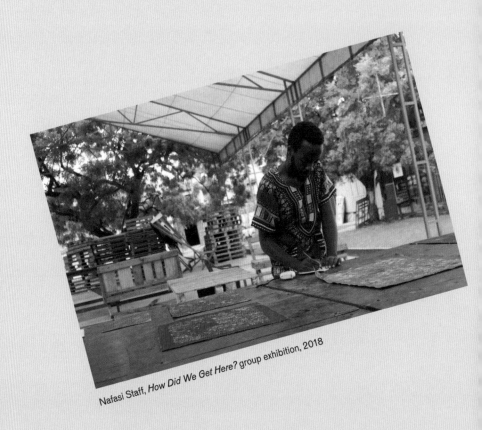

Nafasi Staff, *How Did We Get Here?* group exhibition, 2018

has become a sort of jumping-off point for arts professionals; it has become this important step for artists and curators alike. Anyone [in Dar es Salaam] who has an interest in working on artistic projects ends up coming through Nafasi at some point. It can give people valuable experience in what it actually takes to run a space like this and work with artists.

ANITA

Do you actively recruit the artists who work here or is there an application process?

REBECCA

It's more of an application process. Usually once people are here they don't want to leave so you just have to keep expanding and expanding and now we've reached the limit. It's almost impossible to administer this many artist members. There are thirty-five studios right now, but some of them are taken up with artist-in-residence studios or shared working spaces. So, there are twenty-eight official members at the moment, with a mix of visual and performing artists. Nafasi started out as a space

exclusively for visual artists, but over time, began to attract more and more artists from other disciplines such as dance and music, and has grown and evolved to meet that need as other arts spaces have closed down or failed to gain as much traction.

EMANUEL
We noticed that you've been doing some work with sites in South AFRICA. Is there pressure to expand even further? Are large institutions within the continent interested in commissioning more work or working with artists at Nafasi?

REBECCA
Yes, for example Zeitz MOCAA [Museum of Contemporary Art AFRICA] recently invited us to participate in an exhibition they had called *The Main Complaint* curated by Michaela Limberis, which looks at issues of inclusion/exclusion, spatial politics, representation, ownership, accessibility, and diversity of voices in museum and art spaces around the continent and how different artists and institutions are addressing these topics. We were excited to be invited to participate, but it remains to be seen what sort of impact that will have on us here. We hope it will lead to more connections and networks and resources for Tanzanian artists. As I mentioned before, Tanzania has a relatively small international footprint in the contemporary art scene. Tanzania has never been to the Venice Biennale, for instance; it hasn't had that opportunity. So, we ask ourselves: "Do we want that? Would it be good, and if so, in what ways?" Success by certain metrics can also mean a loss of something — whether that is a loss of autonomy or independence or a certain type of freedom that comes from not being included in spaces with their own sets of rules and expectations.

The individual artist has to decide what they want, and I'm not in the business of convincing people *not* to do what they want. From the perspective of space, I want artists to be in the positions where they're making those decisions on their own and are in control. I want to give artists the kinds of tools that would help them make decisions with agency. So, does the artist want to move to Denmark and be a Tanzanian artist in Denmark, or do they want to be an artist in Tanzania? How do we respond to the demands of the artists? We would like to build alternatives for artists, to give them the ability to choose to stay in Tanzania and work from here, if that's what they want to do.

EMANUEL
The other thing I'm curious about is the political situation in this country and how that has shifted recently. Is there any type of direct engagement with some of these

169

political issues? How can Nafasi protect artists from censorship or being trapped into making work which can be understood as propaganda?

REBECCA

In my opinion, traditionally artists are more at risk of their work being co-opted by the United Nations than they are of being censored by the government. But now, it's leveled out and artists have to contend with censorship or pressure from both sides. Power tends to attempt to control and squash any kind of threat or questioning. It's very hard for journalists, while artists have the ability to speak in abstract, metaphorical ways that improves the quality of the work when it's about asking a question rather than giving an answer. What we've seen with this kind of current political environment is that it creates an atmosphere of tension and anxiety for everyone, and of course that is not a nice feeling, that's a scary feeling, and it does impact how everyone feels. Even last year, some of the challenges we had, it just comes from this paranoia. For us, it's about supporting artists as much as possible, and there is collective strength in being around other artists and people who care about art, so that helps. The big question is always: "To what level is there going to be self-censorship and how do you help artists to overcome that?"

EMANUEL

Is there direct engagement with the art school?

REBECCA

Yes, we've been reaching out to the art school and trying to engage them. Their focus is a bit more on the performing arts side.

EMANUEL

There is no painting school?

REBECCA

No, I think they have visual arts classes there. There's a creative arts department at the University of Dar es Salaam. But right now, everyone wants to do film and music so those things naturally have more support. For visual art, there are very few opportunities to get any formal training so I want to establish some sort of visual arts-focused program. For artists who come here, there are workshops all the time, there are exhibitions all the time, but there is no way for artists to get any kind of core visual art education. It's piecemeal. So, we really try to engage the University of Dar es Salaam, their creative arts department, and TaSUBa [at Bagamoyo College

WHEN DOES
AN ART SPACE
BECOME
A REFUGE?

of Arts], and we often have students from nearby universities do their summer internships here. I'm really trying to focus on that because there's a gap between the internationally funded NGOs and public institutions that creates some sense of: "Nafasi is getting so much money from outside while public institutions have so little money," and it creates distance and mistrust. I'd like for us to act as a conduit — bring resources in and try to spread the wealth as much as possible.

EMANUEL

Thinking of Nafasi five or ten years down the line, are there specific things that are beginning to reveal themselves? Are there clear goals for Nafasi?

REBECCA

Nafasi is becoming more and more resilient, but it's always walking that line between saying to donors: "We still really need your support but also look how good we're doing." We're trying to get to the point where we can stand on our own two feet. The donors really want to hear two things at once: "We really need you" but "We're not going to need you very soon." There needs to be space for artists to grow, learn, exchange, and share their work. That vision is less a vision for Nafasi as an institution and more about a decision that drives artists in the community as a whole. The future is not about Nafasi alone, it's that the art community and the art sector in Tanzania looks a certain way and we're hoping that Nafasi continues to play a big part in that. Over time, any institution can get weighed down by its own bureaucracy. That's something that I want to avoid. We want to stay focused on Nafasi's core work, while continually refining and improving.

HOW BLACK
IS AFRICA?

174

AMANDA
WILLIAMS

As someone who had romanticized and mythologized Africa as a place that
is at once present and timeless, in that nine-hundred-hour ride, I found myself
dislocated, disoriented, and trying to get my bearings, literally and figuratively.

YOU USED TO THINK THE TERM BOUGIE WAS AN INSULT

Instantly, mine had become one of those narratives that sounds so predict-
ably trite — you know the one about an American Black, usually educated
and economically middle-class, making journeys and pilgrimages back to the
motherland only to discover that they, too, bumped *All Eyez on Me*. Imagine
my surprise when I learned that Tupac was also in Gondar.

YOU BELIEVE WE INVENTED TIME,

THEREFORE, WE'RE ALWAYS RIGHT ON IT, YOU EMBRACE THE TERM CP

I'm not exactly sure where Africa is, but I can definitely tell you where it was NOT circa January 2002. It was not in me, as I sat traveling on an unpaved winding road, in a yellow school bus, that was passing itself off as a coach bus. We were being transported to what is sometimes referred to as Ethiopia's African Mecca, the eastern city of Harar.

YOU BUY YOUR PORK RINDS FROM WHOLE FOODS

Africa was not in pasteurized orange juice, credit cards, name brand malaria pills, $500 Swiss Army travel luggage, ATM machines, or any of the other things that I craved in that moment and that made me more American than I'd ever wanted to admit I was.

But Africa was not there.

ALTHOUGH
I DON'T
ADVOCATE FOR
ITS USE,
EVERY CHILD
SHOULD KNOW
THE PURPOSE
OF A
GREEN SWITCH

Africa was not in any of my lived experiences that day as I watched a chicken sit, untethered but obedient, under the seat of its owner for the eight-hour bus ride. A rusted hole in the bottom of the bus filled all our lungs with red dust. It was so agonizing to try to not breathe, but I've never seen more beautiful light.

YOU'RE NOT AFRICAN- AMERICAN YOU'RE BLACK

Disregard for the Americanness / Dislocation from the Africanness
And so where then is Blackness?
And which Black is it?
And what Black is this, you say?

I WISH I COULD
SEE THE
BLACK ON
THE INSIDE OF
STEVIE
WONDER'S
EYELIDS SO
I, TOO,
COULD HAVE
INNER VISIONS

Even when I was in Africa, I was not in Africa. It was much further away than I could ever travel. It's not contained or bound. I cannot see its edges.

For me, Africa is a distinct not-ness.

Amanda Williams, *What black is this you say?*— *"You're hardheaded AND tender headed at the same time"*

—black (09.12.20), 2021

Amanda Williams, *What black is this you say?*— *"You wish you could see the black on the inside of Stevie Wonder's eyelids so you too could have inner visions"*

—black (09.24.20), 2021

Amanda Williams, What black is this you say?— *"You're not African-American, you're black"*

—black (09.20.20), 2021

INTERVIEW
WITH

ROBEL
TEMESGEN

ANITA BATEMAN

You were educated in Ethiopia and Norway and you were a resident artist in Sweden. Can you talk about how each place has affected your worldview in practice, especially since you center traditional Ethiopian places in your work?

ROBEL TEMESGEN

Engagements with different places are the most interesting aspect of the research. They help me understand the trajectories of the projects and what I end up doing with them. So, if I have a project that deals with a specific place in the city, moving around that space always introduces new perspectives to the project. My work mostly deals with public space, and it's not just about Ethiopian public space. The idea of "public," regardless of what kind, is universal. Then when a project begins to unfold, each work is affected by new findings of how people interact and connect in different situations.

Because these are the questions that people have when traveling anywhere: how do people interact, how do they connect? So, these are the questions I'm always trying to navigate and understand. How do new or existing public spaces shift? What are the politics around them? So, spending time in the places I visit for my research and inspiration offers the potential for new trajectories or new readings. It is an infinitely widening circle. Being present in specific sites informs my articulation and adds depth to the conceptualization of the work I produce. What kind of engagement does it facilitate? Be it theoretical or experiential, proceedings and accounts of places and

people are always how I read my projects. In most cases, proceedings and accounts are braided in traditions.

EMANUEL ADMASSU

Ethiopians who have been educated in Europe and North America rarely come back to Addis Ababa and get involved in academia. What drove your decision to come back? Did you feel like you needed to be here to create the type of work you have been producing?

ROBEL

For the most part, I want to feel like an artist, and for me, that feeling is connected to the idea of production. I knew even before I went, that I'd be back because most of my projects are produced in relation to this place. I could have a universal topic, but it still has a lot to do with what is around me. As long as I had the opportunity to travel around, it became much easier to situate myself here. Besides, Addis Ababa is growing in many aspects. It is important for me to witness and be part of the rapid change that is currently taking place.

ANITA

In some ways, artists make themselves very vulnerable when they are commissioned to do a work, instead of experimenting at their own pace with their own practice. Do you think that is partly driving your interest in protective spirits? Where is that body of work moving from?

ROBEL

I think it is the urge to go beyond the ordinary. I wanted to understand public space from the attendant's perspective. If you see the *Adbar* project, the place doesn't end up being a place of belief or a place of rituals.[1] It is a very active space for the secular and that's more interesting for me: seeing spaces being altered beyond the obvious. This led to the newspaper project. It's less about finding new public spaces rather than trying to read existing public spaces differently. So, the *Adbar* has obviously been a type of public space for ages, but my interest lies in how it affects everyday secular lifestyles. It has had a huge influence. Incidents like the 2016 Irreecha celebration or beforehand, marks how such places offer alternative platforms for people

1 "Adbar," also the title of one of Robel Temesgen's ongoing projects, is an abstract Amharic term referring to the embodiment of protective spirits within various elements of the natural landscape such as lakes, mountains, rocks, and trees.

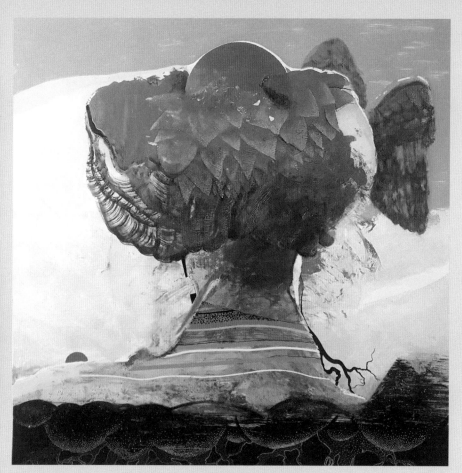

Robel Temesgen, *Adbar*, 2018, Courtesy of Robel Temesgen and Dawit Abebe

to be heard, for marginalized voices to vent.[2] So, these are the urges that drive the work. That's usually where it comes from.

EMANUEL

Can you speak about the newspaper project? We're interested in how you are reclaiming the newspaper as a space for activism or public engagement.

ROBEL

When I was living abroad, information had particular channels, mostly online, but being in Addis has given me an opportunity to explore alternatives. Every Saturday and Sunday I go to Arat Kilo [a neighborhood and public plaza in Addis Ababa] to borrow newspapers from the vendors and then I give them back with a bit of money. That's a weekly routine for me and my friends; and for most people, that's a common

2 On October 2, 2016, hundreds of people died at the annual Irreecha cultural festival of Ethiopia's ethnic Oromo people, following a stampede triggered by the federal security forces' use of tear gas and firearms.

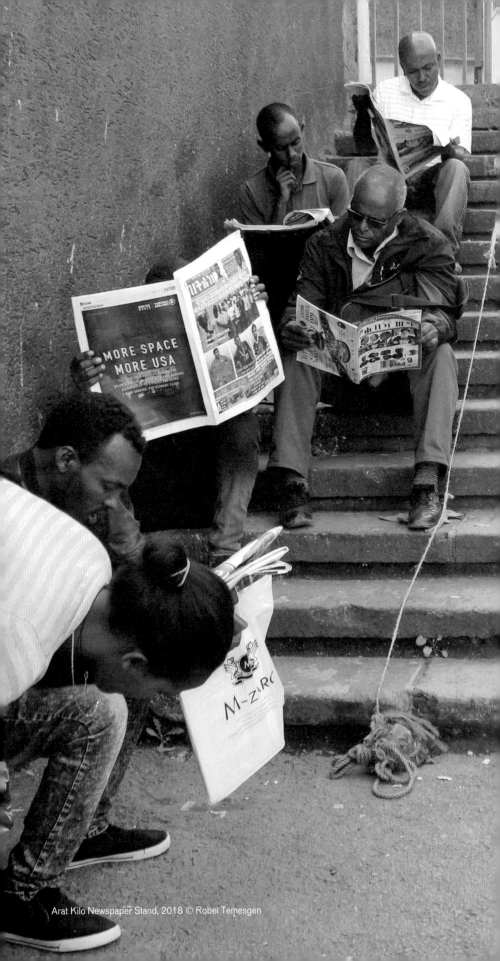

MORE SPACE
MORE USA

M-ZIRO

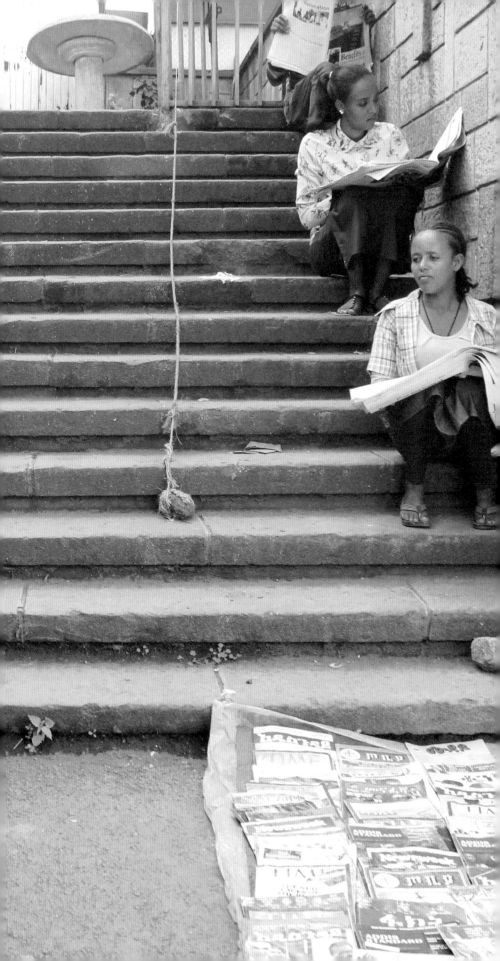

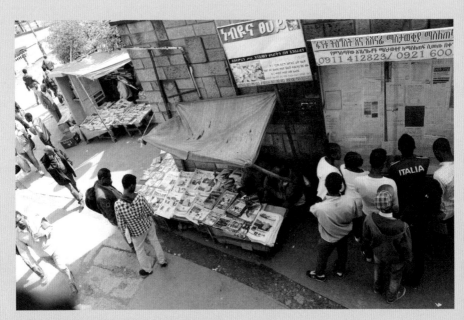

Arat Kilo Newspaper Stand, 2018 © Robel Temesgen

way of accessing the newspaper. However, when I was abroad, I was limited to the internet, and in particularly social media. So, in 2014 there was quite a big move by the Ministry of Justice. They convicted six magazines and newspapers, and even more bloggers, editors, and journalists, of terrorism charges. All six magazines and newspapers were shut down immediately and most of their publication and distribution was put on hold. So, it got me thinking: "What is actually safe to write in Ethiopia, at least in Amharic? And what strategy could allow us to keep writing while protecting ourselves from danger?" One of the court cases focused on Befekadu Hailu from the Zone 9 Collective, a group of bloggers who were active on social media roughly between 2013 and 2016. One of the pieces of evidence that was used in his case was an article that was written by someone else. He was the editor-in-chief when he received the article, and though he had decided that it wasn't ready for publication, it was still brought as evidence against him. This creates a situation that questions the freedom to think or process information privately, in your own mind or notebook. So, I thought about developing a newspaper that would be limited to one copy, and it would contain old news written entirely by hand. Strangely, most of the topics that I was covering in the newspapers were still very relevant and vivid. So that was the start.

I was interested in investigating how newspapers create various forms of public space in Addis Ababa. As a continuation, I made some more issues duplicating the

six [banned] magazines and newspapers from the national archive. I went to get the last issues that the authorities had archived and made a copy of each of them.

EMANUEL
It's amazing that they have them in the archives.

ROBEL
I got access because of my affiliation with the university; these archives are not accessible to the general public. I (re)wrote the majority of content from those issues along with past content that is highly relevant to the present. Later on, I created an issue framed between the resignation of the previous Prime Minister, Hailemariam Desalegn, and the appointment of the current one, Abiy Ahmed. It was an editorial based on what had happened in the country, within those six months: it was a peak time with nonstop, breaking news after breaking news. Huge decisions were being made every day and I thought it was a good moment to capture in that format. That was the only issue that was duplicated. I commissioned two artists to do silkscreen reprints (one hundred copies) of that newspaper. My aim was to actually go to Arat Kilo and infiltrate existing weekly newspaper distribution. I wanted to see how they would interact because most of the content in my newspapers is about how news and information is curated. If you see the newspaper I did on the Prime Minister, it's slightly twisted. For example, there was a debate on social media about whether our Prime Minister deserved to be nominated for the Nobel Prize or not. I strongly opposed the nomination because I believe that people have to do something to receive a prize. So, I wrote a headline saying that the Prime Minister had received the Nobel Prize, but the article talks about Winston Churchill, who received the Nobel Prize in Literature in 1953.

Even in 2014, I had a similar approach. I wrote about Reeyot Alemu (a prominent journalist who has been imprisoned several times) being freed from the prison. I wrote that the authorities haven't announced when they plan to put her back in prison. My newspaper aims to be in-between the "pro" and "con" because with most Ethiopian newspapers and magazines, you can definitely say that this is pro-government, or this other one is against.

One of the problems is that people do not get balanced and accurate information. In that sense, there's a lack of ethics with most of the publications in Ethiopia. My newspaper takes it to the next level. One of the issues congratulates the current government for winning the election by one hundred percent of the votes (knowing that could never happen), but then, it would kind of go back to this in-betweenness. The Prime Minister might be doing well, you don't need to constantly praise him;

189

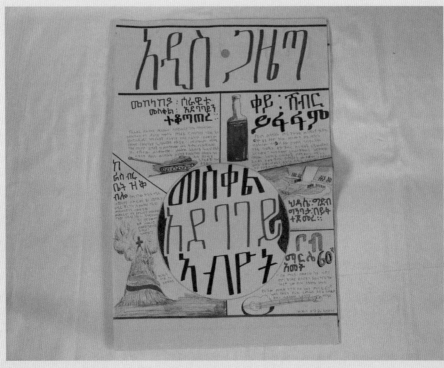

Robel Temesgen, *Addis Newspaper—Mesket Square Issue*, 2019 © Yero Adugna Itecha

after all, it's his job. I would expect him to do it, because I hired him; literally, the people hired him.

The last issue I did a couple of weeks ago was about Meskel Square. I made this issue for a presentation at Addis Ababa Museum, where I did a reading performance in January 2019, so that was about the dynamics and the history of Meskel Square, which is a politically charged site in Addis Ababa: it is a material-ization of what the country has been going through for at least three generations of governance.

ANITA

Do you feel beholden to a public? Are you making content in order to express something to them? Because it seems by virtue of your handwriting the newspapers and self-publishing them, you are grappling with the fact that the art couldn't exist without the public. Does the fact that the public might misunderstand the content factor into your writing?

ROBEL

The contents are designed to be open. It could be read as a replica of what is actually happening in the news. The misunderstanding or the understanding of the fake news — the fabrication of information could be read as a reproduction of reality or an attempt to bring back this idea of underground publication. It was probably towards the end of the Derg regime [a pseudo-Marxist military junta, led by Mengistu Haile Mariam, that ruled Ethiopia from 1974–1991] that underground publications were thriving … but since then, at least to my knowledge, they have mostly disappeared. Back in 2006, 2007, 2008, when there were protests throughout the country, there were underground publications that produced invitations to the protests; young people would produce them in their houses, make carbon copies, and distribute them by hand. Other than that, there were no underground publications, and that's scary. Having a population of a hundred million people and not having alternative publication platforms was the major reason for making the newspapers. It is for the platform to be the message in and of itself. Instead of a "direct" message, I'm addressing the fact that all of the information we receive is distorted and twisted.

ANITA

So, it's satirical?

ROBEL

It's satirical definitely. In the sports section, rather than talking about the recent peace treaty between Ethiopia and Eritrea, there is an article about a football club from Gondar [in northern Ethiopia] proposing a match in Asmara [the capital of Eritrea] with an Asmara football club, and this gave me a crazy rush because we are actually engaged in media-related performances, instead of actual reconciliations; because a lot of people died and that shouldn't be brushed aside as if nothing happened. This happened in our generation. To our own mothers, brothers, and sisters. It is present, not some hundred years ago. How do you give emphasis to these conditions, real matters, instead of making it about two leaders visiting each other every weekend or football match proposals and peace concerts? Who has spoken to the mothers who have lost children in that war? Thousands of people have died from both sides. So due to the absence of these kinds of conversations, the contents of my newspaper are satirical, but if one traces the original information that my contents are informed by, it's easy to understand the intention behind each topic and the wording.

191

EMANUEL

Do you have an interest in engaging with the intensification of digital consumption, especially in the diaspora right now? My relatives, most of whom are Ethiopian immigrants living in America, have an insatiable desire to hear something new about our new Prime Minister every single day; a lot of it ends up being fake news through Facebook groups or YouTube channels. And this rapid consumption of information actually limits political engagement because they just want to hear something positive about this country and its new leader. I'm wondering if your ongoing subversion of the newspaper can be extended to these digital platforms?

ROBEL

I am planning on it. To be honest, it's just a very rough idea that I have, and I have been conversing with some experts. The idea is to have autonomous software or a platform on the internet that would produce similar content to the newspapers. So, the idea is to make an algorithm or artificial intelligence that would trace all of the elements of the news — words, incidents, time — and juxtapose the information in order to make something new. It could be a self-feeding platform on the internet.

EMANUEL

Like an artwork.

ROBEL

Exactly. I would arrange sources of data and then it would combine news across space and time. I don't have the tools and experience to make this happen, so I have started speaking with experts to make work that addresses the fragility of the internet. I need to take my time to carefully think it through because once its online, I would have very limited control over it.

ANITA

Do you see a difference between the isolation that digital technology permits versus something like *Buy Me a Car* where you're actively making people participate in your work? Is that a different sort of impulse or is it all part of the same thinking?

ROBEL

Both projects engage with a sense of shared space, community. I have had a different level of engagement in the two projects: on the web-based work, I detach myself, as do the participants/spectators; whereas the *Buy Me a Car* project is very physical and demands to be present in a place.

HOW DO ARTISTS ACT AS AGENTS AGAINST CULTURAL, POLITICAL, AND ECONOMIC POLARIZATION?

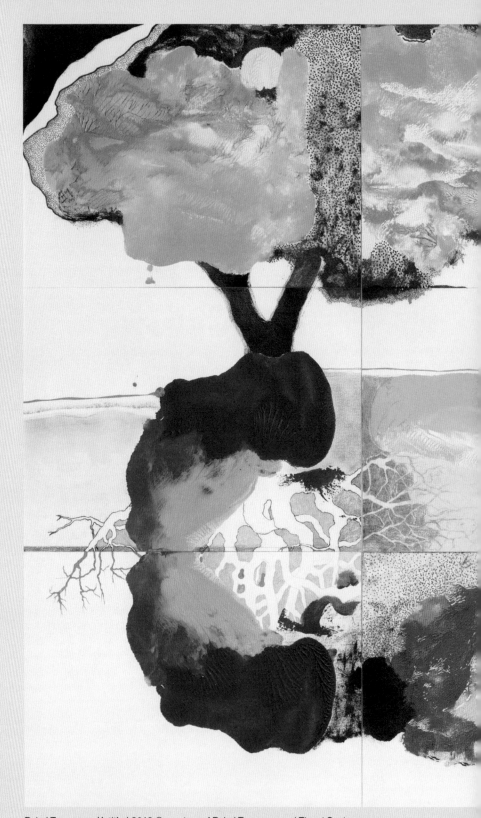

Robel Temesgen, *Untitled*, 2018 © courtesy of Robel Temesgen and Tiwani Contemporary

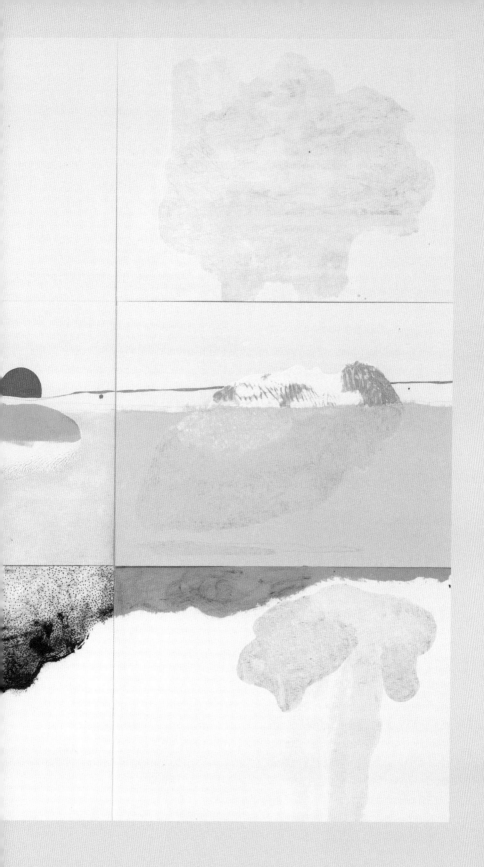

195

I tried to implement an approach that delimits my authority over both projects. Even if it is impossible for me to completely remove my involvement and interference, I try to be conscious about the kind of inclusive platform I am offering.

EMANUEL

How are you cultivating an artistic community here in Addis and how much of your practice relies on developing relationships with artists who live here and produce work? Are there spaces beyond the School of Fine Arts where you can meet and discuss each other's work?

ROBEL

It's not formal, but most of my work engages with artist friends or other people that could contribute to the work, both conceptually and materially. For example, when I commissioned a couple of artist friends to make silkscreen copies of one of my newspapers it took more than five months and a lot of money out of my pocket; but I wanted it to be produced with an artistic sensibility. I wanted it to be an invitation to the artists who wanted to engage with my work; it was also an opportunity for them to extend their work. It creates various linkages between my work and theirs.

The conversations are also happening over extended periods of time: everything ranging from simply exchanging information to having discussions about the difficulties and opportunities associated with artistic production in Addis Ababa. I usually use my studio to host a lot of friends; I frequently gather four or five friends to have conversations. I'm interested in cultivating more intimate and personal platforms because Addis doesn't really offer spaces for large community gatherings. In the everyday, many aspects of the city tend to cut you off from these types of engagements, but at least with my studio, I encourage my friends to come over and have dialogues about their work, my work, or whatever else they want to talk about. As an informal/formal gathering, recently, we've been having conversations every Monday afternoon at Guramayne Art Centre. It is a gallery space run by Mifta Zeleke [a young curator and gallerist who also teaches at the Alle School of Fine Arts and Design]. Artists, writers, filmmakers, actors, directors, and poets gather at Guramayne and have conversations every Monday afternoon; mostly about art and politics both local and global. Not everyone comes every week, but at least some seven, eight people would show up. These gatherings started at the beginning of 2018; it's been quite a nice platform so far. There was a show called *Manifesto* [an exhibition that took place in September 2018] developed from these conversations.

After the Netsa Art Village closed [a platform for artist collectives hosted in a public park near the French Embassy that was shut down], it became somewhat scary for artists to initiate such a thing.

EMANUEL
Was that operating at a much larger scale?

ROBEL
It was originally established by eleven artists but expanded to twenty artists. I was part of the second generation joining the village.

EMANUEL
That was the place you met once a week?

ROBEL
No, it was a different type of space organized by the collective in a public park. It was a space for dialogue. So, you can go whenever you feel like as long as you have a project to share or work on. So, after the Netsa Art Village collective was dismantled, there hasn't been much energy around creating artist collectives, except for informal meetings with friends or Saturday morning conversations while reading newspapers and magazines around Sidist Kilo and Arat Kilo [two public squares in Addis Ababa].

ANITA
Do you consider yourself an activist?

ROBEL
The projects I do deal with the country's current politics, but that doesn't necessarily make me an activist. I'm interested in the contemporary politics and the current conditions of our country and continent.

EMANUEL
The politics injected in your work are never explicit, never direct — it always leaves you open to misinterpretation, as Anita was saying earlier. Is that driven by the current political context in Ethiopia or is it just an artistic sensibility? If you were operating in a different political climate, would the work still be elusive and indirect?

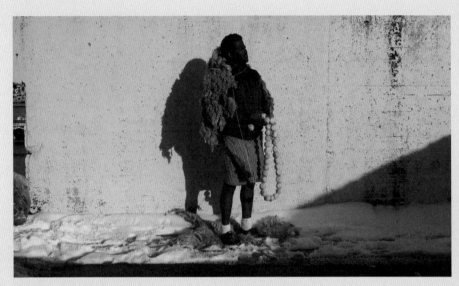

Robel Temesgen, *Semone Himamat*, 2014 © Camilla Renate Nicolaisen

ROBEL

There are two reasons: first, my method mirrors the current politics of this country and the world at large; and second, there are longstanding endogenous forms of communication and wisdom like *Qene*, or *sem-ena-worq*. The wax and gold approach has been prominent in the formation of political and social life in Ethiopia. I think the work has both of those influences. I enjoy the ambiguity, the in-betweens, the duality, multitude, and multi-translational aspects of my work. The duality is driven by the need for critique and survival. Leaders were questioned through the wax and gold approach. *Azmaris* (musicians) would go in front of the kings and queens to perform and entertain; ultimately using those opportunities to question their competence, not through direct critique, but by using words with dual meanings in order to avoid repercussions.

INTERVIEW
WITH

AIDA
MULOKOZI

EMANUEL ADMASSU

Maybe we can start with your personal journey. What led you to DARCH [Dar es Salaam Centre for Architectural Heritage]? How did you link up with people who were putting DARCH together?

AIDA MULOKOZI

I joined the project nineteen months into the thirty-six-month project timeline that was given. I wasn't there from the beginning, technically, but even when I joined, the project wasn't really moving at the pace and the speed that had been supposed. Some of the delays included getting the agreement to start work on this building. The Old Boma is owned by the Dar es Salaam City Council. In order to allow for restoration the project needed to get hold of a building, and preferably a historical building, to show conservation work. However, once a building was identified, an agreement was made verbally, but then, it took eighteen months to actually sign the MOU and for the city council to physically hand over the building to the project. That was a huge delay. When I came on board, they had just finished with the signing of the MOU, the building had been handed over, and work was going to start. That's how we acquired the building and that's my starting point. Should we go back to how I came to be here in the first place?

EMANUEL

Yes, definitely.

Ms Samantha G Mang'enya, *Old Boma*, 2017 © DARCH

AIDA

I was born here, in Tanzania. When I was ten, my father was posted as Ambassador to Belgium, so we left and lived in Europe for nine years. I had an opportunity to come back to Tanzania for university; I attended the University of Dar es Salaam, which was great for me because this was in the 1980s. There was no way for anyone to establish a firm link with their country. I did feel a little bit like a displaced Tanzanian.

EMANUEL

Your father was a politician?

AIDA

He was a civil servant for thirty years. At that time, Tanzanians were going through some quite difficult times. We were still trying to follow the socialist mode of governance and our founding father, Nyerere, was really vested in accomplishing socialism and *Ujamaa*, which means "social working." But that didn't quite work out very well. In the 1980s, it was difficult to even eat. Food was scarce. But, when you spoke with Tanzanians, you could see that there weren't any signs of discontent or planned uprising. People were looking for food and a little bit hungry, but still, there was a general sense of peace and happiness. That is a testament to Nyerere's positive impact. We remained a very peaceful country even though we're surrounded

by countries that have gone through major civil wars including Rwanda, which had a whole genocide, and the continual fighting in the Congo. But when Nyerere realized the socialist model was not working, he decided to step down and another president was elected who tried to open up the economy: President Mwinyi was elected as the second President of Tanzania in 1985.

I was away from 1980 to 1989. When I came back to Tanzania, it was just beginning to prosper again and opening up to doing business with other countries. It was a good time to come home and it was great for me because I was reconnected to my culture, to my country. Unfortunately, I didn't have any friends, because I had already lost contact with a lot of the friends I was in school with prior to my departure. Upon joining the University of Dar es Salaam, my ex-classmates had not yet joined the university; it was another two years, when I was in my final year at university, before they joined. I was a little bit ahead, academically, and I ended up going to school with friends of my sisters. It was still a great experience being there: I remember the first year that the university shut down. The President was running an anti-corruption campaign and he was encouraging people to come forward and speak up, and, of course, university students are always the first with that kind of challenge. But things went very wrong and we ended up running a strike that culminated in the university being closed for nine months. We lost a whole academic year. Ultimately, it was later established that suspending the students was uncalled for and unnecessary. But it happened. It was an experience.

Essentially, the students speaking out about the obvious corrupt practices were perceived as speaking against our elders. Granted, there were instances where some very unpleasant posters were put up and in our African culture this was considered disrespectful towards our elders, and for this one ought to be reprimanded. We were severely reprimanded.

I ended up doing my Bachelor's and then my Master's and I graduated in 1995. Upon finishing university, it was just at a time when, unfortunately, the Rwandan genocide had taken place and a UN resolution was passed to establish an ad hoc tribunal to try the perpetrators of the genocide. I was fortunate enough to get a job in the UN. So, fresh from graduating I find myself in Arusha and I ended up working for the tribunal for fifteen years. Initially I was in Arusha for four years, and then I moved to Kigali for eleven years. I worked very closely with the victims of the Rwandan genocide. It was a tragic, tragic chapter in Rwanda's history. But again, this is what keeps us suffering in AFRICA: the fact that at times we let the colonial influences overtake us, and you end up running into a genocide where close to two million people died, and for what? It just seems like the point really got lost. Rwandan lives were lost and it's a national loss for the country. This is something that they're still

203

recovering from, even today. I lived there for eleven years and I never really felt at ease in Rwanda because I felt that there was no definite resolution to the problem. You still had the two tribes, the two prevalent tribes, and I think the reasons why they decided to pick up machetes and [crying] I'm sorry... The reasons that led them to pick up machetes and kill each other senselessly were not resolved. They say: "Never again," and we hope that they will really abide by that, but time will tell. The tribunal was set up as an ad hoc institution and it ended up running for almost twenty-five years.

In 2012, when they started scaling back on staff and operations, I returned to Tanzania and I had a bit of a shock because I came back with a lot of hope and a lot of enthusiasm and I felt that this was the right time for me as a Tanzanian — who was educated by the Tanzanian government — to give back in a certain way: my father was a civil servant and one of the benefits is free education. So I came back and was ready to join the workforce and I wasn't going to be too picky. I had had a good job in Rwanda, with good earnings, and I said: "You know, I don't mind if the payment is not fantastic, as long as there is some opportunity for me to give back to my country."

I was discouraged after looking for employment for a few months as nothing was happening. I realized that my time away from Tanzania had cut me off from certain networks and in order to enter the workforce in Tanzania, I realized that I needed to have these networks, especially with government opportunities or government institutions. If you weren't part of that structure, then you were an outsider. So, although I'm Tanzanian and female (female candidates are always given special consideration which I wasn't ashamed to explore) and I had the benefits of an education abroad, this was not enough to be able to identify and relate to the context here, so I was still an outsider.

I ended up trying my hand at being an entrepreneur. That's how I came to open a restaurant with my sister. The idea was to show that we don't need to rely on foreigners coming in and opening business in order to create local opportunities. We do have a lot of restaurants of a certain standard and certain caliber, but there tends to be a foreign individual in the background. Even after we opened, people were surprised and taken aback when they learned that the establishment was owned and operated by two Tanzanian women. It really illustrates the perceptions that people have. It wasn't just the foreigners: even the Tanzanians were taken aback. This, to me, was a little surprising. In the management of the restaurant I had the privilege of meeting different people and through conversations I came to learn that a new organization had been set up and they were looking for someone to run it. Preferably

a local person who can make connections at government level but who the community can relate to and identify with.

That's how I came to DARCH. I had no background in architecture, I did linguistics at university, so you can imagine how very far removed I was. But I was reassured because DARCH is an institution with partners like the Architectural Association of Tanzania, Ardhi University, a local university teaching Architecture, and TU Berlin University: institutions with requisite expertise in architectural conservation, and heritage management. DARCH is a nonprofit organization, set up to save and promote architectural heritage through research, documentation, and community engagement. The Architectural Association helps to guide upcoming architects who are graduating from Ardhi University. At the same time, after graduating, the architects are getting a formal education exposing them to the fabric of historical buildings that have heritage, historical and architectural significance to the city, which has not always been so obvious, because we've kind of run into the idea that in order to be developing and moving in the right direction, you need a Dubai-like skyline. Even today, you will hear people expressing interest in Dubai-style buildings, but why are we looking for Dubai-style buildings if we have our own special and unique architecture that's already here? Why are we demolishing buildings and replacing them with poor copies of Dubai-style architecture? We're still a Third World country that's developing and finding our footing: preserving our architectural heritage is important in establishing the identity of the city and the country at large.

This was the idea being sold to most of the population — that if you want to see development, you go to the West where you see high-rises, so high-rises equal economic development. The US is a little far, but many people travel to Dubai, so, if I say: "Dubai," people have some family member who has traveled there and can give a firsthand account of how Dubai looks. For a long time, we were sold on this basis, which is sad! This meant that some of the more interesting and unique architecture that we have locally was always being sidelined, which is what made it easier for all of the demolitions that took place over the last twenty years. The transition from socialist developmental process to, all of a sudden, opening up the economy created confusion. Tanzania is truly blessed with resources: we have minerals, natural resources, the port, and tourist attractions like parks, lakes, and mountains. We were almost bamboozled into thinking: "We can do anything and we can do everything and we need to just change everything in this city to show that we are in it for the long haul."

ANITA BATEMAN
Can you talk about the architectural influences of this city and what makes Dar es Salaam unique?

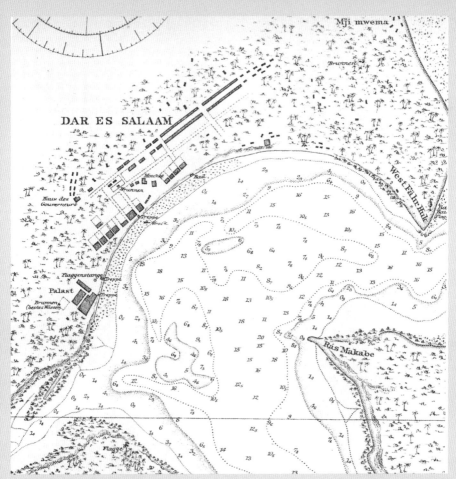

Dar es Salaam, 1888, (engraving) German School, 19th century, Credit: British Library, London, UK © British Library / Bridgeman Images

AIDA

I would say the first, earliest types of architecture that came to the shores of Dar es Salaam came from the Omanis. The first sultan, Sultan Majid, built five structures when he first landed. When he arrived, he got some of the tribal leaders to sell him portions of land, he took the best parts, right by the shore, and built some structures that would help to establish his city. Dar es Salaam comes from Arabic, it means "haven of peace." He was really here to stay. Unfortunately, he didn't live for very long and out of the five buildings that he built initially, only two remain. His younger brother took over after he died and the brother wasn't really interested in building up the city. He was more interested in the slave trade and he did that for a few years until Tanganyika was partitioned to the Germans and then the German East African Company came in as a colonial power and an administration. When they landed, they took over the few structures that were standing here. The Old Boma building itself, where DARCH is stationed right now (though it's currently owned by the Dar es Salaam City Council) was the first building that the Germans finished

constructing — the Sultan died before completing it, and they used it to set up their base in Dar es Salaam.

ANITA
The Germans?

AIDA
The Germans.

EMANUEL
I thought that was the Sultan?

AIDA
He didn't actually complete it. There are some pictures from the 1870s where you see even the rooftops are still open. The second Sultan, his younger brother, whose name was Sultan Barghash, was still ferrying between Zanzibar and Dar es Salaam and later moved further away to Bagamoyo to escape the German colonialists because they were trying to abolish the slave trade. So the Germans continued building up the city of Dar es Salaam.

They built a lot of structures from office buildings to recreational spaces. There's a building that used to be a casino and another that used to be a yacht club. They envisioned establishing themselves here for a long time. When they lost the First World War and the British took over, they automatically inherited the structures that were still present. So a lot of the architecture that we see in Dar es Salaam today was essentially built by the Germans. The British did set up a few structures but not as many. When Tanganyika gained independence and unified with Zanzibar in 1964 to become Tanzania, we saw the emergence of the indigenous Tanzanian architects. However, when the Germans were here — I should go back a little bit — they were the first ones to map out a master plan of the city. The city was mapped out segregationally. They actually subdivided the town into three zones. They had the European zone that was right up on the shore, and then they had a big Indian community that had been here even before the Germans because they were always trading on the monsoon winds. Immediately beyond the European zone you had the Indian zone: even today you can see typical Indian or Asian architecture in Kisutu, Upanga, right in the center, and a lot of the temples. The Asian architecture stands out because it includes shops on the bottom and living quarters on top.

So there was no mingling of the races or sexes. As long as everyone stayed in their section of the city, there was no need to go beyond. Now, after the Asian or

208

HOW DOES THE DEVELOPMENT PARADIGM COMPROMISE PRESERVATION AGENDAS?

Emanuel Admassu, *Kisutu*, 2019

Indian zone, you had the African zone. The African zone was basically where the Tanzanians and other Africans were allowed to live. They were able to implement this rule because they set up a special building code where they said: "Only certain types of structures are allowed in each sector."

EMANUEL
The British?

AIDA
The British enforced that as well, but it started with the Germans. In the African sector, they were only able to build temporary structures using grass, straw, palm trees, some timber, and mud. Very rudimentary structures. That was not allowed in the Indian sector and it was not allowed in the European sector. Automatically within those different sectors it became that different races had certain purchasing power, a certain amount of wealth and you found yourself in that sector whether you liked it or not. You also have the Swahili architecture which is an adaptation of a little bit of the Arab or Omani influence where there were typically the houses built by Tanzanians: so you had a little veranda space in front where people would congregate because you still had a lot of community so there were always opportunities where people could sit and congregate. The veranda, "baraza" as we called it in Swahili, was a way in which people could sit and converse and basically interact. This is what you find in the African zone in the area called Kariakoo. Recently, when new legislation was passed, there were very specific instructions on the type of structures that can be built: if you demolish anything, you have to build a minimum five-storey building. If you look at Kariakoo today, it's completely different, it's more of a business quarter. There are some residential spaces, mainly high-rise apartments. Recent architecture in the "African zone" has changed the fabric of what the city looks like. In the European and the Indian zones, it is more intact, you can still see fifty percent of the type of architecture that was there seventy, eighty years ago.

EMANUEL
What do you think about the future trajectory of the architecture in Dar es Salaam? Will the Dubai influence or the Chinese influence continue to be prevalent? Or is it becoming even more ambiguous?

AIDA
It is not altogether ambiguous because the government is not saying that outright, but our President's new policies follow the example of industrialized nations, so the

message we're sending out there is: "Investors, come in and invest" and a lot of the investors who come have their own blueprint of what they want to do. It's a question of being in agreement, but we're still not in a space where the government is really looking at buildings and spaces and asking: "What is our cultural richness and what are we losing culturally?" Unfortunately, we're not there yet. This is why an organization like DARCH is here, ready to try and bring in that aspect so we can develop and build buildings, yet maintain and preserve the important fabric of our architectural history.

We're not saying that we should not be moving forward in terms new architecture. We need to do that as we're not a fully developed nation, but along this development path, let us be cautious of what it is we're tearing down because part of it goes hand in hand with the history and the identity of the city. We risk losing those legacies if we're not careful. But there is still a kind of strain and dilemma. Buildings were nationalized in 1977 — it was declared that all buildings need to be nationalized because no one should seemingly be more affluent than anybody else, in line with the *Ujamaa* doctrine. Even private houses were nationalized. This was reversed in the 1980s: people were given back their houses. But then, people were not allowed to own land. Even today, Tanzanians don't own land. We are given tenancy or lease agreements, so you're given thirty-three years, sixty-six years, or ninety-nine years. Land still belongs to the state, in custody for the people.

EMANUEL
You don't own the land but you own what you build on it?

AIDA
You don't own the land. If your title deed is revoked, you've lost the building. Technically you've lost the building. It's rarely done but it's being done more and more now, in situations where there is a particular interest. This is the danger we are always in.

ANITA
What are some of the challenges of getting the public interested in the urban landscape and how do you find out about the needs of Dar's old buildings?

AIDA
When I joined DARCH, and began intentionally learning about the history of the city, I started speaking to people to gauge their understanding of its history and I realized that there is very little information they have in terms of the city's origins.

Ms Samantha G Mang'enya, *Sokoine Drive*, 2017, © DARCH

They may know the history of the buildings, but they sometimes view them as impediments to development. The high-rises seemingly look like buildings that could have opportunities for them. One way that we have made this information available is through our permanent exhibition which was done through research of the buildings in Dar es Salaam, the buildings that still stand and those that have been demolished. We realized that there is a generational gap: the older generations appreciate and understand and are probably more knowledgeable of the history; but the generation in their thirties and forties are not particularly aware. The younger children definitely don't have this information. A lot of the history is not really taught in schools. We tried to find ways in which we can involve the younger generations by visiting schools and just beginning to plant those seeds of them wanting to know more and they've come to visit us here at DARCH and we've allowed them to look through the exhibition and learn a little bit more. There is still a lot of work to be done. We're trying to engage the government so that we can find ways to add these historical touches into the curriculum, into the history classes. It's still something that we are having a hard time with, because everything is a little slow. But we hope that we're going to get to a point where there are enough opportunities, that there is enough information, accessibility, that your regular Tanzanian does not have any reason why they should not know their own history.

214

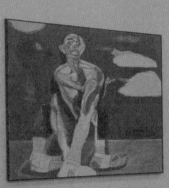
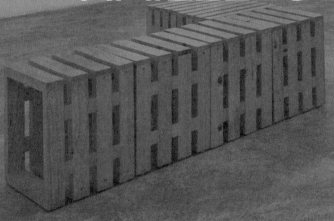

INTERVIEW WITH

RAKEB SILE & MESAI HAILELEUL

EMANUEL ADMASSU:
What motivated you to start Addis Fine Art at this particular moment in this country?

MESAI HAILELEUL
It's been three years since we opened the space here. But Rakeb and I had been working together prior to that. She lives in London and I lived in Los Angeles when we first started collaborating about seven, eight years ago.

RAKEB SILE
Addis Fine Art as an entity (as Mesai and I collaborating) started in 2013. The progression has been very organic. I actually sought out Mesai, because there weren't many people I could find, even online, who could put the art history that I was looking for into any kind of context. I would come to Addis Ababa and buy artworks but I didn't really know what I was doing in terms of collecting. There was nobody to guide me. When I found Mesai and his gallery in Los Angeles, I just thought: "OK! Well, this person will help me" in terms of what I was trying to figure out. After realizing that there aren't many people who understand the regional history in depth — from the modernists to what's going on now to what might be going on into the future — and then meeting Mesai, I felt like we needed to do something with this knowledge. That was the spark.

MESAI
In my case, I left Ethiopia in 1974, just before the Derg regime. I didn't return for

217

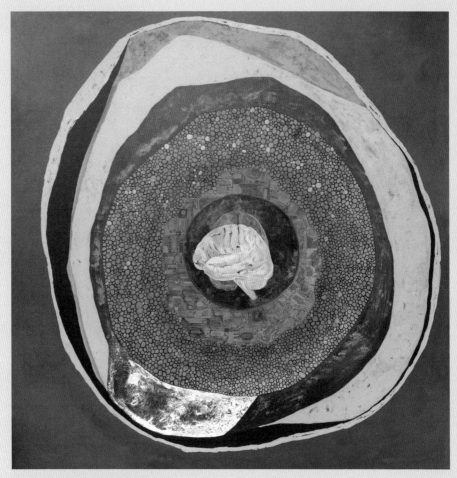

Merikokeb Berhanu, *Untitled XLIII*, 2020

eighteen years. When I started coming back, I found friends who had moved here. Everyone was taking me around and showing me these amazing artists and their works and I spent most of my time doing that: buying, collecting. It was a fun thing to do. That went on for a few years. Then artists were like: "It's not just buying from us, we need exposure, is there anything you can do?" To be honest with you, I knew nothing at that time. We're talking 2000…somewhere around there. To cut a long story short, because there was such a need here, I said: "OK, the least I can do is share this within my network." We started picking cities and doing pop-ups (before pop-ups were a thing). Those were in Washington, Oakland, Los Angeles — places with large Ethiopian communities. That went on for five years. I was pleasantly surprised when people just bought art. I realized I had to educate myself and see

218

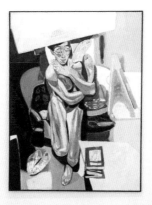

Tesfaye Urgessa, *Untitled Women I*, 2018

how we could do this properly, moving forward. Trying to set up a gallery in Los Angeles that is primarily representing Ethiopian artists is not easy. Mind you this is 2001, 2002, 2003. And finally, after five years it was like: "OK, let's give it a shot!"

EMANUEL
Is the gallery in LA still operating?

MESAI
No, no, no. It ran from 2005 to 2008/09. A lot of things changed in America at that time. The gallery, and everyone else on that same block, had to close. But that gallery was the starting point. It was an amazing experience. Maybe I was slightly ahead of my time. What we see now and what we saw then were worlds apart. In my gallery's day, most of the activity was driven by institutions that were trying to figure out how to show art from this continent. For most institutions, it's always artifacts, masks, or... We'll leave it at that.

ANITA BATEMAN
Can you talk about the difference between what you were looking for when you were representing artists in LA, versus what you look for now?

MESAI
Back then, it was all just a lot of experimentation. What can we show in this space that might connect with people? Because, until recently, the outside world has not really known about the kind of art being produced here. Yes, there were a few Ethiopian artists who had some recognition, with some museums collecting their

219

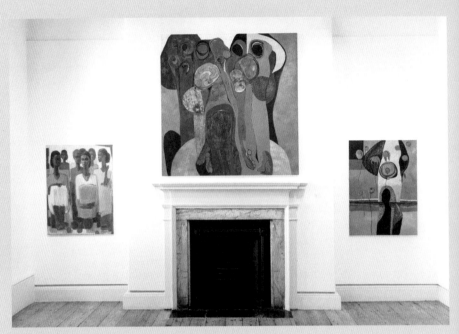

1-54 Contemporary African Art Fair, London, 2019, installation view. Artworks by Merikokeb Berhanu
© Bandele Zuberi

work. The art that I was getting here and taking to my gallery, there was no criteria or rubric behind it other than that I liked it and wanted to share it. Surprisingly, some of the artists really, really did well. When I opened the gallery, there was a particular artist who attended the opening. He came and showed thirty plus works and we sold everything. How crazy is that? Yes, a lot of the buyers were also Ethiopians, but they were not *Ethiopians*, because at the time, Ethiopians weren't returning home. They were yearning for something to live with, see, and appreciate. There were quite a few people who were like us. But actually, anything that I felt like might work, "let's put together this group of artists" or "this particular artist," believe me, I would do! Not a lot of that kind of thinking went into it until Rakeb and I met and by then, we already had vast experience and had started to see what's happening on this continent. In particular, in London, there was this energy about what's coming out of AFRICA. Collectors who were not only curious — they were also buying art.

RAKEB

I grew up in London and I live there now. I felt like it was the epicenter of the contemporary African art discourse. It felt like, 2012, 2013 — that was when people were ready or wanted to know more. I collected art, not in a big way, but I was an active

participant in the art world in London. Just by virtue of me being an art collector and an Ethiopian, you know, people would approach me and ask: "What's going on in your region? Who should we be looking out for?" I'd think: "I need to learn about this myself." Yes, I have an art collection, but what does my collection actually say? Is it relevant? What have I collected? I couldn't even tell people about what I was doing. I felt like I really needed to figure this all out. That's how Mesai and I got together. I did some research, and I found his gallery and I went there to meet with him. We really connected and I felt like we could do *something*.

Going back to your question: "Why at this time?" We really believed that if we didn't do it, this region would not be highlighted in the wider African contemporary art discourse, which would be a shame. There is such a rich and long art history here, which still permeates through the young artists, in particular in the medium of painting. Also, through the untrained young photographers who are producing works which speak of contemporary Ethiopia and simultaneously pushing the boundaries of the technology. They have no boundaries. Girma Berta is one of those artists. His *Moving Shadows I* series was exclusively produced on his iPhone.

Once we started talking and working, we found it to be such a rich and largely untapped area. It was done out of necessity. With Mesai's art background and my business background, we felt like a commercial space would serve our vison best. The artwork had to be seen, but the endeavor also needed to sustain the artists, in a real way. That's why we set up a gallery in this manner. We've used the same systems and procedures as any gallery anywhere in the world. We just put it here. We take them through all of these processes that any other gallery would. It is very formalized. We wanted to engage with the art market — that's the only way that artists can see the dividend.

MESAI

What we were trying to do was something no one has attempted here. To ask artists to sign with a gallery. That conversation by itself is not easy. Artists were asking: "What does it mean to sign with you?" They're used to selling out of their studios. There's never been a gallery like this *ever*, in the history of this country. It was very challenging. They knew me, they knew her. But it was challenging to have these formalized agreements. To be able to build on that and have the artists' trust, especially those who took that risk initially; they are being rewarded nicely now. All of that is because of this shift that happened over the last four, five years. There's been this incredible, market-wise, appetite for what's being produced on the continent. By and large no one really knew what was here even though we have one of the best art schools that was started in the 1950s. That is, to this day, the only place where

221

students can attend and be well-trained to the point where their work is professional enough that Rakeb and I can take it out and proudly show it anywhere in the world.

RAKEB

There's a huge amount of talent, but also, there's training.

MESAI

The training! Honestly, I'm always struck by how unfortunate it is that there aren't more places where artists can show their work. Or galleries to help them show it and engage the outside world.

EMANUEL

We actually went to the school and got a tour, and it was fascinating to discover that, for example, there's only one sculpture student. He has the whole studio to himself and he's doing all these experiments.

How are you engaging with the city itself? How are you engaging with the school? Are there ways that you are directly recruiting talented artists from the school and exhibiting them in shows here?

RAKEB

I suppose, we've kept ourselves quite independent and we've done that deliberately because of the way that we operate. We knew quite quickly that we would be inundated with requests, otherwise. We've engaged the school indirectly because we'd go to the end of year shows. We work with one painter who is actually a lecturer there. What we look for are the artists who have graduated and have a few years under their belt because this is such a hard market, the artist needs to have the grit to see it through. We signed a few artists who have had no help for fifteen, thirty years, and yet their work has only gotten better and better. It's really inspiring. We're looking for those types of artists now. In our third year, we took on some really young painters. But in the beginning, we were looking for artists who were established, and then helped them to take their careers to the next level; Addis Gezehagn is one of those artists. For fifteen years he's worked as a studio artist and he's sold from his studio, but the response that we got internationally from his meticulously painted works has been phenomenal. We struggle to meet the demand. His work is so well executed. Those are the artists that we want to help because they're already at an international standard. There's just no bridge; they were stuck. There's a market here, but it's small. Like anywhere else, local markets tend to be smaller than global markets.

222

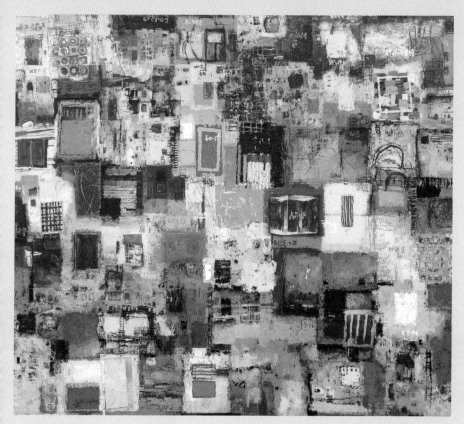

Addis Gezehagn, *Floating City XIX*, 2020

MESAI

The biggest problem here for the young artists is that the market is small. When they come up, they are forced to adjust the kind of work they want to share because selling that work here is going to be very difficult. We see a lot of young artists doing experimental stuff on the side, and then, primarily, they make art that tourists will buy. The tourist art shops encourage those types of works to be produced. So, the artists are feeling the pressure imposed by the tourist market. It's not unlike many other African countries: you train the artists, they come up in this market, and then some of them are forced to go to the United States. You have Ethiopian artists who have such a hard time connecting with galleries or finding customers for their work and they're forced to do something else to survive. It's tough! There are very few who are still practicing. That's the way it is for artists in Ethiopia: it's very unfortunate. We really don't have much choice other than to go to the ones that we feel will be able to do well internationally because, at the end of the day, we're running a business.

RAKEB

Also, the artists that have made that sacrifice to continue with their real voice without any real help, they're the ones who are important to us. We feel they have something to say. They're looking at their surroundings, they're looking at social justice,

hyper-urbanization. Our endeavor is commercial, but we are trying to find the most critical voices and the most important artists from this region, locally, but also, from the diaspora. We have so many artists from the diaspora who are first generation. They weren't raised here, but they still have an attachment, something that they're still pulling on that's from here, from their culture. That's what's interesting to me. What is this region collectively, in its consciousness, saying from various parts of the globe? What are the conversations between these people in all these different locations? From a curatorial perspective, that's really exciting to me.

ANITA
How do you approach who you want to represent and who's already on your roster? Is it a matter of finding artists that complement other artists to make the gallery more holistically representative?

EMANUEL
Yes, how many artists do you have at the moment?

RAKEB
Right now we have nine artists on our roster. When we sign an artist, we do a lot of PR and a lot of institutional shows. And yet we are growing, and we have a project space in London that is growing faster than this space here at this point. We will be moving in the spring of 2020 with a permanent office and program [at time of publication Addis Fine Art are based in Fitzrovia, London]. We want to work with more artists in the diaspora. For example, Tariku Shiferaw is first generation: he left Ethiopia when he was young. His work is different from other work we show as his works are in the realm of abstract minimalism, but still, there's something in his work that speaks to his identity. We're interested in taking on more artists in Europe who are from the diaspora, to look at that side of things as well. To answer your question, I think it depends on the individual: if you like the work, if you like the artist, if you feel like they have something critical to say, if they engage us. Working with an artist is like a marriage. It works well or it just won't work. Even if the artist is fantastic, if they aren't doing their bit, the marriage just won't work. There are a bunch of unwritten criteria that help us make these choices.

MESAI
We do that every year. It's our way of saying: "OK, who can we bring and show here for the first time?" But before we do that, we kind of follow and see what they do.

We go to their studio. We observe their growth. In the case of Tadesse Mesfin, we wanted to show his work and also work together because we really respect him.

RAKEB
Yes, he was on our wish list. He's super important art historically because he's influenced every artist below the age of forty-five. As a professor at the Alle School of Fine Art and Design in Addis Ababa, they've been through his class. He's been at that school for thirty years now. He teaches a painting class but also a conceptual art class. They love him. We felt really strongly that we needed to work with one of the artists from his generation. He's pivoted dramatically; he's Ethiopian, he went to the school, but also, he's got that whole American institutional background because he did his Master's at Howard. He's really important to global art history but he stayed here. He's a really, really special artist and we're lucky to have been here at this time, to show him and work with him.

MESAI
You'd be surprised though. There are a lot of artists who have never really gotten their break. And they're still here. Maybe we'll be working with some of them in the future.

RAKEB
What we've done hasn't been easy. People initially thought that we were crazy.

EMANUEL
I actually came and looked around a week before your opening.

RAKEB
Everybody was waiting for us to fold that first year. The point is that the artists are here and they're willing to make it work. If there were more galleries and more art spaces, our conversation would be very different. I mean, the city needs this. There are a hundred million people here. Of course, the market isn't that big, but what we found is after a couple years of relentlessly beating down doors and making people understand what the role of a gallery is (because people thought we were just *dalala* or agents, but it's not a good term here). The idea of the gallery as a place that not only sells art but shores up artists' careers was unheard of here. Once people understood our role, they were more receptive. When we have a show like this, we make sure that we price for the local market and we make sure that local people have an opportunity to buy first when artists show for the first time. Once an artist gets to a certain price on the global market, we can't come here and price

it low. We make sure people here have the opportunity to buy first and then prices generally go up in the West. It's supply and demand: that will push up the value. It's not only creating cultural value; we're creating monetary value for the collectors here. That just clicked this year. They see our role. And it's not just the collectors, I think artists are understanding better the work that we do and how that complements their career.

EMANUEL

You guys are interested in forming a different model of an art space.

RAKEB

What we wanted to do is bring our experience from the wider market and just transplant it here and not think too hard about what people have been doing, because people have been doing what was relevant for this market at that time. We had to do what we believed needed to be done. We have so many barriers to break, with the artists, with the collectors — having people pay a certain price for art. We decided to remain true to the vision, I think that's been our strength.

MESAI

People respect us. At first, they were like: "Who do you think you are charging over BIRR100,000 for an artwork?" Part of the problem on pricing is the punitive tax issue that we don't like, that's not really fair. Though now a lot of people understand this and actually they come here and say thank you. The artwork that we're showing is not the same as the artwork and curation that you see elsewhere.

RAKEB

To answer your question about public engagement, we do artist talks, we had a series of artist talks that were related to, for example "art and architecture," "feminism in art." We run a public program — not as rigorously as our exhibition program — but that's how we bring in students, architects, and fashion brands.

MESAI

We do it in a way that's related to art. This idea that art is in everything.

RAKEB

There's art everywhere here. There really is! The biggest thing we do and this perhaps makes us less commercial, is that we keep each show up for two months, it makes us act like a semi-institution so that the maximum number of people can see

226

WHY AREN'T THERE MORE BLACK DEALERS IN THE CONTEMPORARY AFRICAN ART MARKET?

the exhibitions. Anybody can walk in. The last show was by Dawit Abebe, an artist who has representation with another gallery in London. He wanted to do a show in Ethiopia because he hadn't done one in a while. It was a difficult show to have due to male nudity and installation complexity. But we kept that show for three months to ensure everyone had an opportunity to see it.

EMANUEL
Have you experienced censorship?

MESAI
No, not to date! Dawit Abebe's was probably the most controversial work.

ANITA
Thinking about the white cube and its ramifications: it's a very polarizing thing because, on the one hand, there's a functional purpose for the white cube, but on the other hand, it is full of white men and white people, white artists. What have been your experiences being Black gallerists in this world that may not be as accepting of diversity?

RAKEB
I come from the corporate world, which is super white. Many times, I've been the only person of color in many rooms. What I've been surprised by, though, in the art world, is how much whiter it is than even the corporate world — by far. We are likely to be the only Black art dealers in one room at any time. On this continent, if we take away the Nigerian dealers, there is no one. One in Uganda. It's so sparse! As this African art discourse grows, that's also a concern for us. Who's curating, how does that affect the art, how does that affect the artists? We are just a drop in the ocean.

MESAI
If we did not have the experience that we share, we probably would not have made it. At these fairs, we're always looking at each other and saying: "There's something wrong with this picture." This is such an important part of our history and who we are as a continent. And yet, there are people who are doing this and not always for the right reason. We see the danger.

RAKEB
We still don't know. To answer your question properly, we still need a few more years. I don't know what I expected. We're still in shock.

228

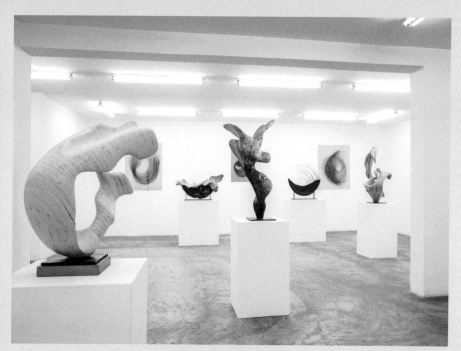

Adiskidan Ambaye, *Liberty*, 2020, Addis Ababa, installation view

RAKEB

There is a real danger that fairs, artists, and galleries — in the contemporary art discourse — get hijacked into something else because of the lack of local voices. Black and African artists can be pushed out of the discourse. If the word "AFRICA" is in the title of anything, then it has to be about African artists.

MESAI

There's not much to add to this. When you walk in, especially into the fairs here on the continent like in South AFRICA or Cape Town, you ask: "Where are we?"

RAKEB

Although, ART X Lagos was a great experience and a possible positive future. We sold to a predominantly African clientele! There were still more white dealers, but there were more Black buyers. It was a window into the future. Maybe that's what could happen. Governments need to wake up to this industry. The majority of people here are so obsessed with our ancient culture. What are our contemporary cultural producers doing? This is going to be old history, if we don't nurture it. There's a lot to be done!

EMANUEL

You have expressed the need for various voices from each one of these regions and the diaspora. How are these interests shaping Addis Fine Art? How are you

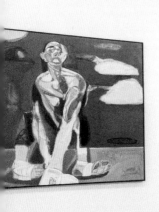
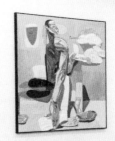
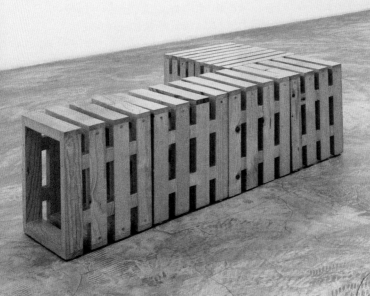

Tesfaye Urgessa, *No Country for Young Men*, 2019, Addis Ababa, installation view

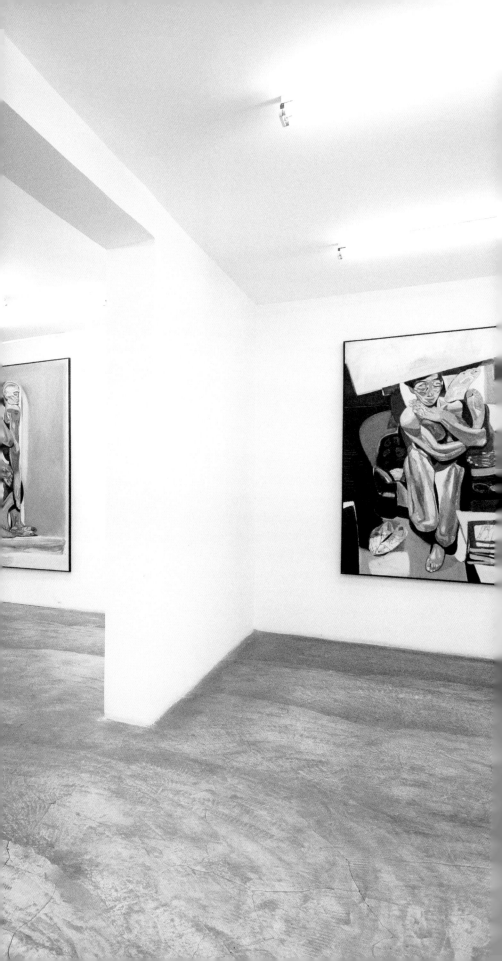

destabilizing the idea that the two of you have been curating everything? Are you going to have guest curators?

RAKEB

One of the first things we're trying to establish is that we are regional experts. That is how we came into this. There were a lot of people saying they're AFRICA experts and we were like: "No you're not! Because you can't be." People have to choose a region and explore it deeply, expanding only to the countries that are related culturally and geographically like Eritrea, Sudan, Somalia. Guest curators are in the works for sure, that's something we're talking about, particularly for London.

When we move, we'll have multiple spaces to play around with and the flexibility to host any kind of show, any kind of artist. That is what we're focusing on and it will bring a real step change for our program locally, including inviting external curators.

EMANUEL

The plan is to establish Addis Fine Art in London?

RAKEB

And the fairs, we do a lot of fairs. This year, we'll do seven fairs. From the very beginning we've done at least five fairs. We'll probably peak at ten. Our London team is growing, and we have a gallery manager there who will take on a lot more work. It's definitely growing and we're pushing our own agenda. What we want to do here is set up a residency program. We've already done one pilot with an Israeli artist. What artists from the diaspora want is to exhibit their work in Addis. Local artists are struggling to find studio space. That kind of assistance and ability to find studio spaces, that's part of our growth plan as well. It goes back to the commercial/social enterprise balance.

OTHER, OTHERS

2034

GERMANE BARNES

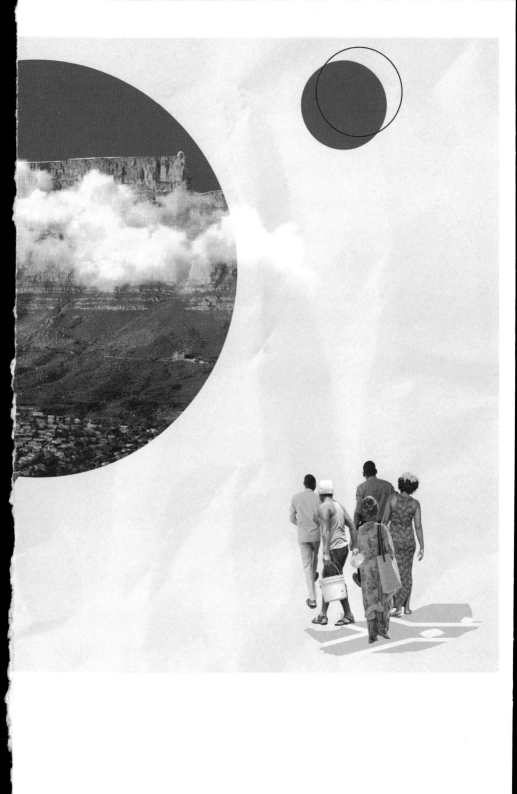

Other, others is a visual essay that details my experiences as a short-term resident of Cape Town, South *AFRICA*. Less than twenty years after the dismantling of South *AFRICA*'s apartheid state, Blackness was viewed as other. However, my American Blackness was viewed starkly differently from Continental Blackness. The status afforded to my blue passport was akin to that of a golden ticket. While I was clearly an other, my presence was even further removed.

INTERVIEW WITH

NIAMA SAFIA SANDY

&

ADAMA DELPHINE FAWUNDU

EMANUEL ADMASSU

Niama, you received a Master's in Anthropology from the School of Oriental and African Studies in London and a BA in Journalism with a minor in Caribbean Studies from Howard University in Washington, DC. Can you talk about the moment you realized that curating could be part of your training as a cultural anthropologist? Also, what is the relationship between visuality and curatorial activism?

NIAMA SAFIA SANDY

I decided to curate before I began my studies. I purposely studied anthropology in lieu of art history because I wanted to create a grounding based on the myriad of socioeconomic, political, historical situations from which African diaspora stories and visualities are couched and born. As for the second question, everything that we see and how we perceive *how* we see things is completely connected to whatever context a person is born into or decides to study because the idea of objectivity is a fallacy. Everyone is bringing whatever positionalities into how they're seeing the world. Whatever art they're looking at is of course included in that.

EMANUEL

Delphine, with the *Deconstructing SHE* project, you used Nina Simone's "Four Women" as a point of departure. There seems to be an interest in deconstructing not only an external gaze but also an internal gaze within Black womanhood. Can you speak about the overlaps between internal and external critique, especially as it relates

239

INTERVIEW WITH
NIAMA SAFIA SANDY &
ADAMA DELPHINE FAWUNDU

NEW YORK PUBLIC LIBRARY
(MAIN BRANCH), NEW YORK CITY
JULY 27, 2018

to your recent project *Passageways #1, Secrets, Traditions, Spoken and Unspoken Truths or Not?*

ADAMA DELPHINE FAWUNDU

There are questions I've been asking myself: "How much is the internal based on the external? How do we see ourselves and what societal or historical influences impact the way that we see ourselves?" I've been going back and forth with those questions. What does it mean? How do I really know who I am if I'm not depending on these external forces? Where's the truth in that? I don't think that I have a complete answer, but that's my investigation, which is ongoing. Sometimes, it's to the point where I'm taking away information that I have from history, just peeling things away to identify the purest internal me or multiples of self. I feel like it's a complicated question. You never really understand the answer. My problem is when that internal is negative, or has a negative impact on how we view ourselves. So, that's what I'm questioning as well. Where does this idea come from, especially for a Black woman? When I think about simple things like just being yourself — you just wake up and you're yourself — then there's a critique about that, whether it's your hair or just being who you ought to be. There's a social critique about beauty and that becomes problematic. Those are the issues that I'm addressing with my series *Deconstructing SHE*.

EMANUEL

Are there lines that you can draw within your work, where the lines are really trying to speak to an internal audience, or, let's say, a specific audience that can associate with subjectivities of Black womanhood versus when you're trying to address an external audience?

DELPHINE

I don't make the separation. I'm making this work. It's going to be viewed differently depending on who's looking at it. I'm never consciously saying: "I'm making this for people who are outside of [a particular context], or people who look like this." I know that it will be interpreted differently and that's fine.

EMANUEL

Can you each speak about the relationship you have with specific art institutions, as people who are affiliated with many collectives, galleries, but not necessarily a museum? What do you think the role of institutions is in foregrounding works and curators with decolonial practices and objectives? For example, the decision to get independent curators for the Southeast Queens Biennial.

240

Niama Safia Sandy, *Southeast Queens Biennial: A Locus of Moving Points*, 2018

NIAMA

Two words come to mind: freedom and equity. Much of what I'm trying to work through in my practice is very much about creating space for the voices that aren't necessarily the ones that have been found in these spaces before. Particularly, making space for people of African descent, alongside women, trans and queer people. We have so many ways to exist in the world, and this moment is really critically engaged with creating space for everyone, regardless of whatever classifications may exist for them. In terms of the Southeast Queens Biennial, that was actually a project that I approached through the No Longer Empty Curatorial Lab, which is like a professional development program for emerging curators. It was me and five (and, later four) other curators, but for me, it was a very different thing because I am the only one of the curators who actually had previous deep connections to the area. I always put the word live in air-quotes, I "live" in Queens, because being engaged with the work that we're engaged with [in this sector], most of the time you have to go outside of where your home is to do your work. That's very much the case for me. But I've been coming out of Queens since I was a kid. My eldest sister has lived there since I was very young, so going to Queens, actually not very far from the area where that show was, as a kid, I've been engaging with this community for

Adama Delphine Fawundu, *Passageways #2, Secrets, Traditions, Spoken and Unspoken Truths or Not*, 2017

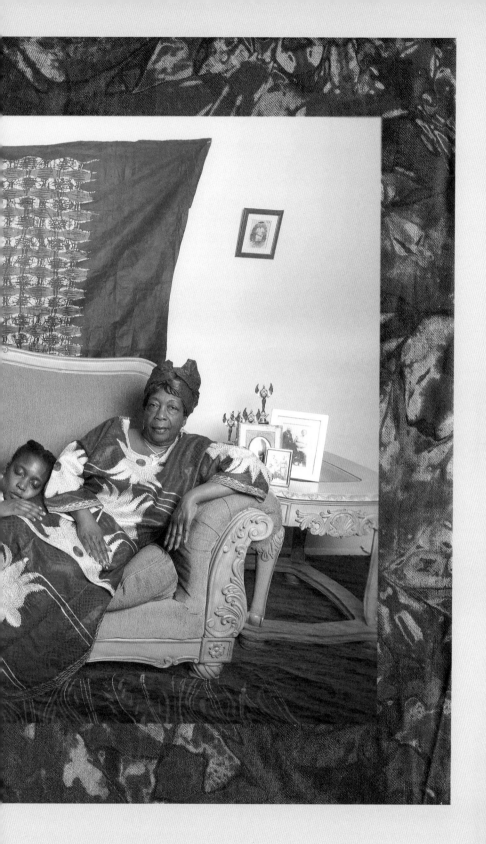

243

INTERVIEW WITH
NIAMA SAFIA SANDY &
ADAMA DELPHINE FAWUNDU

NEW YORK PUBLIC LIBRARY
(MAIN BRANCH), NEW YORK CITY
JULY 27, 2018

something like twenty-five years. It's a very different relationship for me than it is for someone else.

Having been raised here in New York, watching all of the changes happening all over this city ... places like this section of Queens, like East New York, like the South Bronx, all are "a last stand" in terms of the battle to have New York maintain its identity. The model of the biennial is a really interesting one, in that it can mean whatever the curators decide it should mean. Most of the time, when you have biennials — with the exception of something like *Made in LA* at the Hammer Museum — biennials often have artists from elsewhere coming to comment on whatever they want to comment on. In this case, we wanted to focus on who is here, because you know what's going to happen in the next five years; God knows how little space will be made for local artists to create. We really wanted to be intentional and listen to them, to learn the challenges they've been facing. One of those challenges is studio space, which is a common issue in New York City because everyone is struggling with studio space. Because the vast majority of people who live in Southeast Queens are working-class people, art is generally not something people think of as a profession, like, a *real* one. The idea of having studio space set aside is not a thing that existed, and we really wanted it to, so in addition to creating the show, we wanted to create resources and connect artists to these resources to further their practices. That said, there were two shows made for the biennial — the first was called *A Locus of Moving Points* at the gallery at York College, CUNY. Our intent was to highlight the idea of movement, of re-orienting the center to the margins (via bell hooks), and this idea of the artists having to move and travel to do their work. We were also striving to highlight the legacy of art, institutions, and the artist communities that have existed in Southeast Queens for decades. We referenced the artist Tom Lloyd's Store Front Museum, which unfortunately closed in the 1980s; all of their archives are at the central branch of the Queens Public Library. We were also able to have an installation at the library called *Notations in Passing*, which highlighted the work of a range of local Black women artists. That exhibition engaged with the idea of making space and highlighting the work of those artists who have been creating work in this community for years. Overall, the project featured eighteen artists living in the Greater Jamaica, Queens area.

We were honored to include the work of two artists who have been woefully overlooked: Janet Henry and Sana Musasama. They both have been producing work in this community for over forty years, and they are both incredibly talented. The project was about changing and challenging the status quo of who can create and occupy space. The area in Queens where the show was held was one of the founding areas of the United States; it was where the Oyster Bay spy ring was located, as

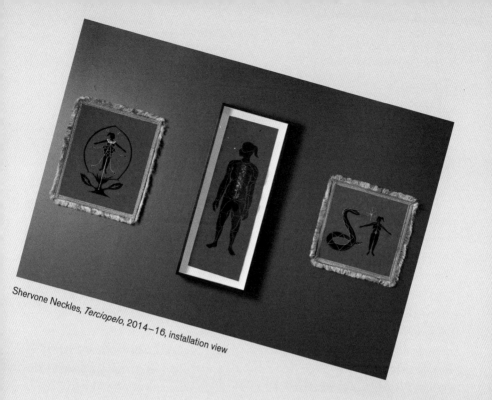

Shervone Neckles, *Terciopelo*, 2014–16, installation view

it gathered information on British activity to feed to George Washington. It is a literal pillar to the foundation of this country and most people who move through this area don't even think about that. We also showed Shervone Neckles' work. She was born in Brooklyn, and her parents are from the Caribbean. Actually, so many of the artists in the show had parents who were from elsewhere, and the [artists] are working through connecting those diasporic histories. Shervone has an ongoing series called *Give and Take* wherein she refigures the creation story with her own female character as the central deity. West African and Indigenous rituals that center healing and well-being are also tied into her practice. It's a lot to work through. We started working on the show in October, it opened in February. I don't even know how we did it, but it was a success since we were able to become part of that community and think about who had been part of that community.

EMANUEL
Delphine, your project *MFON: Women Photographers of the African Diaspora*, co-founded with Laylah Amatullah Barrayn, has been described as an archive of authenticity that documents the life and culture of the African diaspora. What is an authentic perception and how does it adhere to, disturb, or construct African-ness?

DELPHINE
I like to stay away from the word "authentic" because I feel like it's based on perception. We could both be from the exact same family and my experience in this one family could be completely different from my brother's or my sister's. Creating

INTERVIEW WITH
NIAMA SAFIA SANDY &
ADAMA DELPHINE FAWUNDU

NEW YORK PUBLIC LIBRARY
(MAIN BRANCH), NEW YORK CITY
JULY 27, 2018

another way of looking and experiencing is more of what we intended to do within the project. It's not even necessarily the life of the African diaspora, but more, what is it like to experience this world through the lens of a woman of the African diaspora. That could mean she's photographing whatever she wants in the world, but this is how she sees it. I think that's kind of different. On the one hand, we could think that all we're doing is telling a story about a specific thing, but no, this is how we see the world and I feel like that needs to be included in the conversation as that broadens perspectives of how we're experiencing this big world that has a multitude of different backgrounds. I just returned from Nigeria and I went to Ghana, where in so many ways the remnants of colonialism still flow through the air. When I first went to Ghana in 2008, I was obsessed with the question: "What would real estate look like, or what would the construction of a city look like, if colonialism never existed?" The fact that I didn't know what to visualize bothered me. And then I realized that it's an unanswerable question. However, if you look at history books, some historians would say: "In African culture, they're just stagnant, there's no growth," so I'm always interested in asking: "What does this thinking look like without that [colonial] influence?" It's an impossible question. That keeps me working, keeps me investigating and looking for answers, and you find little bits of answers here and there — you're trying to reconstruct something that you really don't have the whole answer to. Yet it leads to another way of looking, another way of experiencing this world rather than the one that has been ingrained in the narrative. For example, being a little girl growing up in Brooklyn in the house of African parents and experiencing the world of New York: that was very different from what was going on in my house. On the outside, my culture was perceived to be so negative and I've been reconstructing ideas of what that even means.

EMANUEL
What are your thoughts on a living archive?

DELPHINE
As an artist, or as someone who makes art or information, it's so important. Everything in the archive is important; it grows, and it continues to grow, and we need to make it as diverse as possible. This idea of getting caught up in what it means to be Black or what it means to be African, really, what does that even mean? That needs to be diversified completely, because there's no single narrative, and in a fight against racism, and all of these intersecting social issues, unity comes into play because you know that you need to be unified. However, within that unification, the complex thing is that we're all this one thing, but we're not all this one thing — I feel

246

that the more that we diversify our perspective, the healthier we grow, then we can make a big change.

NIAMA

Archiving is critical. Much of my practice is about creating a document, creating a testament of what people are doing. Not necessarily from my lens, but from theirs. We have far too many books about white male artists, and there need to be books that clearly define artists' practices from *their* point of view rather than from a context that is completely removed from the place of where the work comes from. Recently, I was telling Delphine about some ideas I've been working on to address this. I was talking to another curator who worked on a show that was in Los Angeles a few years ago, and she had to do so much to find the work that eventually ended up being the show. She was calling artists' former spouses and family members, and other crazy things! That was seven years ago and that shouldn't still be the case! In twenty years, I would really like for there not to be a dearth of information about what people are doing.

DELPHINE

I also want to note the importance of those archives that exist on the continent. When I was in Nigeria, one of the things that was complicated, even in Sierra Leone, was just to get access to archives. "Where are they?" "Oh they're in someone's personal collection."

NIAMA

We don't always work that way. It seems that oral histories are often more reliable. Oral history is critical!

DELPHINE

Some of the items I'm looking for are just photographs, but cultural things you can get through oral histories. I'm really interested in newspaper articles; I want to know what the newspapers were doing. If you want to go and find what African photographers are doing, these archives, these collections of work are on the continent, but to get to them, you have to go here in order to get there. I feel like, in terms of this living archive, you need to have some sort of access point. Rather than if you want to find these images of what happened over the last twenty years, you have to go outside *AFRICA* to get that.

247

INTERVIEW WITH
NIAMA SAFIA SANDY &
ADAMA DELPHINE FAWUNDU

NEW YORK PUBLIC LIBRARY
(MAIN BRANCH), NEW YORK CITY
JULY 27, 2018

EMANUEL

This relates to your physical position here in the US and how that frames the relationship that you have with your African ancestry and with the continent at large. If you're talking about AP [Associated Press] for example, you, being based here in the US, would probably have better access to AP than photographers on the continent. How does that play out in your work?

NIAMA

It's one of those things where your location is theoretically a privileged position, but in some ways, it isn't because you're in this place where you're contending with all of these negative ideas about who you believe yourself to be, so it's almost like a handicap in a way, being positioned here [in the US]. Obviously, the idea is that you have more access to resources, but that's almost purely theoretical for most. Though it's also a source of inspiration because you're wanting to connect with other people with whom you share this history. In my case, my family's most recently from the Caribbean, but we had this project, as part of which I did a DNA test and I was one hundred percent Mende—what are the odds of that? You need to take all of the imagination out of it and really connect with the actual histories of people. Like the real, lived experiences, whether that's in the recent past or four hundred years ago.

DELPHINE

In the most practical terms, we knew a bunch of photographers from our travels and here was this thing that we could build something together, and now it's continuing to grow. There's something about physically going to some part of the African continent and spending time there. I've been thinking about ways to create residencies and to physically interact [with other artists] either somewhere on the continent or somewhere here, where worlds collide. Otherwise, everyone is in their own minds concerned with what it's like to be here or there.

NIAMA

Can we talk about our work marriage? We are work wives. I just co-curated a show called *Refraction: New Photography of AFRICA and Its Diaspora*. It was very intentionally titled, and this was again harkening to this concept of taking [experience] out of imagination and into the real world. Much of what I do is underscoring this idea of diaspora. For a lot of people, diaspora is a very abstract idea, and at this point, we don't have time for that anymore. We need to create opportunities where we can see the connections that exist between our heritages, between ourselves, and all the multiplicities of Black identity in the world. *Refraction* was a serendipitous way

248

of seeing that happening. We had twelve photographers, from all over the world, Delphine here in New York, Keyezua from Angola/The Netherlands, Eyerusalem Jiregna and Girma Berta from Ethiopia, other artists with roots in Haiti, Guyana, and Barbados, and so on. It was this really wide swath of looking at the world through Black people's experiences. I actually want to do more iterations of that show. There are some other ideas that I have about how we can extend it.

DELPHINE

I want to see more opportunities for contemporary art with everyday people. To just sit down and have these conversations because it's not happening enough. I was at a conference, and someone who was based here in America said something about starting dialogues and [how] one thing we have to do is start policing what's going on on the continent. They brought up scarification, and how it was socially unacceptable. And I made it clear: "You can't be American and think that you can dictate how people are living their lives elsewhere!"

So that's what I was saying; that being here is a handicap because you're not really connected to the reasoning for other people's adornment, you can't apply your lens and your value systems to the thing! This is not how this works! This is, of course, why the world is burning around us.

EMANUEL

That's the legacy of colonialism, the civilizing reflex.

DELPHINE

Let's have a real conversation about how we can really build.

EMANUEL

You've stated that your aim is to use the visual, written, and performative arts to tell stories that we know in ways that we have not previously thought to tell them, and in the process to lift us all to a higher state of ontological and spiritual wholeness. How does one develop this as a practice? How does this serve as a strategic form of resistance to neocolonial reframings of African spirituality?

NIAMA

So much of what exists in the art world is a narrow way of looking at the wider world. You said something a few moments ago — about how, the more ways we have of looking at the world, the more cosmopolitan, the more nuanced, and richer a society becomes. Ultimately, that's at the heart of what I'm looking at. We also have this way

249

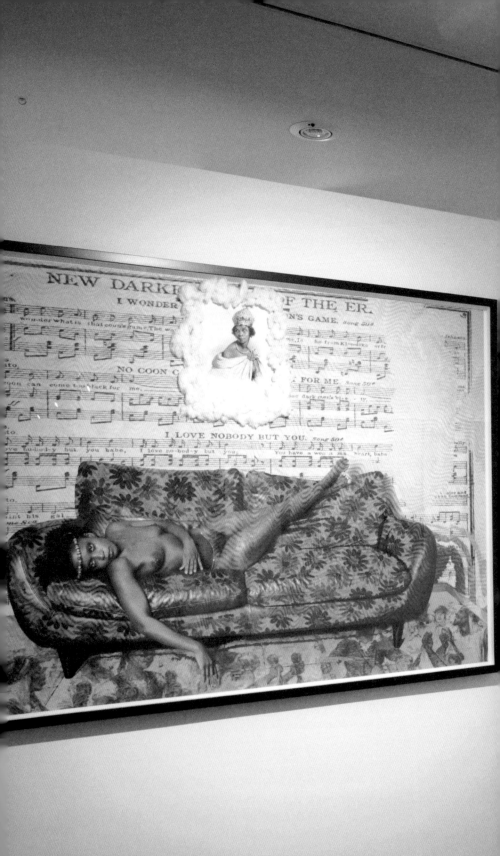

Adama Delphine Fawundu (left), *The Sacred Star of Isis*, 2018, from the exhibition *Refraction: Photography of Africa and Its Diaspora*, curated by Cassandra Johnson and Niama Safia Sandy, photograph: Freddie L. Rankin II, courtesy of Steven Kasher Gallery

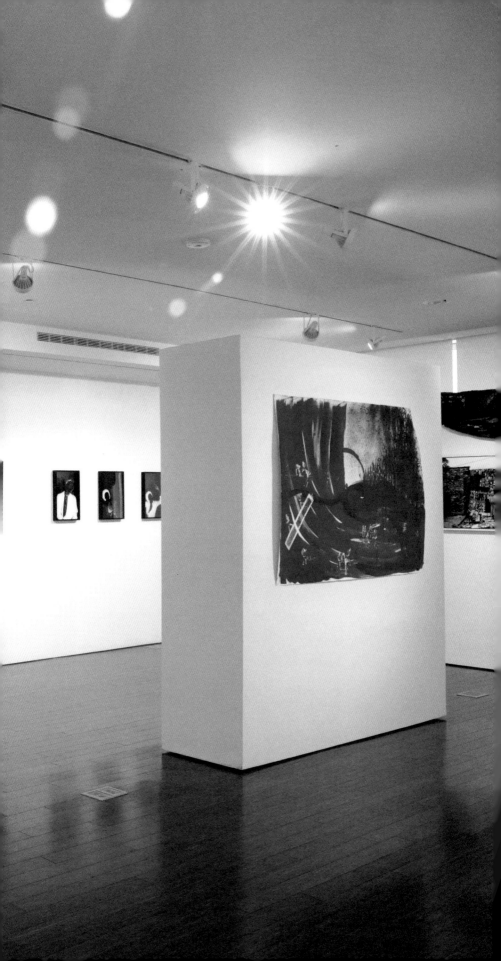

INTERVIEW WITH
NIAMA SAFIA SANDY &
ADAMA DELPHINE FAWUNDU

NEW YORK PUBLIC LIBRARY
(MAIN BRANCH), NEW YORK CITY
JULY 27, 2018

of thinking: "Oh certain things are only for entertainment," but that's not really how this works because for most people, there is some therapeutic, cathartic aspect to whatever artmaking they're doing. There's another project, *The Circle of Trust*, that I'm hoping to revisit. I was able to do an iteration of it at Building 92 at the Brooklyn Navy Yard. The premise for it is to be an interactive and contemplative space where different performance and healing modalities transform people. We had three performers, one woman doing sound healing with Tibetan singing bowls, another woman just using her voice, and a dancer responding to the sounds that they were making. I also had crystals that were meant to help in shifting the energy in the room — this probably sounds so unnecessarily new age-y, but these ideas of how our bodies operate and how the world works are really suffering from not connecting to ancient histories — these ancient modalities of healing and just living and existing in the world. I want to reconnect to those ways of knowing through this project. It was about lifting because the current moment is really heavy. If you're weighed down by the hatefulness that exists in the world, you can't do what you need to do.

EMANUEL

It's not even necessarily an artistic practice, it's a spiritual practice ...

NIAMA

Yes, it is! Because it's actually not just one [thing]. My intention is that every time we do another iteration of it, we have another rotation of people. It could be someone who is a practicing *sangoma*, another person may be doing some form of performance. It's about how you're creating healing for yourself. We're not thinking about the cumulative impact of a life, if that makes sense? Because this is not even inclusive of whatever personal things exist. The climate in which we are forced to exist is damaging.

EMANUEL

Can you both talk about the predominance of tradition, ritual, and spiritual consciousness in your methodologies? Delphine, maybe you could talk about your work, *the cleanse*?

DELPHINE

Consider myself to be a spiritual being that connects to art. We'll peel these layers of influences and expose what's at the core of it. For me it's this beautiful existence. When I was making *the cleanse*, I was thinking about ritual in several ways. Even the cycle of life or the cycle of my hair: what happens when it's wet, what happens

252

when it dries, the impact that water has on life. I thought about that and the elements that exist in culture that lead to ritualistic practice. I found some ritualism in trap music — they don't know it! I'm going to take the things that writers say and make it into a ritual. That's really what I was thinking about: how I can sample life and then make something new out of it that follows the same pattern of performing a really deep spiritual practice. The new work that I'm creating is using different elements from different places and creating a new language, so to speak. I'm obsessed with the idea of language because you don't really know a culture unless you know the language of that culture. What happens when you sample different things and then create this new language that we can identify with? For example, with *the cleanse*, visual aspects are identifiable, so we have a peek in, but now when we listen closely, we hear new things. It's about exploring and hearing new ways of existing and being.

NIAMA

I'll tell you a story. The first exhibition I ever did was at Corridor Gallery in Brooklyn, one of the former Rush Arts Galleries here in New York. I had this idea of how I was going to lay out the show and arrange the exhibition design. There's a poet whose work I had asked to have a video recording of. He didn't do it, so I ended up having to use an audio recording that already existed. I had this idea of having [the piece] in an alcove in the main gallery. That didn't work, so I had to start over. The poem is called "How the World was Made." It's a heroic crown of sonnets, which is a form of sonnet wherein the last [line] of the preceding poem is the first line of the next. It was something like nineteen minutes long, with twenty-five sonnets. In it, the poet takes on the character of Anansi, the mythical spider trickster character from famous Akan fables told all across the diaspora. In the poem, Anansi wakes up as a human being with arms and legs and a mouth, and a will that he has no idea how to use. The gallery was called Corridor Gallery because originally it was just a fifteen-foot corridor. I decided to activate that space with a sound installation. I knew I couldn't just put a sound recording in the corridor by itself, so I began researching similar trickster figures like Anansi in other African cosmologies. I then decided I wanted to add scent [and at the same time] I'm researching Legba, a possible corresponding figure who happens to be one of the patrons of the arts in Yoruba cosmology. This was my very first exhibition and what happened next was weird. I find these *vèvè* drawings that are related to Legba, which are extremely similar to a tattoo on the inside of my wrist. Legba is sometimes known as the master of the crossroads, the gateway to all of the other Yoruba deities. This portion of the exhibition is literally in the corridor. It was meant as a poetic joke, but maybe more

253

INTERVIEW WITH
NIAMA SAFIA SANDY &
ADAMA DELPHINE FAWUNDU

NEW YORK PUBLIC LIBRARY
(MAIN BRANCH), NEW YORK CITY
JULY 27, 2018

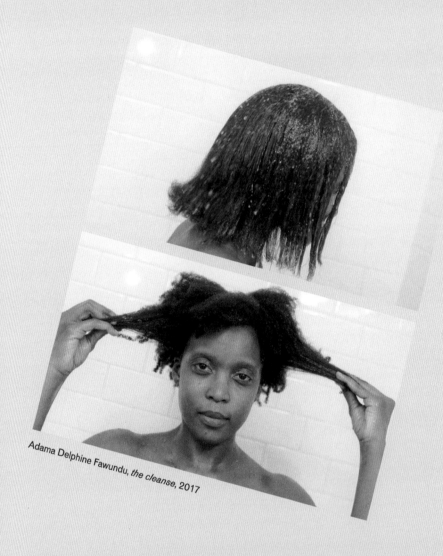

Adama Delphine Fawundu, the cleanse, 2017

than that. I believe you're always exactly where you're supposed to be, even if I have no idea of what's actually happening in the moment. I felt very led as I think back on that moment. I also did another iteration of *Black Magic*. (I forgot to mention, that show was called *Black Magic: AfroPasts/AfroFutures*). We … Delphine had posted these mixed media images of a series of screenprints that she did. She's always traveling, and she tries to visit archives to collect documents, covers of newspapers, sheet music, whatever. Right?

DELPHINE
Right.

HOW DOES
ART
SUSTAIN
FRIENDSHIP?

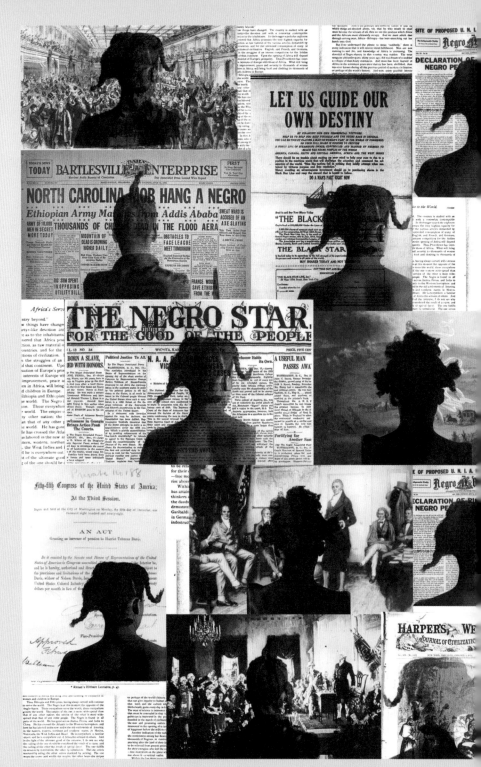

Adama Delphine Fawundu, *In the Face of History*, 2017–18, from the exhibition *In Plain Sight/Site*, curated by Niama Safia Sandy, photograph: Jessica Smolinski

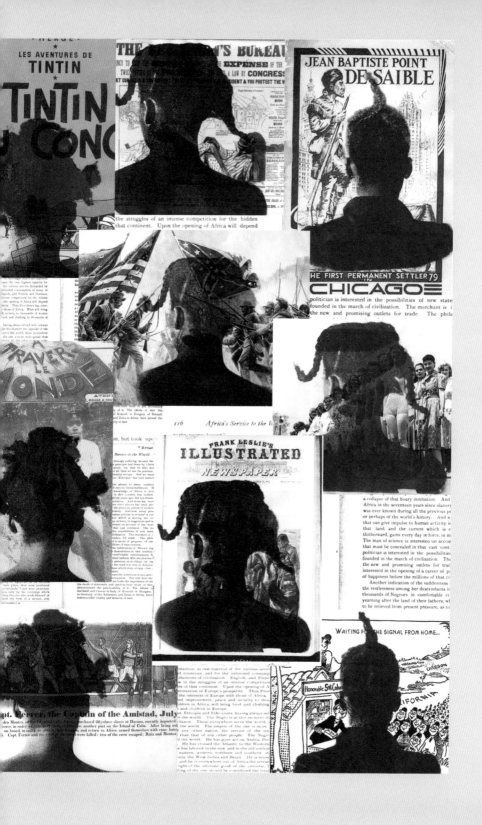

LET US GUIDE OUR OWN DESTINY

BY FINANCING OUR OWN COMMERCIAL VENTURES,
HELP US TO HELP YOU HELP YOURSELF AND THE NEGRO RACE IN GENERAL
YOU CAN DO THIS BY PLAYING A MAN OR WOMAN'S PART IN THE WORLD OF COMMERCE;
DO YOUR FULL SHARE IN HELPING TO PROVIDE
A DIRECT LINE OF STEAMSHIPS OWNED, CONTROLLED AND MANNED BY NEGROES TO
REACH THE NEGRO PEOPLES OF THE WORLD.
AMERICA, CANADA, SOUTH AND CENTRAL AMERICA, AFRICA AND THE WEST INDIES.

There should be no trouble about making up your mind to help your race to rise to a position in the maritime world that will challenge the attention and command the admiration of the world. "Men like nations fail in nothing they boldly attempt when sustained by virtuous purpose and firm resolution."

Money awaiting an advantageous investment should go to purchasing shares in the Black Star Line and reap the reward that is bound to follow.

DO A MAN'S PART RIGHT NOW

Send In and Buy Your Shares Today

"THE BLACK STAR LINE," Inc.

Capitalized at $10,000,000 Under the Laws of

2,000,000 shares of common stock now on s... only
office of the corporation, 56 West 135th Street, ...

The Black Star Line, Inc., is the result of ...
famed Negro orator, who in July, 1914, foun...
ciation and African Communities League, of ... is now Presi...

The Association now has a membership of ... three million pe... the United
States, Canada, South and Central America, ... West Indies and Afr...

THE BLACK STAR ... Inc.

is backed today in its operations by the full strength of its organization of millions of other
Negro men and women in all parts of the world.

BUY SHARES TODAY AND NOT TOMORROW

- -

CUT THIS OUT AND MAIL IT
SUBSCRIPTION BLA...

"THE BLACK STAR LINE, Inc."
 56 West 135th Street, New York City

Date ...

Gentlemen:
 I hereby subscribe for ...
S...

NIAMA

So, she started doing this thing where she was screenprinting the back of her head with afro or braided styles into those images, and she was calling it *In the Face of History*. I read it as her inserting herself into those moments of history and bearing witness. I asked her: "What are you doing with those?" And she was like: "I don't know." And I told her: "Give me one hundred of those." I had a vision of an eight-foot wall of them. She said yes. And a few months later, I installed every piece by hand myself. I separated them by their orientation and color; I didn't organize them in relation to any historical connection. I was working away at this one by one, reaching intuitively for each piece. The date was August 12, 2017. I had been at it for a while and the director of the gallery said: "Did you hear what's happening in Charlottesville?" I hadn't, and he told me. Here, I was looking at a wall of proof because these documents that Delphine had collected are literally from the antebellum period to now. I want to say you even had *The Adventures of Tintin*, which was an extremely racist serial cartoon. It was so weird. It was like I was on autopilot when I was placing the work. We always felt like we were on autopilot. What does that mean for me? It means that your hands are not your own. It means that you can be guided. Later, when I stepped back and looked — there were prints next to each other that told a story: for instance, there was a document that referenced Jean Baptiste Point du Sable, the Black man said to have been the founder of Chicago. And then next to it was a newspaper cover featuring a story about the murder of Emmett Till. Although he was killed in Mississippi, Emmett Till was born and raised in Chicago. I did not do that on purpose. There was another similar positioning: a *New York Daily News* article about Yusef Hawkins, a young Black boy who was killed by racists in New York City in the late 1980s, and another story about Emmett Till next to it. The parallels through time were jarring. Again, I installed this the same day the news broke. It was surreal.

EMANUEL

Do you feel like you have to keep redefining the African diaspora?

NIAMA

Having to define something — naming — is problematic. There is always going to be something missing in us trying to respond to this silent body in this moment of reckoning. It's important to continue to hold onto individual experiences because everyone has had some kind of engagement with modernity, in a way that's not necessarily a positive experience. So, how do we maintain that collective while also maintaining individual vantage points?

INTERVIEW WITH
NIAMA SAFIA SANDY &
ADAMA DELPHINE FAWUNDU

NEW YORK PUBLIC LIBRARY
(MAIN BRANCH), NEW YORK CITY
JULY 27, 2018

DELPHINE

I agree, because there's always a danger in groupings. Like: "This is who we are."
It's so unfair because your life can't be about reacting all the time. When do you
get a chance to live and be who you are without reacting? I have sons and when I'm
raising them, I don't want to raise them to embody the identity of Black men who are
being shot down on the street. At the same time, you also have to protect yourself.
It's so unfair! You're starting below the line! There's joy in also accepting that what is
happening in a moment is critical to our engagement with these things. Knowing that
the horrific things that happened does not have to define who you are.

NIAMA

And we're still here!

DELPHINE

Exactly.

NIAMA

So, to me that has to be for a reason. We just have to keep doing what we're doing
and living in our own way.

DELPHINE

Living in our highest selves.

INTERVIEW WITH

WITH

VALERIE AMANI

262

EMANUEL ADMASSU

You mentioned that most of your family members are economists, so was there a particular moment when you said: "OK I need to shift into art?" Or was it always present?

VALERIE AMANI

It was definitely always present. I think from a young age, I used to love cutting up my clothes and writing on my shoes with white-out pens. I used to drive my mother crazy, and eventually I moved away from that to drawing. I've always kept a diary since I was in, maybe grade three, so I just started drawing in my diary and then turned to design; so fashion was my first introduction to art. By the time I was fifteen, I entered a competition and made a dress from newspapers and some useless things and I promised myself that if I won the competition, I would become a fashion designer. I won the competition so then I thought: "Ah! Now I must be a fashion designer!"

My dad is a lawyer. He also went to Columbia, and he very much wanted me to become a lawyer. Law is super boring to me [but] it seemed like something I could find interesting because it has a little bit of the human aspect and philosophy. I did that for three years and actually I was going to continue full-on with economics, but then I had this moment in my life, in my last year in economics, when I asked myself: "Why am I doing a Master's degree in economics? I hate this!" So, I bought a sewing machine and I started just making a mess because I didn't know how to use it. I didn't tell my parents, but I made a small portfolio and applied to fashion

263

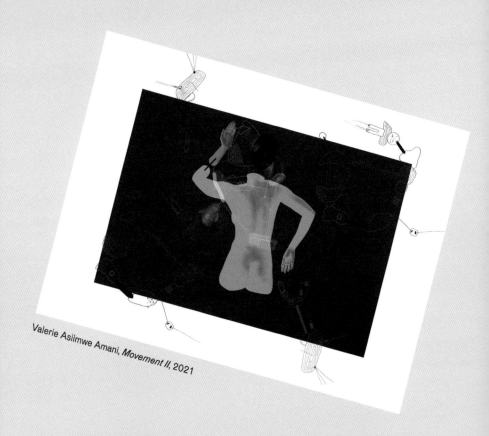

Valerie Asiimwe Amani, *Movement II*, 2021

school for a Bachelor of Arts in Fashion Design. I graduated from my degree pro-
gram and then I started doing fashion. I'm lucky they didn't kick me out.

 Then I went to fashion school — fashion was my gateway drug — but it was never
enough for me because I was always hungry to do more, to be more creative. While
there, I was part of shoots and I did a makeup course. Throughout this time, I loved
playing with graphics. I've had a Photoshop license since I was fifteen, and my
brother was always doing animations with little stick figures and I wanted to compete
with him. By the time I was in fashion school, I had started making posters for par-
ties and then I started combining that with photography and fashion design, and that
merged into this fashion/photography/graphic design thing that I now do. Honestly,
I never considered it art; the fashion industry always seemed separate from art
because of what it's become now with fast fashion and the fashion shows. It's really
ridiculous. I never really felt welcomed or like I belonged in that world. I found it very
pretentious. Coming back home, I had this year where I didn't know what I was doing.
I moved away from Cape Town; I felt like I was not really growing there. [However]
I established my fashion brand there. I graduated and stayed there. I worked for

Woolworths and did visual merchandising. I did all the styling for all the national windows, but I just felt comfortable: I can style mannequins choose wigs, and whatever, but I needed something else. I came home for my dad's seventieth birthday and I stayed [in Dar]. I had no plan whatsoever, so I kind of built up Kahvarah [the fashion label] again, but here, the fashion industry is very conservative. It's very different. I went further into graphics just so that I could survive.

ANITA BATEMAN
Between your content creation, working at Nafasi, doing photography, and establishing a collection for a certain season — can you take us through a day in your life, and how you compartmentalize all your jobs?

VALERIE
I usually spend Friday half days at Nafasi, so my Friday afternoons are when I do all my fabric shopping. Then on Saturdays, I take the fabric to my seamstress with the designs to make because I also have a store in Masaki. It's a pop-up shared with other artists, Jamilla Vera Swai, Lily Massa, and Joy Kemibaro Jewelry. It's a pop-up because we did it for a year and then we're going to another location, but we don't know where yet. Also, with the content creation, I try to finish Nafasi work as fast as possible because it's a lot of emails, planning events, and then meeting up with artists, and if I can do all of that quickly then I can have time to do my graphics and other things. I really need a lot of time for Kahvarah when there's a fashion show coming up. I do Swahili Fashion Week, and I usually need two or three weeks to prepare the concept. Depending on what's going on around me, I come up with a concept two to three months before. The last [show] I did was a response to the creative industries in Tanzania. Then I figure out if I want to collaborate with people: if so, I approach that person. I collaborated with Sabrina Yegella on the previous one. So, week one, I draw, get the fabric; week two, sew; week three, fittings and final finishes; then that's it. I actually work very fast on the concept collections because I have so much to do. I've literally learned how to sew a concept collection in a week and then I'm done.

ANITA
In your line is there a difference between the prêt-à-porter and haute couture?

VALERIE
Runway, I always do by myself because I like the freedom. Sometimes I change my mind, sometimes I want it to have more drama. But if you give it to someone else

then you're not able to change those little things as you go along, especially if it's something a bit complicated. Then as you're making [a piece] you realize: "Wow this does not make sense, how is someone's head going to fit through this?" So I have to make other adjustments. I find it easier to make haute couture myself, and then your everyday sundresses, skirts: those things are pretty difficult to mess up if a seamstress has been doing it for years, so I can take those to someone else. If I could just do runway, I would, because that's where I get my joy. I do my ready-to-wear just for sales, so I can survive. My days are usually pretty random. Usually a week before, I'll plan things. Never more than a week before, just because there are a lot of things that come up. Many things are very random, like this book launch [for *Black Amara*], I was told [it would be] sometime in February, but then yesterday I was told it's next Saturday!

The book…so my best friend [Charmaine Mojapelo] is based in Pretoria. She's a psychologist, and she left [South *AFRICA*] before me after we were both in Cape Town. We were going through a very difficult time emotionally, and in order to keep contact, and also as a kind of therapy, we created a Google Doc and said: "Write whatever you want and put it in there." Then a year later we realized: "Oh snap, this is actually starting to make sense!" We stopped only referencing our gut emotions and pivoted to including stories and experiences from other people. We focused on African women's experiences and we started collecting poetry, short stories, images, pictures that we made ourselves, and we compiled it into this book called *Black Amara*. Amara is "paradise" in Amharic. So, it's *Black Paradise*. It's three years in the making and then last year we got a South African publisher and we're having the book launch next Saturday. It's kind of crazy. I designed the book cover. It's just a book with short stories and it comes with some pictures.

ANITA
Is it going to be sold internationally?

VALERIE
We're starting with South *AFRICA* and Tanzania, and then we'll see where it will go from there. We basically want to start a conversation by collecting video clips from different African women about their experiences around sex, love, loss, pain. I love Kahlil Gibran's *The Prophet*. It's a mysterious work of art. It's so profound. So that's what I had in mind when I was putting the different chapters together. Charmaine, my co-writer, had never read it.

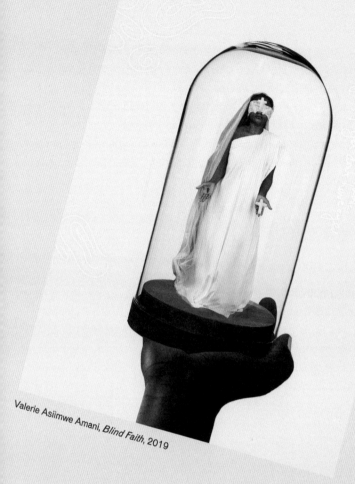

Valerie Asiimwe Amani, *Blind Faith*, 2019

EMANUEL

Going back to your graphic work but also the fashion design, do you feel like that work is in conversation with other women creatives on the continent or in the diaspora? Is there an attempt to connect with people outside of Tanzania?

VALERIE

Definitely. The first piece I did was called *Mother Andromeda* and it was centered around the role of Christianity in colonialism in East *AFRICA* particularly. It really opened up conversations not only with people outside Tanzania, but I had my own friends approaching me wanting to talk who would have never talked about religion in another context. Especially as young Black African women, most of our mothers are really devout Christians or really devout Muslims and we grew up in households where we're told to believe and I thought it was really important for us to think about

267

where these religions come from. An article got published on the *AFROPUNK* platform as well, which garnered some random responses from people I didn't know. I try to collaborate as much as possible: the residency I did in Maputo was really a creative one. That picture, the girl in it, is a Nigerian poet and coding artist (I didn't know that that even existed) so I collaborated with her and we had a really great conversation about femininity. I usually work with African women photographers and videographers for my fashion shoots. I think it's so important to create opportunities and tell each other's stories.

ANITA
How do you define style?

VALERIE
I would describe it as something that is very personal to an individual; something that one can transform to become one's own. Style is not universal. My style can change from day to day. Style evolves, it's truly unique, and it transcends time. That's what style is! As long as someone is being true to themselves and expressing themselves through their hair, their clothes, their jewelry — it just depends how that person wants to express themselves.

ANITA
Is there such a thing as "bad fashion"?

VALERIE
Bad fashion is a lack of being able to combine aesthetically pleasing elements in order to create a concise image or presentation. People can look crazy and combine plaid and neons and look great because they're in balance. Bad fashion can also be a lack of confidence. How someone wears something really changes how that look carries. Sometimes people wear things because they're being sheep and they don't really feel themselves in it, and it just translates to bad fashion because it's not really looking how it's supposed to. Lack of originality. The fashion industry, unfortunately, now has a lot of copy-pasting — well, now I think it's changing, especially with South African designers getting more of an international scene — but this thing of having African fabric under one umbrella needs to stop. It needs to stop! There are so many different cultures and inspirations and fabrics and history that it's unfair to put it all under "African fabric" or "African clothing," and unfortunately it results in our runway shows being very monotonous and boring.

268

EMANUEL

I work in design in another field, but a lot of the conversations that we have are about sampling and what it means to take fragments of different works that came before, and how we can recombine them into something new. In your work, are there specific samples that are Tanzanian or East African that you are trying to reconfigure or reassemble?

VALERIE

I really love my own history from my father's side. My dad comes from a tribe called Watimba and they used to be warriors. They are very much related to the Maasai, and kind of branched out. And the Watimbas had such beef with the Maasai that my great-great-grandfather actually killed a Maasai and it was a big, big thing. They also have this tradition: a man goes through a coming of age where, when a boy becomes a man, he has to fight with a lion and bring back its head. In much of their dressing, and their symbols, they have a drum, that's carried from the chief's house. I really love a lot of their symbols, with these earthy tones. A few of my first collections have these very rich soil colors and mustards. I also like the Makonde people: their shapes and their sculptures. They have piercings as well and I'm also inspired by — this is not even just in Tanzania — many African ethnic groups that have the scarifications, the markings. Those kinds of patterns are symmetrical, so I take that and try to find geometric patterns. I really love batiks: there's a lady here who I work with that makes handmade batiks, and they're beautiful. The whole process of dying it and re-dying…. I like that labor of love. There's something very chilled about someone taking that much time to create fabric. So I take all those elements. And of course, I've been inspired by the Maasai — not so much their Scottish plaid stuff, more the beadwork, how they do their hair. I like the shapes and forms and creating shapes in the outfits, very asymmetrical, layered, that's how I get my inspiration, not so much the fabrics because I'm very suspicious of some of the artists.

ANITA

Can you talk a little bit about *Fufuka*? The *Fufuka* series?

VALERIE

Whoa! You're taking me way back. In 2015 or 2016, my godmother, who's my mom's cousin, got married. My uncle's Nigerian. When they moved back there, she passed away. I went there for her funeral. It was the first time I was in Nigeria, and it was a culture shock for me because how we do funerals here is very, very different. There it was more of a celebration. I was offended — that was my first

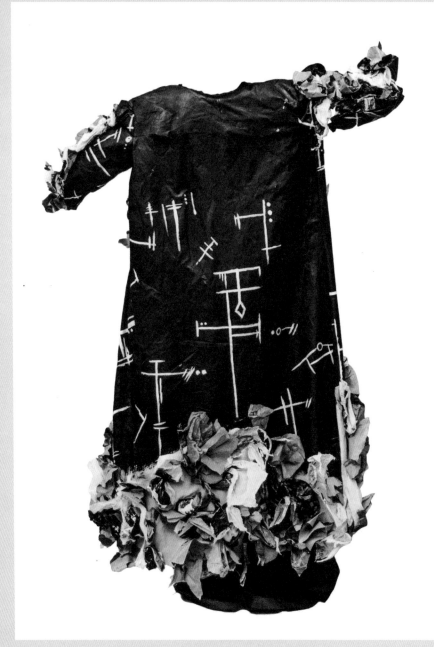

Valerie Asiimwe Amani, *Death Coat*, 2018, back view

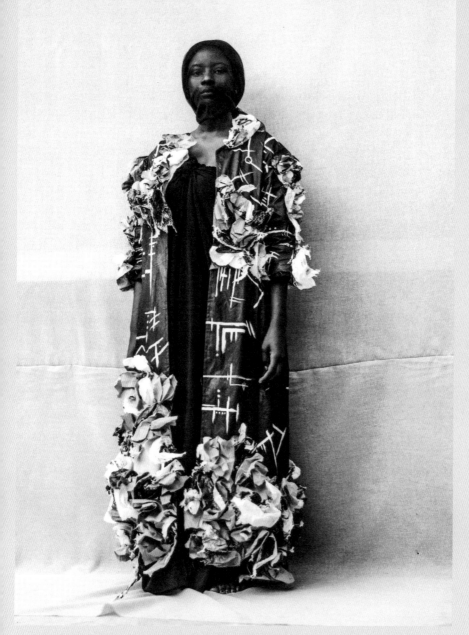

Valerie Asiimwe Amani, *Death Coat*, 2018, test shot © Andrew Munuwa

reaction — because they were dancing with a coffin and it offended me, my mom, my aunts. We were all so not used to this. After coming back and thinking: "Oh wait, so this is how they bury their people," I started doing a bit more research into pallbearing traditions in Ghana and Nigeria, and how they look at death and realized that as I was entering a new culture, I should have maybe done my due diligence and learned about them.

Anyway, with that whole conversation about death, I wanted to know more about different African cultures. Being in South AFRICA, I heard about the Zulus and how, when someone dies in the house, you have to cover all the mirrors, all the photographs of them during the time of mourning. In Nigeria — I forget the name of the tribe — but if someone dies, you can't take them out of the house through the door, you have to make a hole in the wall and then seal the wall. So then to find a link: most African cultures believe in the afterlife. Most traditional cultures believe in the afterlife and believe that the body is just a vessel that will live on. I still believe that there is an afterlife.

I wanted to explore creating a work of art that honored a few of these different cultures around AFRICA or cultures that I've come into contact with. So, I created this death coat which was inspired by my mom's tribe, the WaChaga. Actually, not just the WaChaga, several tribes in Tanzania used to do this: at a funeral, they had Watanis. Your Watani is another tribe, like your twin tribe, that, when someone in your family dies, let's say my husband dies, the Watanis will come dressed as my husband to the funeral, and they'll be making jokes, acting like him, as comic relief, but also to clean and cook, just to elevate the mood of the funeral. The death coat was a representation of not only the person who dies, but anyone who puts on the death coat becomes the Watani, the person who elevates the funeral. I took photographs of the death coat and made a collage with a video, and in the middle was a photo that comes to life. Usually in the church you have a photo [of the person who has died], but here the photo comes to life to tell you that there is still a spirit present. I then made these three coffins as an installation piece where I hung different notes in different trees telling you which country of origin and what they do within the continent. I had pencils and pieces of paper for people to write down their goodbyes, notes of memories ... I wanted people to stop and think about it.

EMANUEL
A lot of your work examines how we process loss. Whether it's emotional or dealing with a relationship, it seems to me like that's the inception of the book, or the loss of a loved one. These concepts would easily translate into artworks, but I don't know how they would translate into design proposals. Or is that the line where you divide

up your practice — into conceptual, contemporary art, which is processing these more difficult and relatively vague themes, while the design work remains more optimistic?

VALERIE

Yes, loss has been a theme, but I think for the book it started off delving into loss, but it transformed into hope by the end. With my collections, I don't think the themes are any lighter. For example, I usually create a narrative. If I do a lookbook, at the beginning there's a full story about what I'm doing and then I set the scene. I then create the clothes with this narrative in mind. I never draw just thinking: "Oh this is a nice skirt." I have to have the narrative first, and I always try to have a point to the collection. Actually, I have had a collection about loss, and it was all pink! Kind of funny. The last one was very political, about creative freedom. The one before that was about regaining African royalty and before that was about loving our environment. So few different themes. It usually depends on what's pissed me off most that year. For some reason I really hate — and no offense to designers who do this — when designers say: "Yeah, this summer I'm inspired by coral" or "This summer I'm inspired by the ocean." I mean that's great, but for me, that's not why I would make a collection.

EMANUEL

Can you speak a little more about the work dealing with censorship? How you're able to produce that work within this political context and how you're willing to produce work in a situation that is highly controlled.

VALERIE

I was very frustrated. Especially working at a place like Nafasi. At least once a week, I encounter barriers that creative people face including — and I'm not afraid to say it — our national arts council. If there's no government support, there's no art fund that you can apply to as a Tanzanian artist. If you want to travel as an artist, for work, you have to pay for yourself. All of these things are driving me crazy: these obstacles to producing content. I used to do this really ridiculous YouTube show with my cousin and friend, but we spoke about things that the government didn't [approve of], like sex, for example. She freaked out and she shut it down; she has her own reasons. So we just shut down the channel for now, but then the government came out with this thing that you have to pay nine hundred dollars a year even if you aren't making any money for YouTube and you can't produce any sort of content off YouTube if you're a Tanzanian without a license! I don't think it's fair. At

273

Swahili Fashion Week, I didn't tell them what my concept was at all as I wanted it to be a surprise and I thought that I could use the platform as I wished. Unfortunately they finally watched the video because five minutes before my show they said: "Oh we can't play this video, the wire for the sound isn't working."

ANITA
It was a video that you and your cousin had made to accompany the show?

VALERIE
I made the video that would accompany the show. Everything was fine two days before, one day before, but then on the day of, it was like: "Oh sorry, the wire's missing." So, I walked onto the stage with the most rage [I have ever felt in] my life! Because you have these creative bodies, even Swahili Fashion Week, which claim to support creatives, but the quality of the shows that they put on is not up to standard. We don't take our creative industry seriously: even the bodies that are supposed to take creatives seriously, don't.

Our Minister of Culture, Arts and Sports makes ridiculous promises every day, and the government doesn't see any sort of relevance or importance in the Arts. The only people who can show how important art is are artists themselves. The people who I meet at Nafasi are incredible, they really inspire me. I think Tanzanians need to really start speaking up for themselves. I found a group of artists who are also tired, and they're going to collaborate with me on the photoshoot for the second video, which will be released soon. It's very sad.

EMANUEL
Because there's a lot of potential?

VALERIE
Because there's so much potential. But you can't, as an artist who has nothing to begin with, pay just to create.

ANITA
Does thinking about the political environment inform your thinking about your literal environment? Do you feel that one feeds into another?

VALERIE
I definitely believe that culturally — thinking of how my grandmother lived — Africans are natural environmentalists. Unfortunately, because of these things — political

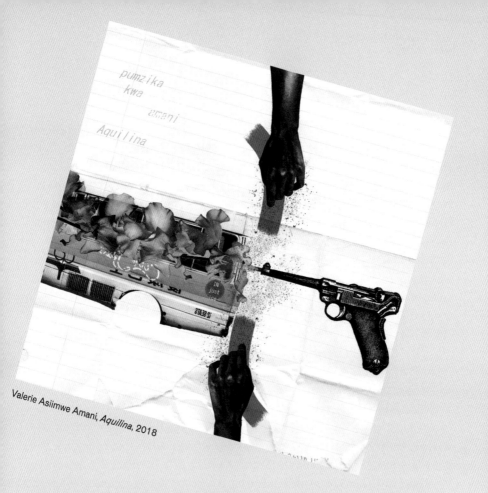

Valerie Asiimwe Amani, *Aquilina*, 2018

frustration, economic frustration — people don't have time to think about the environment. I do have to be aware that I'm coming from a place of privilege, as someone who's lived outside of Tanzania, who has lived in different African countries. I have a different view and understanding of society compared to someone who has lived in Tanzania for their whole life and I just try to balance that. I know that sometimes my ideas go over some people's heads, even the people whom I'm trying to reach. I guess there's some sort of bridge, and maybe I need to work harder on closing the gap.

ANITA
Do you feel some frustration with Western fashion and its fascination with African models versus investing in African fashion, or having African designers on major platforms? Is there something to be said about how fashion deals with perception and which roles you can inhabit?

VALERIE
I probably had more to say about this seven years ago when I was just starting in fashion: that was one of my biggest concerns then. All the big fashion houses that you see: they don't promote African fashion houses. The West will always have its

agenda. I saw one famous fashion photographer — I think Trevor Stuurman — talking about how there should be African *Vogue* and I think Naomi Campbell was also backing him, and I [thought] this is ridiculous. Why do we need validation from the West? Why can't there just be an African fashion magazine with its own standards? The West is exploiting African models, that's an issue, but we need to start respecting ourselves, respecting our own platforms, and telling people to come here. A platform like Swahili Fashion Week has the responsibility to create an environment and a platform that's professional enough — that's established enough — that people come to us. We're undermining ourselves by having substandard events, but maybe we don't even need to have the Western standards, maybe we need to set our own standards completely differently.

ANITA

You have these very high-profile people who are concerned with the state of fashion, and it's interesting because with a certain amount of success comes a certain level of scrutiny. There's an expectation or a belief that these big names in fashion are going to solve the fashion world's problems in terms of access, and you know that's not true — that's how people get typecast. It seems to be a catch-22, at least in the West, that when you gain a certain amount of success, people expect a certain orthodoxy. You have people making strides, but then there aren't many Black women in fashion to begin with, so it's rather unbalanced.

EMANUEL

You speak critically about the issues here, about fashion on the continent, but fashion is a global industry; we're going to have to deal with the asymmetries of the global market, but also we're going to have to deal with the asymmetry of the representation. How do you position yourself to be simultaneously global but also local with these issues? Are you interested in being global?

VALERIE

I'm interested in being global because there's a lack of female African fashion designers who are global and it's important that we have a voice, and it's also important that we have a seat at the table of the international fashion market. But, that said, I am still in this limbo in terms of what exactly that's going to look like for me because I still have to answer these questions of how I want to represent myself. If I'm presenting as an African fashion designer, that means that I'm representing the continent, which is unfortunate, especially if you're going [into these spaces] as a minority in a group of Westerners. You're automatically an ambassador. I need to grow a little more and

276

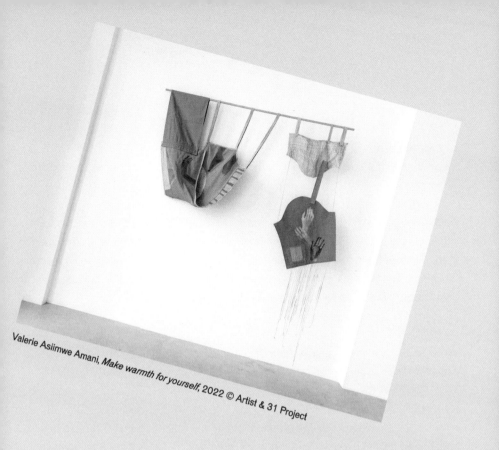

Valerie Asiimwe Amani, *Make warmth for yourself*, 2022 © Artist & 31 Project

figure out where exactly I want to place myself. I wouldn't want to go into the international fashion community feeling unprepared or undeserving of being there; I want to build myself up to a point where I feel like I can do any of this with an understanding of what the continent needs so as not to speak from a place of ignorance. That's why I'm in Tanzania: Cape Town was very inaccurate in terms of what's happening in the global fashion scene. South *AFRICA* has built a very nice fashion industry for itself, but it's also not a very wholesome view of the African fashion scene. Same thing in Nigeria; Nigeria is doing really well, even Accra Fashion Week. There are a few more places on the continent that I want to explore before going to Paris or New York or London. And I think, with that, I'll become global because those places are becoming more global and they're becoming more respected in their own right.

EMANUEL
Are there designers on the continent that you are interested in collaborating with?

VALERIE
I have the biggest crush on the designer Rich Mnisi from South *AFRICA*. His clothes are amazing. Orange Culture is really cool. Probably I'd collaborate with them just because I want to go into men's fashion and it still terrifies me.

EMANUEL

I'm wondering if there are multiple markets that your brand is interested in developing.

VALERIE

Definitely South *AFRICA*. I still have ties in South *AFRICA* that I want to revisit. Definitely Ghana and Nigeria. And when I was in Mozambique, there was a small market there. I've also been to Kampala Fashion Week. They have something going there too. I think Tanzania still has a long way to go in terms of the fashion industry. This year I really want to do Mozambique Fashion Week and Nigeria.

EMANUEL

We're focusing a lot on your fashion design. Do you see your career as maintaining both, the visual arts and the fashion, or is the focus going more toward fashion?

VALERIE

I think both, definitely both. I've always thought in terms of visual art, but the only way I knew how to express it was through fashion. Now I'm finding other ways to express it. In some ways, fashion is my first love. I don't necessarily love the fashion industry, but I definitely will continue creating clothes, and I definitely will continue creating visual art. It's another layer of expression and it gives me more freedom. An outfit itself can say something, but putting that within the context of a visual art piece or the artist statement or the research behind it ... people take more time [with art]. The first time I did a runway show, I was super disappointed because I put in all this time and I printed out the story of the collection, and put the stories on the seats, but people just came to see pretty clothes. With visual art, I like the satisfaction of knowing that people are going to spend time [with it]; there's more intimacy with visual art.

Regarding the next exhibition, the theme is "How Did We Get Here?" which is partly about journeys, but also abou how our current social structure is influenced by our past, i.e. colonialism, traditions, leaders. I want people to think about where we came from as a society, as a people; I want artists to try to have some sense of artwork that maybe lies somewhere between the past and the present.

I also had this thing called Dar Art Club (Dart Club), which is a struggle because it's very difficult to get people into a room to talk about art. We have one that started with the topic "Can Creativity Be Taught?" We screened a clip from a Canadian psychologist and the director of a Canadian art museum. Then I invited two art teachers and a few artists to talk about whether creativity can be taught in schools, and then

WHO
NEEDS
VAL/DAT/ON
FROM
THE WEST?

diverged into the creative industry as a whole. These are some of the ways I've been able to create dialogue through Nafasi.

Through the whole art-talk thing, I realized that maybe the people who go to Nafasi are one crowd and then you have the cool-kid Tanzanian crowd that goes to art events in Masaki. In the last year, I sneakily invited people to my house and forced them to talk about art here, and it was really nice because they were these people who don't usually interact; they come from different worlds, but are all very talented people. I had about twenty guests here and maybe I'll continue doing that. We talked about issues of the environment of creativity, of social structures, of how we can contribute to that, of how we can change that. That's also due to Nafasi. Nafasi really opened my eyes and opened the doorway to meet a lot of great creatives from all different areas of Tanzania.

EMANUEL
Is there anything else that you want to talk about?

VALERIE
I feel like I'm telling you so much!

EMANUEL
I was just wondering if you wanted to end the conversation by speaking about the future of your practice.

ANITA
And Afrofuturism?

EMANUEL
Yes, if you're interested in Afrofuturism.

ANITA
I mean, it's a big thing when you think about the recent popularity of *Black Panther*. It's on another level. It's huge.

VALERIE
It really is. I was so into Afrofuturism before *Black Panther* and then "Wakanda Forever" really killed my vibe, to be honest. No, *Black Panther* was a great, great film, great initiative, but at the same time, it really did promote the stereotype of one

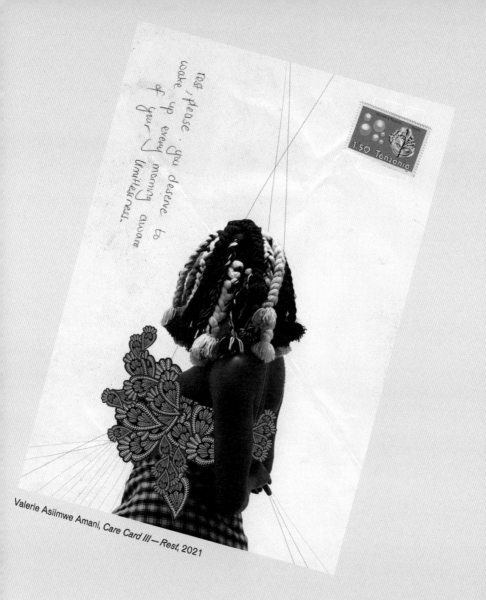

Valerie Asiimwe Amani, Care Card III — Rest, 2021

AFRICA. Unfortunately, that's my only critique of it. And the accents! They should just not do it, that was just not necessary.

EMANUEL

Wakanda is in Ethiopia not in Tanzania, just to clarify [laughter]. If you saw the animation where they landed, it's definitely ...

VALERIE

... Let's say it's somewhere in Kenya. But no, let's not give it to Kenya. Let's give it somewhere else. I would have said I'm an Afrofuturist before, but I don't know right now, I'm molding and merging and evolving into something else. I'm very much interested in learning about the facts and truths of my own history. Before, I was very fast to jump onto trends and to believe things. Recently, I've been learning a lot from my

father and mother about the history of their experiences, and I'm molding that into my own kind of Afrofuturism or Neo-Africanism. I don't know. But sure, I think it's great, it's beautiful. This continent has so many gifts, so many mysteries, so many talents and I'm so blessed to first of all be from this country. Tanzania itself is just incredible, despite all these challenges. There are a lot more opportunities here than in other countries. And, there are a lot of opportunities as a Tanzanian female artist to explore and go to other countries, so I'm really well situated.

KMT

MIKAEL
AWAKE

Not long ago, a literary acquaintance of mine tweeted that he felt like people sucked their teeth "way more often in fiction than they do in real life," highlighting the point by using almost thirty A's in the word *way*. It had a couple dozen reposts and five hundred or so heart-likes when I found it and a string of responses from others who were in agreement. "What does it mean? It's one of those things I've only read about in books," said one. Another said, "I've never known what this means at all."

Chuh.

Here's the tea: I know this writer. He lives in Brooklyn, one of the teeth-sucking capitals of the free world, which is why I was somewhat taken aback by his tweet's suggestion that teeth sucking was something that existed mostly in literature, not in the neighborhoods all around him. Hasn't he ever heard someone sucking their teeth at a train delay announcement or while disciplining a toddler? The tweet was a reminder that one can be sensitive to the presence of the white gaze in literature and simultaneously oblivious to its presence in one's "real life." That craft is affected by the white gaze not just in books, but in line at the bodega.

As many writers of the African diaspora were quick to point out, characters suck their teeth in fiction because people suck their teeth in real life. "I gotta invite you to Mississippi, fam," replied one writer. "This guy doesn't know enough West Indians," someone else quote-tweeted. But it is conceivable that a similar tweet

could come from someone who has been to Mississippi and has known West Indian people. That the tweet and its responses had come from people with a working knowledge of fiction written outside the white gaze made it even more troubling. It seemed to encapsulate the dissonance of our historical moment — a time of ground-breaking work by African diaspora writers emerging at a time when white supremacy is attempting and succeeding to make the world as segregated, xenophobic, and unequal as it has ever been.

Tche.

The mouth is not only a deliverer of words that carry meaning; it is also itself an instrument of wordless emotion and music. What we call "teeth sucking" hits with a power between language and music. It encompasses so many different sounds and damn-near-impossible to describe oral micro-maneuvers of tongue and teeth and cheek and air, with a different contextual meaning attached to each, that it could safely be described as comprising a distinct and discrete language system, but I leave that to the linguists. As a fiction writer, the appeal of using the straightforward "sucking their teeth" phrase is the pleasing tension it poses: it is specifically Black, but ambiguous enough to allow a reader room to interpret the precise sound and sense.

A part of me does worry "teeth sucking" is a bit too ambiguous. The West African *twee* is not the Carribean *chups* is not the East African *mschew*. There are as many ways to spell and describe the teeth-suck as there are meanings it can have. I can hit my bicuspid for a higher pitch that's more meditative, or hit the molars on the left for impatience. The molars on my right produce something more drawn out, like grudging acquiescence, the kind of peeved sound that compelled French teachers to ban Black students from sucking teeth in class.

Le tchip.

"Sth" is how Toni Morrison begins her novel *Jazz* — a coinage meant to pleasantly challenge some readers while probably annoy others. When I first read those words, I knew immediately that they represented the speaker sucking her teeth, but the

white gaze made me doubt my instincts. What a writer like Morrison is asking us to do is to trust our experience of the world more than our training in the white gaze and to write always out of that trust, which is so much easier said than done.

On the first page of the first short story I ever wrote, a character sucks her teeth at the late-night arrival of her boyfriend, a married man. I was proud of that story, mostly I was proud that I had finished it. I was proud that, unlike all the of short stories I had attempted from high school through college, I had seen the idea through to what felt like its most fully realized conclusion. Having recently been fired from the publishing house where I was the lone Black person on a large editorial team, writing the story helped me through a difficult time. I had based it on a story that a friend who cleaned the offices at the publishing house had told me one night, a story from her own trying marriage. I never published it, out of respect for her. Instead, I submitted it for graduate study in creative writing.

Every work of fiction I have ever written is a blurry facsimile of the living thing trapped in my body, my mind, my heart. Even works of nonfiction, like this essay. Being a writer for me means constantly running up against the insufficiency of language to say what I want, to make it do what I want it to do. You get better, of course, the more you do it. But for writers of the African diaspora, there is an additional layer of complication revolving around the aesthetic and commercial sides of fiction. I was plagued by questions about audience that colleagues at my mostly white writing program never considered. "Who do I write for?" said one writer, repeating back my question over the ruckus of a party. "I write for him," and at this she pointed to one of her beloved friends in the program, who was also white. In other words, she wrote for people who had good taste, fuck everybody else.

Because I had worked at a New York City publishing house, my question was, I suspect, understood as vaguely commercial in nature, somewhat disinterested in craft. When I said "audience," perhaps my classmates heard "market," and thought less of me as an artist. Perhaps she thought I wanted a focus group more than a workshop. The truth, which I can see with the clarity of a decade's hindsight, is that I was bristling at the notion of an artist who toils alone in an office, reading his stack of books, disconnected from the lived realities of Black people. I was too scared to suck my teeth, to tell my colleagues that I was not writing for them or for our professors. That I was trying, constantly fighting, to unburden my English of the white gaze, to devise new and evocative ways, in this language that never dreamed of us, of sucking my teeth, knowing that I would never (*tut-tut*) get it right.

Stchoops.

For reasons owing to the history of the civil rights movement in the US and the student movement in Ethiopia, my mother's tongue became my other tongue and not my mother tongue. I have made a life of English, studying it, writing it, teaching it. I do not own it, it does not own me, for ownership has always struck me as an English word for theft. The white gaze and those institutions of culture and training that promulgate it would like me to think that English is what puts a roof over my head, clothes on my back, food on the table. And that I should respect it as such in my work. It took me years to understand that it's the other way around. That by writing it, I pay English's rent, let it squat in my memory, my imagination, and my mouth, rent-free.

If language is a kind of home, I grew up with three different homes in one sub-urban gabled roof: the Amharic my parents lived in with each other; the utilitarian English we all shared, with its awkward flourishes of idiom and emotion; and the giggly mishmash of US pop-cultural-TV-and-music references that my brother and I spoke to each other and our friends in, which surely sounded to my parents like nonsense.

Outside the house, English was power, but not *all* English. They never said it, but we knew it. Knew it by their faces whenever a waiter would tell them to repeat an order for a hamburger they had already stated clearly. Knew it by how our father would cackle at the mangled English of caricatures on sitcoms, as though at a for-mer self. I partook in this laughter, not least because US pop culture relentlessly encouraged it through the punch-lining of English spoken by nonwhite people on *Seinfeld*, *South Park*, and *The Simpsons*, to name only the most successful few. This is how the white gaze shaped the way we looked at ourselves.

English, we understood, was not the honeyed singsong of Black English spoken by customers at my father's gas station in the city. Nor was it the twangy idioms of Southern whiteness. Good English — Peter Jennings English — that was power. But, of course, that was not fully true either; the mouth that spoke it, and what it was saying, or not saying, also determined how much power you could get from good English. And then there was the even deeper question: did we even desire to play that game of power with something so important as our mouths?

Tweee.

A writer's craft begins and ends with a writer's life. It is a verb that molds itself to the challenges, circumstances, resources of an era. Craft begins with attention, attention to the craft of other writers around us for sure, but also to the circumstances of life, which can be random. But fiction is not random, nor is the fiction you choose to read or hate-read. I often say that the most revealing corner of a writer's home is the bookshelf. And to a certain and very real extent, I still believe that to be true. But I realize now that these are not the only questions.

We're in a new era of what I might term abolition writing, abolition of prisons and capitalism and fossil fuel economies, and abolition of whiteness and the white gaze. Writers are seeking freedom from this broken Weltanschauung built and sustained on stolen labor and land, wondering if societal change is even possible before the ticking doomsday clock of climate change leaves us no choice in the matter.

I want to write a novel in Amharic before the world ends. I want to suck my teeth at this word processing software that I am using to draft this essay, which never fails to flag my name with a red underline, if I weren't so used to it. To write honestly and unapologetically in this language born at the same time as capitalism and African slavery is to see a page fill up with red, to watch the names of family members dance on a software developers' beds of grammatical coal, is to be faced with two equally distressing options: conform my prose, assimilate my syntax, dilute the strangeness of proper nouns and untranslatable sounds, approximate and translate their song and sense so that there are no more red squiggles on the page; or add those words and sounds to the database of the software, even if it's only for this specific version, toiling only for my own private sense of belonging, changing nothing for others, freeing no one else from the squiggles.

Then, of course, there's the third option, which is to incorporate and expect those red squiggles, on the page, in line at the coffee shop, in job interviews, at restaurants, and at airports, and suck my teeth at the boring predictability of it all, and manage to incorporate them into my understanding of how it will always feel that my mother tongue is not my mother's tongue, to write in English while also writing against it, under it, and around it, in order to find my way to you.

/NTERV/EW W/TH

REHEMA CHACHAGE

ANITA BATEMAN

Your mother, Demere Kitunga, is a poet, writer, and frequent collaborator in terms of providing textual elements to your work. Did you always know that you wanted to be a cultural practitioner?

REHEMA CHACHAGE

I've been doodling and drawing since I was young; it was partly imitation. My dad used to draw and I think he would have been an artist in a different time and [under different] circumstances. He was imitated a lot by my brother, and I was imitating my brother. When I was growing up, my dad wasn't drawing and painting as much as he was when my brother was growing up. Then, in secondary school, I thought I was going into fashion. Somehow, I decided I wanted to make art.

ANITA

How did you decide between fashion and visual art? Was there something that happened or influenced that choice?

REHEMA

Consciously? I don't think there's anything that actually happened. I just remember deciding this going into my A-levels, but no memory of what prompted it. First of all, I've never been able to study art as a subject because it's not offered as a subject if you go through the national curriculum [in Dar es Salaam]. I've always had to find art clubs or art classes outside of my schooling, so it's something that I've always

291

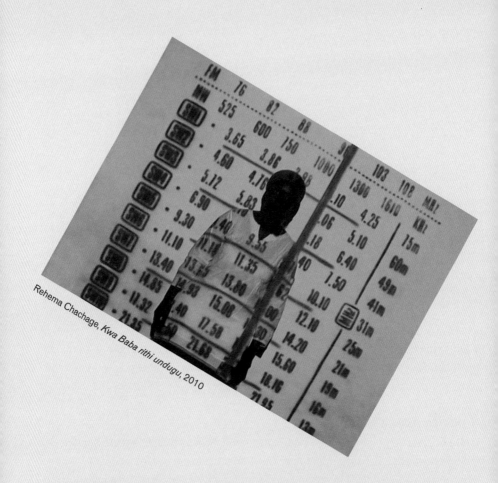

Rehema Chachage, *Kwa Baba rithi undugu*, 2010

chased. After my A-levels, I was resolved to pursue art as a subject for the first time. When I started applying for university, the only programs I was looking at were art programs and so it was somewhat of a scary undertaking, something I very much had to negotiate with myself and with my family and immediate community.

ANITA
In your art classes, were you looking at art from the African continent or European art? Were you satisfied with your education?

REHEMA
No, there were quite a few issues. We did study a little bit of what's happening in *AFRICA*. But the structure of the course itself was still very much rooted in Western thinking/curricula. We, however, also had issues beyond the curriculum. There were politics surrounding issues of subject matter, as well as race dynamics. From

my experience, South *AFRICA* is just like that; especially Cape Town. To give an example, with my fellow students in our year, we had only nine Black students out of seventy. And that was the most they've taken in from the last three years before me and the next three years after me. If counting students of color, we totaled to about twenty, I doubt we made it to even twenty-five. In terms of subject matter; a white peer within the same class could, for instance, paint a surfboard and get a distinction for a surfboard well-painted. But a Black student never had this luxury; everything created had to be tied to one's background. You get boxed into the politics of identity from very early on.

EMANUEL ADMASSU
Why Cape Town? Was that something that you thought about for a while?

REHEMA
No, it was very circumstantial. My father used to be a sociology lecturer and he spent a few years teaching at the University of Cape Town. When he left Tanzania, he went with my older brother; my sister followed after my dad and brother, and I followed my sister. Besides it being circumstantial, Cape Town was also considerably more affordable than going to study in the United States or the United Kingdom. As an art school, Michaelis also had a good standing.

ANITA
Nego-feminism [negotiation/no-ego feminism] is a specific type of African feminism that encompasses motherism and womanism. How do these concepts show up in your work, and do you have your own definition of your ideological position?

REHEMA
That's going to be a very hard question for me to answer. When people ask me, I never say that I'm a feminist. I know that my work has feminist politics, and so do I to a large extent, in my personal life, because I don't exist in a vacuum; I was raised by a feminist mother. There's so much one has to do for and with the movement to be part of it, and I don't feel like I have arrived there yet, but maybe I'm being unfair to myself.

ANITA
Do you have an ideological bent to your work?

293

lisagree wit...

rectness' w...

patriate' in...

ers the indigni...

s) as having bee...

mployment e...

e or nothin...

ho has take...

Rehema Chachage, *Mizizi/Nasaba*, 2010

REHEMA

Yes I do, but I also struggle with this; so much because of the way that the art world is structured, and the many systems that exist within it. Artists are always boxed within their stated ideologies, and I don't like to always list mine because I worry it's going to be the only focus. I would like to think that my work can speak to so much more than the struggles/harshness of being born "African" and "woman" as many texts that have theorized my work essentially decide this is all that my work is about.

EMANUEL

It seems like there might not be a clear ideological position to your work, but there is a clear cultural and geographical position to it. So, there is a big interest in positioning it in Tanzania.

REHEMA

There is a very big interest in positioning it in Tanzania. Being a woman, a Tanzanian, and an artist, I am already positioned within histories or stories that surround those three categories. At the moment, I'm using my practice as a space for archiving women's stories and histories — their resilience, their brilliance, their resistance, love, camaraderie, compassion, etc. I spent a lot of time looking at my matrilineal line, now I am looking beyond it. I am positioned in an act of reflecting on and trying to make sense of the present by looking into the past, but also imagining some kind of future through the same process.

ANITA

Is part of it re-enactment that delves into your interest in thinking through your matrilineal line — or is it a fictionalization of how you wish things could have been for them — i.e. the gap between your ideology as a contemporary African woman and a sort of retroactively ascribed agency to your family?

REHEMA

The work is midway re-enactment and midway imagined or fictional rituals. Because the things I put in my work, some of the rituals, I witnessed them myself as they were handed down to me by my mother and grandmother, based on whatever stage I am or was in, or passage I cross in my life. It was out of my own curiosity that I would ask: "Why are we doing this? Where does it come from? What is the history behind it?" But, like with many histories, there are elements of fiction, of the imagination taking over, especially with the texts that my mother writes. As much as she bases her texts on things that actually happened, most of these histories, she herself did not witness.

They were told to her as a young woman, and in her processing and reimagining of these stories, there's a lot of fiction that comes into her texts. The rituals in the work that I'm making now are almost purely fictional because most of them are based on piecing together an imagined story from a plethora of written histories.

I also don't think and don't believe that the women whose stories I am archiving through my work didn't have any agency. I think they did, and all that I am doing is re-affirming their agency.

EMANUEL
What are your thoughts on cultural preservation?

REHEMA
There's a huge percentage of Tanzanian culture and Tanzanian history that is missing, scattered, or simply disappearing. I think of something as simple as the layout of the city center of Dar es Salaam from maybe the late 1980s or the early 1990s; I don't know where to find this if I needed to use this information. I know I can find old colonial maps and documents of what it looked like pre-independence, and maybe a few years post-, but I am not sure where to find or how much was being preserved during the 1990s or the early 2000s. When I started this project, it was a result of the access that I had to my mother and, especially, my grandmother. I also had the option to choose my father's side, but he has passed on and hence not personally here to hand these histories to me. At least surnames and clan names are carried down, and in an act of tracing your father's side, you might perhaps get much farther than an attempt on the mother's side. My grandmother is in her mid-late eighties now, and she has so much history buried in her memory that I would like to gain access to while I still have her.

EMANUEL
Is there an element that's about translation? Translating something that is primarily oral into a visual realm?

REHEMA
Yes, there is. The bigger struggle for me is in doing justice to the translation. It is hard when creating work or writing about things that are so personal, and not only personal to you, but also to the people around you. A lot of care has to be exercised, otherwise you could end up letting many people down due to a bad translation or misrepresentation of the thing you are portraying and its significance. It's harder once the work leaves the studio because there is no controlling how it is received and/or

translated by the public. In written text [about my work], there has often been a lot of misrepresentation or narrow mindedness or missed translations of the work and what it stands for, which is something that has bothered me and my mother very much.

ANITA

The body of work, correct me if I'm pronouncing this horribly, *Mlango wa Navushiku (Navushiku's Lineage)*, started in 2012. That project will consist of twenty-five different ritualistic performances that consider Black female identity. Does most of your work fall under this larger project and can you talk about where you are in this project as of 2019?

REHEMA

My project did start there; from a text I encountered whilst at Gorée Island in Senegal in 2012. The text is in French, but the English translation reads: "When one of these unfortunate [women] was pregnant, wrote Schoelcher, 'a hole was dug in the ground to accommodate her pregnancy while she was receiving twenty-nine lashes regulatory that tore her flesh.'"

The work I created for the *Navushiku Lineage* chapter began as an alternative to the violence that we often encounter in histories and texts such as these (and especially in relation to women). As an alternative; I thought to explore, look at, and find twenty-nine rituals — different ways that women have been there for each other, over the generations. The rituals they used in the past as a means for surviving, molding, resisting, subverting, etc.

What I realized along the way, however, was that every ritual I pursued ended up telling me something about a female figure within my matrilineal line (a matrilineal ancestor). Eventually, and especially now, I am beginning to realize that my work is becoming less and less about the documented rituals and more about the stories and histories that I end up uncovering as a result of researching the ritual. The project gets a life of its own.

At the end of the exhibition of the Navushiku chapter, I made a work, a shrine for Nankondo, a matrilineal ancestor who was snatched away from the line (erasing her from our matrilineal history). Because of my encounter with the story of Nankondo, the project became focused on this ancestor that left and imagining where she went and the fate that awaited her upon her arrival.

At this point, I don't know if I'm still pursuing twenty-nine rituals or whether I will do less or more. The project is at a point of uncertainty. I do know that the work that I'm making is very much looking at Swahili culture and Swahili stories of women in history within Zanzibar.

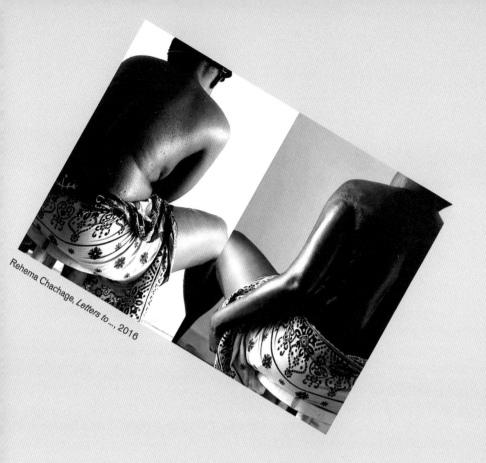

Rehema Chachage, Letters to ..., 2016

ANITA

So, to get this right. Navushiku is not your great grandmother. Nankondo is who you're talking about. So how are they related?

REHEMA

Navushiku is the ancestor who ties the whole chapter together, but her story has not been explored in any of the works. The women explored in the chapter are from both my mother's mother's side (grandmother's side) and my mother's father's side (grandfather's side). Navushiku has blood relations to every woman explored in the chapter.

Nankondo is the ancestor who was taken away from our line because of her abduction. She is the figure that closed my previous chapter, and she also opens and inspires the current chapter.

EMANUEL

What number are you in out of the twenty-nine?

REHEMA

Maybe nine or ten, but I work slowly. Because my practice is not entirely a studio practice — I also work as an arts coordinator, I write, I take time off to study, research,

etc.—I can, as a result, make a work or two in a year, or some years none at all. I sometimes struggle with this in making applications—the fact that my portfolio does not grow fast enough—but I'm OK with it because I know I can't, and won't, keep up with the expectation to constantly produce. This is also good for me because I like to take time with the work, with the research, and have some distance from the work to truly reflect on how far it has come and where it could go. Leave it and revisit it later—this is for me the best working process.

ANITA

Can you speak about the process of making shrines and how you negotiate the public process of your art with the more private function of the shrines being an intergenerational channel for you to speak with your ancestors?

REHEMA

The shrine I made for the *Nankondo* installation was my first attempt to create one. It was not a literal shrine, but was based on a shrine I have actually seen and learned to create. It was imagined, as was its function. There was never a public engagement of me with the shrine, the process of engaging with it very much remained a private one. But the shrine itself, as an art installation, was very public.

I really like that installation because within the week after its installation, you almost feel like the ancestor is in one way or another also communicating back to you. The shrine begins to get a life of its own. The candles blow out, dust collects, depending on the time of the day, you could get a reflection of the water and text on the roof of the space, etc. I approach it very personally, also in very private ways even though the public is interacting with it.

The relationship between the public and the private is always a tough one because the public is so different depending on the context in which the work is exhibited.

EMANUEL

It also leads the conversation in a certain direction about audience and where you choose to show your work. It seems like the work continues to be vulnerable to various interpretations.

REHEMA

The choice is hard. For an artist practicing in an art scene that is very young and small, Tanzania is really the quietest in East *AFRICA* when it comes to artists that are seen outside [it]. I often don't have too much choice about where I show the work. I like to show it here first. I like to have those conversations and also to see the

links in terms of the ways that some of these rituals are practiced in other parts of Tanzania. But once it leaves here, it's often not by choice. I would get in contact with a curator somewhere and they'd say: "Oh this work is interesting, how do you feel about showing the work here?" I showed it in Dakar as an ending to a chapter that essentially started in Dakar, but the audience there was very much from the West, with a language barrier when it came to local audiences.

ANITA
Have you thought about transforming this space [Soma Book Café] into an exhibition space?

REHEMA
This space? I've thought about transforming the little garage space outside into an exhibition space because I know I cannot get this [room] because it's an office space. This is a readership space. My mother started as a publisher and a book editor; she also ran a publishing house. However, I think she has always been an activist and development person at heart. Once the publishing business took off, she started a nonprofit sister company that just deals with readership and literacy-related projects.

EMANUEL
So, she's not going to let you take over anytime soon.

REHEMA
Not to turn it into a visual art space! I incorporate art in the art and readership projects that we sometimes curate together within the space, and she is open to this, but I doubt she would want the readership aspect of the space to completely disappear. But I don't think I would like to "take over" the space right now or in the near future, if at all. From my experience as Arts Manager of Nafasi, and part-time program manager for this space [Soma]; managing a space can take so much time away from your practice; it's also a really big commitment that I don't think I am ready for just yet.

ANITA
Have you thought about collaborating with Black women artists in other places, specifically in the diaspora?

REHEMA

I have but if you ask me right now, I don't have a person in mind, but I do have a person in mind in South *AFRICA* who I would love to collaborate with ... maybe not really a collaboration, more like exhibit or [a chance to] converse together in the same space because I struggle with the idea of a collaboration. I actually don't know how people pull it off: when I see an article that has been written by two people, I always wonder how they do it. I always imagine it's so hard but maybe it's not.

EMANUEL

You do that with your mother!

REHEMA

That is true, but for whatever reason this has been an easier process. We speak the same creative language, my mother and I. I also tried to collaborate with my sister in one project, which was a commission, but we ended up spending three months coming up with absolutely nothing. So, our collaboration is still pending.

In terms of collaboration, I've always imagined having a conversation with Berni Searle from South *AFRICA*, and more so now that my work looks so much at identity formations and at the Indian Ocean as an archive, and I think her work touches on the same. I also really like her performances and the way she uses her body and the way she remembers through her body.

I've never been to the US; I know several artists from there even though I have not met many in person. There isn't one particular artist that I have in mind that I'd like to collaborate with, but I think that there's room for a lot of conversations. I love to talk about my work in other places, where others would say: "In my culture we do this, this, and this. It's so similar!" We've all been practicing the same things, but we call it something different.

ANITA

Early on in the process of getting together this roster for *Where Is AFRICA*, we encountered someone who we are going to bring to RISD — she's a photographer who also deals with rituals and bathing practices, but her practice mostly encompasses photography.[1] When she started this other body of work that had to do with water, it seemed so different from her canonical works, like the opposite of you, where rituals have become the center of your work. Do you think that the return to ritual is something that still moves your work?

1 The artist referenced is Adama Delphine Fawundu.

HOW DO YOU CHANNEL [HER]STORIES TO CENTER ERASED NARRATIVES?

REHEMA

I still return to rituals; even now that fiction and imagination has become prominent in the work, I'm still working with ritualistic symbols. I think I'm still going to return to rituals, especially because I use oral tradition as a form of research, a process that in itself is already very ritualistic. I often use the term "ritual" very loosely. It starts with a repetitive gesture that I observe and try to find out more about.

ANITA

Do you feel that there are two different issues or two sorts of paths to what you define as ritual?

REHEMA

Yes, because often when you say you work with rituals, the imagination always goes to the spiritual. But I am looking at the everyday, even though at times, the everyday is also spiritual.

EMANUEL

Recently, we interviewed Robel Temesgen; he has been doing a series on the ritual of drinking coffee, but at some point the work has shifted to looking at the actual objects, like the traditional coffee pots or the cups that we use to drink coffee. So, I just wonder, in addition to the oral practice, but also these everyday activities, are you also fascinated with the objects associated with the ritual and, if so, how do you begin to translate them or represent them?

REHEMA

Sometimes the interest is in the objects. I'm very interested in fabrics. In the kanga work, and in researching rituals surrounding the kanga, I could almost say the object — that is the fabric — was of greater interest than the rituals themselves. In the other works, I'm more interested in the origin, the ritual itself and where it started. I'm interested in digging for the history behind the object, but sometimes it means looking at the object itself.

There was a time when a woman came here, I think she was American, and she was doing research on objects that she encountered in an ethnographic museum in Europe, I think Germany to be specific. The interest was in objects and rituals from several groups in the Kilimanjaro region, where my mother is from. She showed us many pictures, many of which I didn't recognize, but my mother recognized some. This was the first time I remember being so drawn to the objects. I think if they still

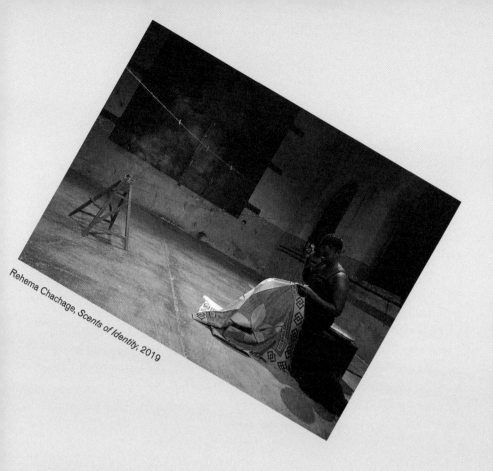

Rehema Chachage, Scents of Identity, 2019

existed here in Tanzania, and I had access to them, I would have taken a big fascination with the objects themselves.

ANITA
There is a part of your website — Kuta-na Sanaa — that started under Nafasi. Could you explain what that platform is and what it does?

REHEMA
It was initially imagined as a project that would eventually grow into an art space. But it has transformed into a project that does different things that are of interest to me, and is able to roam, so it's not situated or attached to a space. What I still want the project to do is to create a platform for artists to meet, to exchange, and to inspire each other. Returning home after completing my BA, I still remember the feeling of isolation — I felt like I was alone as an artist with inadequate access to other artists but more so to an audience, to a truly local, non-expatriate audience.

So, when I started Kuta-na Sanaa, the idea behind it was to have more access to artists and local audience. Initially we were collaborating with friends and colleagues, doing residencies and pairing local artists with international artists from *AFRICA* and the Global South. Then after I left Nafasi, I thought it would be

interesting to do interventions within the public space. There is this notion that
Tanzanians don't like art, but I always believed that art spaces do not do enough to
reach a truly Tanzanian audience and hence it's unfair to conclude that Tanzanians
don't like or appreciate art. So we did two public exhibitions in Dar es Salaam and
one in Zanzibar. And what I learned from this experience is that the Tanzanian public
is in fact very interested in art. They might not have the vocabulary for it, or even
fully comprehend it, but the interest is there. I remember we did one exhibition
in barbershops and beauty salons in an area near here, and one of the audience
members came up to me and said: "I don't know what this is. This is really beautiful,
but I don't know what it is. All I know is that I am really moved by it."

Kuta-na Sanaa doesn't currently have a very defined vision. I left Tanzania for
a year to pursue my Master's degree. When I came back, I invited some artists
to an excursion in the Kisarawe region of Tanzania where we traced histories [by]
speaking to people who have those histories. This, I thought, was also an interesting
direction for Kuta-na Sanaa to take. The project will continue to cater to the two
areas for a while: artists and audience.

EMANUEL

Do you have a community of Tanzanian artists with whom you're regularly discuss-
ing your work?

REHEMA

Not consistently, but this has always been my wish. I do have a lot of artist friends,
but we don't always sit together and visit each other's studios. Most artists are also
busy. There are also the politics, as is the case with many art scenes out there. It
recently occurred to me though, that I don't just need artist friends or community;
if I think if I expand my circle, I could find an interesting community of creatives
ranging from filmmakers, writers, artists, curators, etc.

EMANUEL

In recreating rituals, you're also updating them. Do you have ideas for projects about
future rituals? Like a fictional reimagination?

REHEMA

The answer, right now is no, though it is interesting to think about the future.

EMANUEL

You're not the kind of artist that has a vision of what your project will be ten years from now?

REHEMA

I don't think I have a clear vision of what it will look like five years from now! I have always been the "right now" kind of artist. When I was in Cape Town, the subject of my work was different, and it completely changed when I came back home. Situatedness plays a big role in shaping the direction that the project takes. It's hard for me to imagine the work five years later because I don't know where I will be, whether in Tanzania or not. Even if you go and come back, there's always some of that that comes back with you.

INTERVIEW W/TH

MESKEREM ASSEGUED & ELIAS SIME

EMANUEL ADMASSU

Your work has a social agenda that is very specific to the history of Ethiopia.

ANITA BATEMAN

Can you talk about the evolution of your work? What does it mean for you to be in the curatorial world and what are some of the challenges?

MESKEREM ASSEGUED

There is a sequence of events that started with a trip I took with my kids to Ethiopia in 1995.

EMANUEL

You were living here in Addis Ababa?

MESKEREM

No, I was living in the United States. We came to Ethiopia partly because my father died and I wanted to spend some time with my mother. Then, we ended up travelling around the country with friends and family from the US. It was a first encounter with my own history. The construction of the ancient buildings was quite fascinating. I was deeply moved by Yeha[1] and Fasiledes'[2] buildings. Most importantly, I was interested in the buildings where people lived. They were mostly stone buildings, two stories tall with arched doors and thatched roofs. We saw these buildings throughout Wollo,

1 Temples preserved from first millennium BCE in northern Ethiopia; including the Grat Be'al Geubri Palace and the Grand Temple of Yeha.
2 Fortress-city preserved from the sixteenth and seventeenth centuries in Gondar, Ethiopia; built as a residence for emperor Fasilides and his successors, including palaces, churches, and monasteries.

Gondar, and Yeha. It really fascinated me because the buildings had been there for a long time and it was around 1995. I thought: "How are they still standing after all these centuries?"

I would go into those homes and ask the people who lived there: "Who built this?" and they would say: "Oh my great-great-great-grandfather built this, we have been living here for generations." And I said: "How do you maintain it?" and they said: "Oh we don't do a lot, sometimes we do a little bit of maintenance on the roof." Later, I found out about all the materials they use and why the building doesn't leak, it's stone and wood, at least what I saw. I thought: "What we need is a museum using this technique because it's a technique that modern humanity needs to know." For one it can be highly technologically advanced, it can be a house of the twenty-first century without having to use air conditioning and reusing existing materials. Everything in that building could be reused. I knew that I had found something amazing, that the world had to pay attention to, and with that I started doing my own drawings — I was really interested in the construction techniques — so I was taking photographs of the details. Then, shortly after that trip, I decided to move back to Addis Ababa with my children.

I was looking at the buildings while I was doing my own anthropological work. After moving back to Addis, I met Fasil Giorghis (an architect and educator whose work focuses on the preservation of Ethiopia's architectural heritage), and told him that we need to build a museum and it needs to be made with these building techniques and materials — I need help. At this point, I had been traveling all across the country, taking many photographs in places like Harar where they have incredible stone buildings. I was already scouting and gathering all kinds of information: *it has to have a library, it has to have this architecture, it has to have this, it has to have that*. Fasil had his students do some incredible drawings, and he did a number of the renderings himself. I took the architectural drawings of those buildings and started going to the city council, to the mayor's office, to see if I could get someone to give me some land to build this museum. This is around the time that I met Elias, and my group and my mind was expanding.

EMANUEL

How did you get involved with curatorial work?

MESKEREM

I've always been making exhibitions. I didn't know that what I was doing was curatorial work. I had no clue. I was always writing about art and I used to do photo exhibitions, Shakespeare productions, or even fashion on the streets; I was always in the arts.

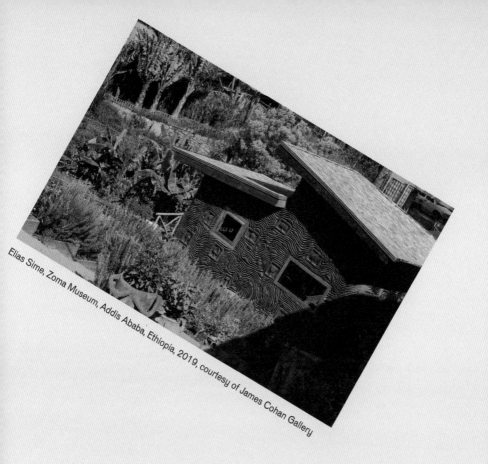

Elias Sime, Zoma Museum, Addis Ababa, Ethiopia, 2019, courtesy of James Cohan Gallery

I also had an incredible husband who always thought what I was doing was so cool. When you have someone who admires you, it encourages you. Then, eventually, some people started telling me that what I was doing was curatorial work. At the time there were no schools for curators, there was no discipline that I could be part of, so I learned on the job. Then I started getting invited to curate big shows. When the Museum of Modern Art [in New York] invited me in 2002, that blew my mind because I thought: "Who am I to be invited?" To make matters worse, they asked me to be on the panel with Yinka Shonibare, Okwui Enwezor, and Salah Hassan, and I didn't even know who these giant figures were; I didn't know them before that event. I was stunned, they really believed in me, and really believed I should be there. And partially, in the emails we were exchanging, one of the questions they asked was: "What's the current trend in African art?" And that made me think: "I'm just from Ethiopia — *AFRICA* is vast! How am I going to talk about the trends in African art?" That's how I started my speech. I said: "What's the current trend in African art? *AFRICA* has more than fifty countries, I can't represent *AFRICA*, but I can talk to you about Ethiopia, and that's only the tip of the iceberg." Then I spoke about the three governmental periods. By default, I became a curator, and I enjoyed it because, for me, it was different from how the academics saw it. I saw curating as a form of art, so I would take someone's art and make art from it. The art that I do is not about hanging work. I learned the measurements and everything on the job. Then I was asked to

311

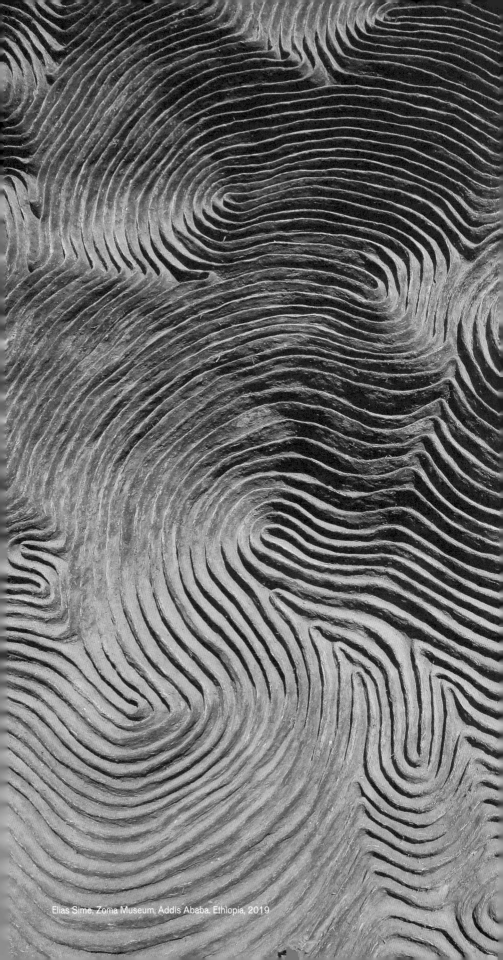

Elias Sime, Zoma Museum, Addis Ababa, Ethiopia, 2019

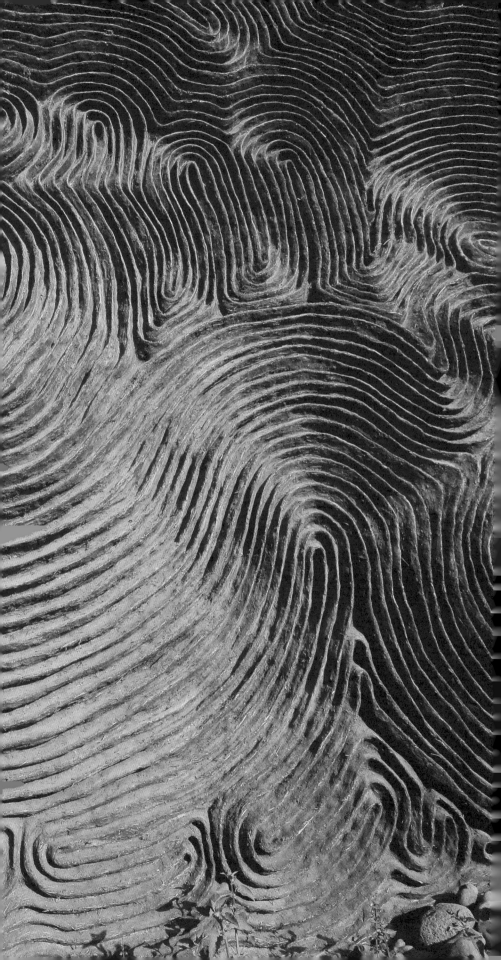

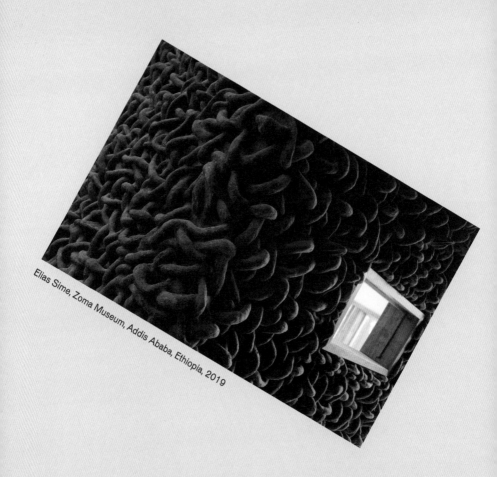

Elias Sime, Zoma Museum, Addis Ababa, Ethiopia, 2019

write, so I wrote, and I enjoyed that very much. Then actually working with the artists and reinterpreting their work and inserting my work into that, you can only do that with artists who don't have huge egos, because then it becomes a collaboration. That's how it evolved. Meeting Elias was the biggest magic of all.

EMANUEL
How did you meet Elias?

MESKEREM
He came and he asked me one day, I was at a bank with a friend, and he said: "Hi, my name is Elias and I know about you and I want you to see my work." And I thought: "Oh, that's very cool" and I said: "Yeah, yeah I've seen your work." It took me a while; he kept on trying to get me to come to his studio. This was at a time when I was constantly doing exhibitions. My living room became the art gallery.

I covered my couches with *Gabi*,[3] so it provided a homogenous background, and then I would place the art, and it became this really magical living room. It became a place for poetry readings, this was 1997/99.

Eventually, I did go to Elias's studio and I was blown away. I thought I was going to see his small wooden pieces, which I thought were great, though I thought he was copying another artist, because I saw that artist doing the same thing, but it was the other way around and Elias was doing it better. When I went to Elias's studio, and I saw his collages and stitch work and sculptures and stone carvings, I was speechless. I went there thinking I would stay for a half hour and I ended up staying there for a couple of hours, and then he asked: "What do you think?" and I told him: "You know, you have to give me time," and he told me: "Oh I waited seven years to show this to you, you think I can't wait another ten?" and I thought: "Who *is* this guy?" and I called my husband and said: "You don't have a clue what kind of artist I just met." Then, Elias said he wanted to travel with me to do my anthropological work, so we started traveling together and sure enough, he was very focused, highly disciplined, and easy to work with. Our exhibitions became one story after another.

ANITA
Shifting gears a bit, *Giziawi #1* was a three-day art happening with events around the city, with forty-five local and international artists. *Giziawi* means "temporary" in Amharic. How does the idea of the temporary fit in with your commitment to sustainable art and, more specifically, how do the ancient techniques that were used to construct this compound factor into ideas concerning the temporary and contemporary?

MESKEREM
That was a strange moment for art in Addis Ababa: there was a constant barrage of criticism. There are no art critics, there are no art historians. I felt like our art was just beginning to gain momentum—the artists were still recovering from a regime that was killing them for making art, and now finally they were making art—and people were coming here and telling them how bad their art is! You know, let them grow! Don't bash them! The artists were so confused. So I thought that we should do a temporary show. Everything about being temporary. We have to love everything about being temporary and give the artists a chance to "burn this damn thing and start over again." I invited a number of artists from abroad. I got funding from private

3 A thick cotton garment often used as a blanket.

Elias Sime, *Tightrope*, 2022, photograph: Phoebe d'Heurle

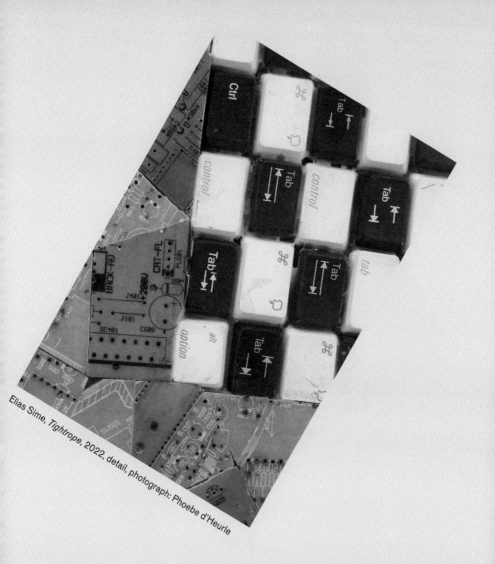

Elias Sime, *Tightrope*, 2022, detail, photograph: Phoebe d'Heurle

companies, cultural institutions, even David Hammons was going to come (I met him through MoMA — MoMA played a big part). So that's how we did *Giziawi* and it was a catalyst for me. I don't think I'll ever do that kind of show again. The amount of people involved, the number of people in Meskel Square,[4] and to have all these international people come and all these artists working on it, it was amazing. I brought the whole city together. That's also where I got to work with Elias because he came as a volunteer, but in the end, I also found him a place in the show. He wasn't an artist in the tent, but when David Hammons canceled at the last minute, I asked the group if he could be one of the artists and they agreed, so he got to be one of the artists in that show.

Sustainability is love, first and foremost. You have to love what you're doing. There is nothing monochromatic about what you're doing, it's colorful. Activities are

4 A large public plaza in Addis Ababa.

317

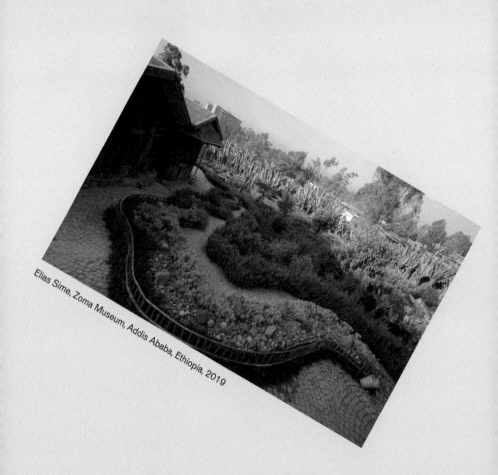

Elias Sime, Zoma Museum, Addis Ababa, Ethiopia, 2019

multiplied when you love what you're doing, time becomes irrelevant. You just do it. I see the future in ancient building techniques, because this modern lifestyle is a road to nowhere, one distraction after another. If you look at what has lasted, our personalities, the construction techniques, the fabric we wear, that is the future because the future generations are going to demand something that works. When you build a concrete house, you're going to need air conditioning or a heater, and all these things require huge amounts of energy — health-wise, it's very harmful. When you build something with earth, you can recycle it. But how do you make earth attractive for people who are addicted to cement? You have to work with that challenge, that's how you bring it into the contemporary. How do you build on this existing knowledge? I saw the beginning of the Great Wall of China, which is made of earth, and it's still standing, it's amazing. I was more interested in the details of that wall, and the surrounding buildings from that time, and how it withstood the

318

earthquakes, the rain, and all the weathering. So, how can I bring these techniques to the present?

ANITA
You're implicitly linking a type of functionality to a structure that makes it appealing to generations after it was built. But the Great Wall is now respected because of its aesthetic value. It wasn't functional: it didn't keep out the people it was built to keep out.

MESKEREM
You know, I'm looking at the construction methods. It's an evil wall, it was made for the wrong reasons. Also, keep in mind, that it was built by different people from different regions. Part of it was built out of mud, part of it was stone, so they used whatever techniques were available.

Elias's piece for the Facebook HQ was made based on the Redwood Forests. We were driving there and back listening to NPR [National Public Radio] and a woman was talking about the roots of trees. She was explaining how plants communicate underground and help each other when a tree is being hurt above ground. So, when you build a wall, you are actually constructing a wall between these invisible means of communication. Whether you're on this or that side of the border, nature has connected us. When Facebook flew us out to California, we took an extended tour of the Redwood Forests and Elias was deeply inspired. Elias's piece for Facebook shows the exposed roots touching.

EMANUEL
Zoma was initially housed in a villa (a small compound), close to its current location, where you were able to host small groups of people; then you expanded it by building a visitor center in the Bale province. Now you have a farm, a school, a museum — a lot of different art and educational programs hosted within the Zoma Museum compound. What does this say about your attitude towards art and the city?

MESKEREM
The first Zoma was at Jama Park [in Addis Ababa].

EMANUEL
It was a small gathering space...

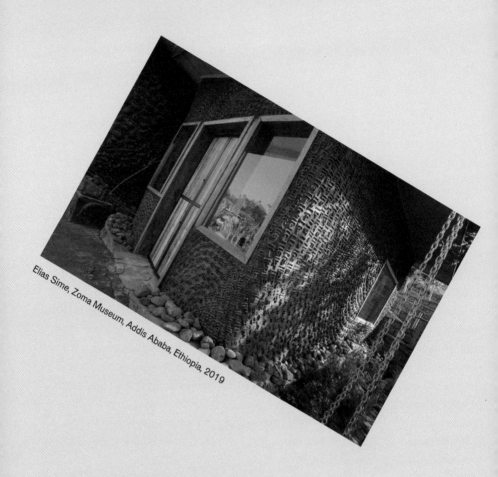

Elias Sime, Zoma Museum, Addis Ababa, Ethiopia, 2019

MESKEREM

There was an existing building and we did a lot of mosaic work and small alterations. We were renting the space and hoping to buy it someday. It was just a beautiful garden, so we invited Tafese Jama — who is an amazing gardener — and he did that whole landscape himself; so that's also where Elias's first solo exhibition happened. Then, the little Zoma came. As he was building it, he said: "I can't bring people here because the walls are changing."

EMANUEL

So you always wanted to make it an educational space?

MESKEREM

Yes, from the get-go. But it wasn't meant to do that and be his studio. So, we started looking for land all over the city. When nothing was coming up Elias came to me

and said: "Why don't we just turn this house into the Zoma Museum until we buy land? I can't work in it anyway because there's going to be a lot of people who want to come and look at the place." We decided that we would work on the big center after that. From that moment on, we announced that it was going to be Zoma.

EMANUEL
So, you bought that place?

MESKEREM
Yes, yes, it's only four hundred square meters of land. As that was going on, we were also looking to buy land near the river, but they were asking for a lot of money. We were always saving to buy land. Once the opportunity came—and we were very lucky because suddenly these major exhibitions started bringing more money—we were able to get this large plot of land.

ANITA
In a video I've watched of yours for *Making AFRICA*, you say you purposely don't want to deal with African issues because a lot of people are dealing with that and instead you take a humanist approach to your curatorial concerns. Is that still valid for you and can art in your opinion exist without a cultural context?

MESKEREM
Yes, that is still valid to me, even more so now. Art has to be free from everything because art is an imagination of where you want to be. It's your dream. It's where you can go from here and what you take into the future. There should be no limitation. Regions put limitations on art, keeping artists in this prison of the mind, making them think only of those terms. Artists have to think beyond their context. If you look at his [Elias's] art, for instance, if you didn't know him, you wouldn't know where it came from. And that's how it should be. This is my argument when people tell me: "There's European art" and I say: "There's no European art, there's art." It becomes politicized, then the artist is stuck in an argumentative position: defending himself or defining himself in a certain way, lamenting about or addressing issues that have nothing to do with his imagination. Artists should be able to imagine what life is like underwater, or in outer space, take us to places that we've never been before. To me art is one of those areas that should remain free from all kinds of scrutiny. But as an African, as a Black woman, I'm so proud of who I am. I'm comfortable being who I am and where I was born, but I don't have this nationalist personality.

321

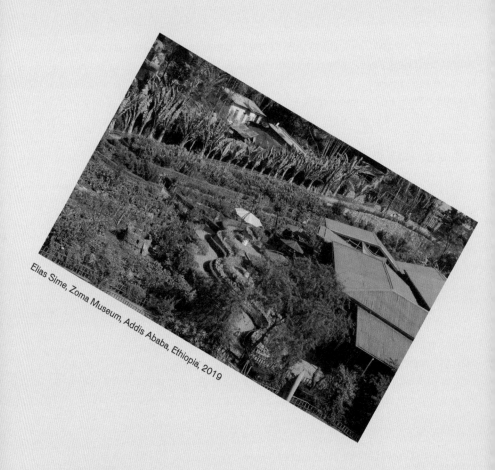

Elias Sime, Zoma Museum, Addis Ababa, Ethiopia, 2019

EMANUEL
The work has to go beyond the artist's identity.

MESKEREM
Absolutely! At all times. Nature forces us to do that. How could you do that? You
and I are sitting here and we're both breathing oxygen from the tree. Both of us
are giving the tree carbon dioxide. How can we talk about our differences? And
art has to go beyond that. This whole idea of who should be what or whose sexual
orientation should be which, or whose life should be in which direction ... freedom
comes with responsibility. Freedom without responsibility is meaningless. I have to
respect you.

EMANUEL
And your right to disagree.

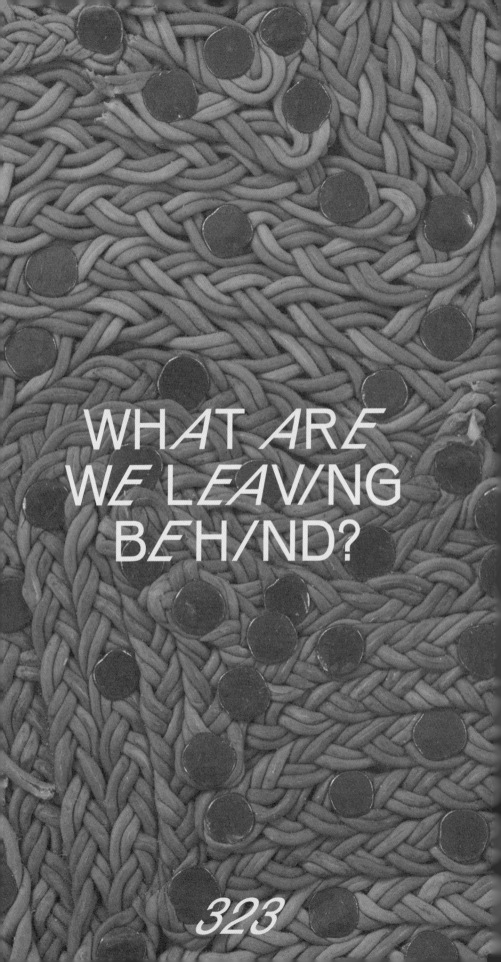

WHAT ARE
WE LEAVING
BEHIND?

MESKEREM

Absolutely. And the right to leave! If someone is harmful to me, I have the right to walk away. I have no reason to hurt myself again.

[Below is a conversation that was translated from Amharic.]

EMANUEL

What was the driving force for your art, when you were working alone, before you met Meskerem?

ELIAS SIME

The only driving force is love. If you love the work, it drives you like a dream. You can't establish boundaries when you fall in love. Love has no calculator — it's an ambiance, a mood. As long as there is love, you have the potential to accomplish everything.

EMANUEL

The things you are building here at Zoma require many collaborators. Why did you choose to establish such a collaborative practice?

ELIAS

There is no feeling of loneliness here. We have all been shaped by our expansive context — including family, friends, and collaborators. This is an extension of that social fabric. There is mutual exchange between us. You have to be willing to accept as much as you are willing to give. You can never feel empty from giving too much — only from giving too little. The communal nature of the work produces a beautiful melody that you could never compose on your own. We have a very short period of time on this earth, the only way to enrich or multiply it is by sharing that time with others. For example, Meski and I believe that Zoma has to continue long after we are gone. Yes, I have some abilities, but I continue to learn a great deal through these collaborative projects. Therefore, my collaborators are full of confidence, because everything is built through this continuous exchange.

EMANUEL

The two of you have traveled across Ethiopia, documenting architecture from different regions. It seems like that knowledge has really influenced the work you have

been doing here. Do you have any interest in travelling outside Ethiopia to document architecture from other regions?

ELIAS

Meski had lots of dreams before we started Zoma. She was exploring her interest in Ethiopian architecture with other artists before we started collaborating. So, I want to be clear that this is something she has been working on for a long time. Once we met, the research started moving in a particular direction because we began to integrate some of my personal experiences, traveling with my father to work on construction projects throughout the country.

EMANUEL

Your father worked in construction?

MESKEREM

Yes, he learned how to build from his father...

ELIAS

Therefore, what you are seeing here is the hybridization of my experience with her passion. Her dedication to realizing this dream has been very strong throughout the process. There have been lots of obstacles, but she has maintained her vision. We had to deal with the shifting context here in Addis. For example, there is an ordinance for this neighborhood that requires you to use the existing materials and structures for any type of renovation or upgrade — you can imagine how limiting that could be when trying to build a new institution. These constraints ended up being dominant forces in determining the final form of the museum.

EMANUEL

But that seems like an ideal constraint for you. It is in line with your interest in preservation...

ELIAS

Yes, but we had to maintain the footprint of the existing buildings. The layout could have been very different if it wasn't for those constraints. This is why it feels like this is only the beginning. We have only scratched the surface of what we eventually want to realize. We are still interested in playing with the limits of art and architecture. I am basically arguing that architecture has no value in and of itself. It can't sing alone. It has to breathe. It has to be playful. This is why we see boring buildings

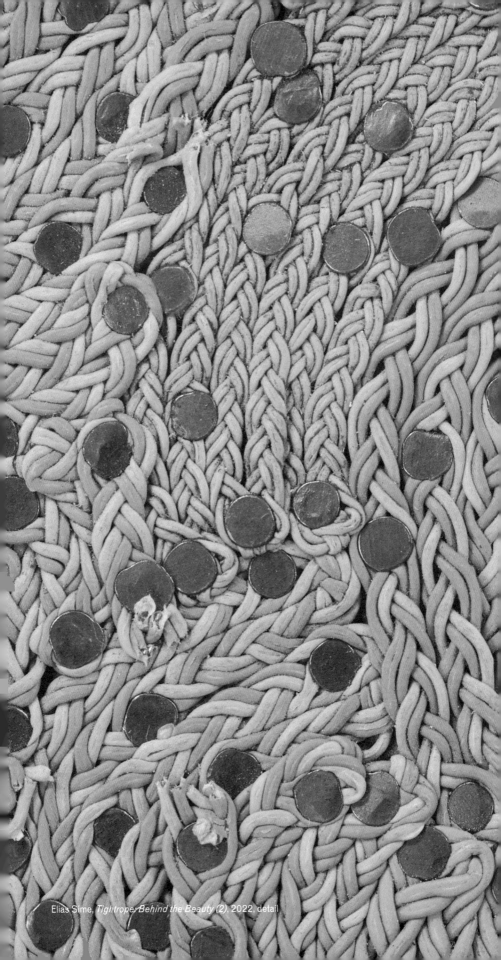

Elias Sime, *Tightrope: Behind the Beauty (2)*, 2022, detail

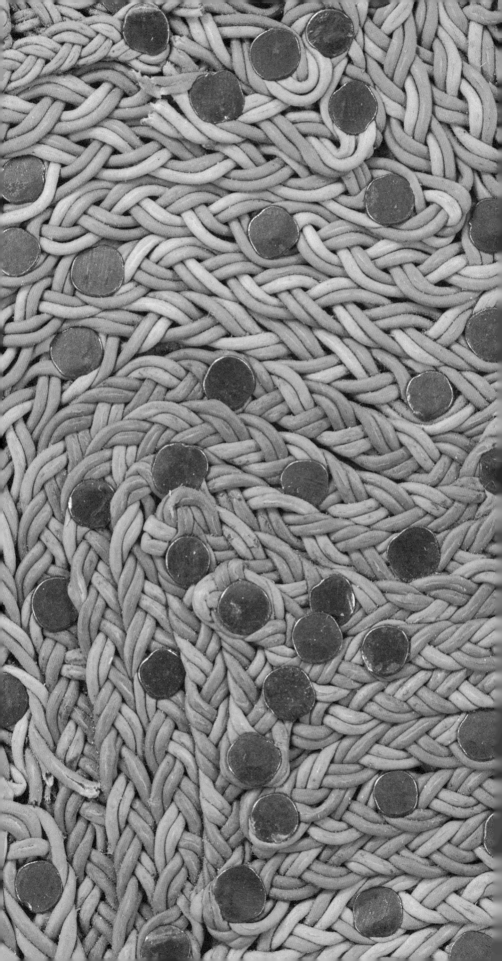

Elias Sime, *Tightrope: Behind the Beauty (2)*, 2022

throughout the city — because they want to sing alone. That doesn't work for us. You can't just accept what is given. You have to add soul to the recipe. I can't even call this building. We are just thinking through buildings. We will eventually change the form and layout of everything. It needs to match our imagination.

MESKEREM

To answer your earlier question about other regions. Yes, we have travelled extensively to China, Europe, etc. Before that, I have also travelled to the Yucatán Peninsula, studying Mayan ruins...

EMANUEL

You did a workshop in the Yucatán?

MESKEREM

Yes, there is an institution there called Zoma Yucatán, which is very much influenced by what we are doing here. When I first went, I was really blown away with the ancient ruins and their means of construction — the underground rainwater catchment systems...

ELIAS

Yes, Meski has done extensive research in this area, but we have a long way to go.

MESKEREM

We have to start collaborating with architects. That will take it to the next level.

ELIAS

Absolutely! The only way to leave something valuable behind is by working together. This is necessary not only for your life but also for your soul. This is not about money.

MESKEREM

We need to pass it on.

ELIAS

We really believe that we can change the atmosphere around art, not only in this country but for the rest of the world.

Elias Sime, *Ants & Ceramicists 11*, 2009–14

EMANUEL
Zoma is already changing the role of art in Ethiopia.

ELIAS
We have a lot more work to do.

BLACK HOLES AIN'T SO BLACK (DRAFT SCRIPT)

A PERFORMANCE IN SIMULTANEOUS ACTS

MARIO GOODEN

Adapted from the following texts:

Stephen W. Hawking, *A Brief History of Time: From the Big Bang to Black Holes*, 1988.

Dennis Overbye, "The Most Intimate Portrait Yet of a Black Hole," *The New York Times*, April 10, 2019.

Tia Ghose, Hear 2 Black Holes Merging in this Unforgettable Sound Clip, *LiveScience*, February, 10, 2016.

@NASA via Instagram

Christina Sharpe, "The Ship," *In the Wake: On Being and Blackness*, 2016.

J.T. Roan, "Plotting the Black Commons," *Souls: Critical Journal of Black Politics, Culture, and Society* 20, no. 3, 2018.

Interstellar, directed by Christopher Nolan, written by Jonathan Nolan, Paramount Pictures, 2014.

"Transcript of the Challenger Crew Comments from the Operational Recorder," NASA History Division, 1986.

Amistad: An Opera in Two Acts, music by Anthony Davis, libretto by Thulani Davis, 1997.

Toni Morrison, "No Place for Self-Pity, No Room for Fear," *The Nation*, March 23, 2015.

EPILOGUE

EMANUEL
ADMASSU
&
ANITA N.
BATEMAN

The interviews in *Where Is AFRICA Vol. I* are interdisciplinary fragments that mark the pre-pandemic world. African and African diasporic identities and spaces are examined through questions of positionality in relation to specific disciplinary, cultural, and political contexts. We have framed the texts in the preceding pages as snippets of ongoing and ever-evolving transnational conversations — centering Afrodiasporic aesthetic practices, and the curatorial, museological, and artistic matrices that confront epistemologies of dominance and exclusion. The commissioned essays and images offer concise methodologies that expand or further complicate the concepts and issues addressed by the interviewees. Our aim has been to convene a robust chorus of practitioners who continue to facilitate, advance, and remake the flow of ideas related to contemporary African visuality.

Where Is AFRICA is a conceptual project that accompanies a conceptual place, driven by the desire to dislodge *AFRICA* from categorical fixity and the representational logics of nation-states. *AFRICA* can never be fully enclosed by the residue of colonial violence or the totalitarian gaze of neoliberalism; instead, it creates infinite malleability, where place and concept are untethered from each other. Not offering solid ground or clear orientation, we are challenged to accept vastness, fragmentation, and uncertainty as other ways of knowing and imagining futures. *Where Is AFRICA* is a project that remains incomplete and open in the face of imperial absolutes.

Initiated in 2017, these conversations were recorded in two regions — eastern *AFRICA* and the northeastern United States — and across six cities where we

had established professional and personal connections: New York, Cambridge, Providence, Greenwich, Dar es Salaam, and Addis Ababa. (Interestingly, one conversation was recorded from a moving car in Johannesburg). Addis Ababa and Dar es Salaam were selected as the primary sites for our interviews on the continent because of their centrality to initiatives that sustain global Black solidarities. On the one hand, Ethiopia holds historical significance in the Pan-African imagination as a place that successfully resisted European colonization, and its capital Addis Ababa has been the headquarters of the African Union since its inception. Tanzania, on the other hand, bears postcolonial significance framed around Julius Nyerere's political project *Ujamaa*, and his facilitation of international African and African diasporic conversations among artists, activists, and intellectuals. Further, Dar es Salaam's geographic location as a port city on the Indian Ocean makes it a critical site for twenty-first century overlaps and negotiations between Asia and *AFRICA*.

The book does not claim to be exhaustive, but reifies a search for notions and ideas that unsettle hegemonic representations of African spaces and people — representations that have been seemingly naturalized through centuries of coloniality and Euro-American imperialism. The issues confronted by this project not only frame *Where Is AFRICA* in such a way to resist the reduction and oversimplification of a seemingly straightforward phrase, but also confront the paradox of following an impossible line of inquiry — one with varied, evolving, and perpetually fluid answers. We chose to remain in the productive friction between de-establishing institutional frameworks and reworking them entirely. The question, addressed by the interviews and commissions herein, can be parlayed into a more expansive one, that is: how can the praxis of searching for *AFRICA* help us find commonalities across the continent and its diaspora? By publishing this series of internal conversations, the project recycles other pertinent questions about audience and reception, such as: how do we, and should we, gatekeep *AFRICA* and Blackness from cultural appropriation and predation? What are the virtues of informal, process-based discussions that amplify different ways of thinking and making?

Woven into these conversations are recollections of "home" as well as explorations of epistemologies, rituals, and ambiguities. In speaking with one another, we channeled ideas that affirm our practices as cathartic, our languages as experimental, and our afterlives as constructions. As an organizing tactic, the questions and keywords trace various throughlines, vocabularies, and major concepts that are in flux in contemporary art histories. Thus, this book functions as a time capsule, since most of the featured practices and sites have transformed or taken new directions.

Where Is AFRICA is haunted by the things we were unable to achieve: the people we didn't get a chance to speak with; the two gatherings on the continent — in Dar es Salaam and Addis Ababa — that we were unable to hold due to the onset of the global pandemic; the lack of institutional support; and the difficulty of devoting time to sustaining a never-ending project. *AFRICA* is time-traveling, however, and effectively, so are we. In recognizing failure as a resource that allowed us to pivot, we were able to evaluate the discussions over a number of years and further reflect on the fundamental premise of the many themes of the project — most importantly, the liberatory ethos inherent in collaboration.

To contemplate "Where is *AFRICA*" as a statement rather than a question is to commit to a subject that eludes resolution.

Emanuel Admassu & Anita N. Bateman
August 2022

GRAT/TUDE

The preceding pages are indebted to expansive bodies of work that came before us that have opened up and reshaped our understanding of theory as active practice. In addition to our contributors, we have been writing, thinking, and speaking with offerings by monumental figures like bell hooks, Walter Rodney, Sylvia Wynter, V. Y. Mudimbe, Édouard Glissant, C. L. R. James, Paul Gilroy, Dionne Brand, Saidiya Hartman, Ruth Wilson Gilmore, Stuart Hall, Kwame Nkrumah, W. E. B. Du Bois, Angela Davis, Julius Nyerere, Wangari Maathai, Baalu Girma, Denise Ferreira da Silva, Cedric Robinson, Aimé Césaire, and Christina Sharpe (just to name a few and begin initiating a list that could easily fill all the pages of this book). To those brilliant minds and intellectual predecessors working across disciplines, we are your students. Because of you, we are.

The launch of this book bears the imprimatur of so many thought partners and would not have been possible without the tremendous support of the collaborators who worked with us and believed in the project over the past five years. The logistics to transform the structure of somewhat interesting, if not discursive, discussions into a cohesive manuscript took an extraordinarily amount of effort, for which we are indebted.

Profuse gratitude to our interviewees Salome Asega, Anthony Bogues, Jay Simple, Tau Tavengwa, Mpho Matsipa, Eric Gottesman, Rebecca Corey, Robel Temesgen, Aida Mulokozi, Rakeb Sile, Mesai Haileleul, Niama Safia Sandy, Adama Delphine Fawundu, Valerie Amani, Meskerem Assegued, and Elias Sime who are the lifeblood of the project. We are deeply inspired by the limitless talent and original work contributed by Mikael Awake, Olalekan Jeyifous, Amanda Williams, Germane Barnes, and Mario Gooden. They offered precise interventions in response to our provocation; expanding the scope and ambition of this project. We could not have hoped for a better, smarter, or more engaging community to brave this journey with. We would like to thank Mabel O. Wilson for the beautiful and generous foreword and the intellectual clearing she continues to carve out through her work, for those of us who are committed to thinking about the spatialities of Black life.

To our previous editor and supporter through NY Consolidated, Camille Crain Drummond: thank you for your guidance and advocacy. For bringing this book to CARA and believing these narratives needed to be put to paper. You gave this book so much care.

To the incredible CARA Team, Jane Hait, Manuela Moscoso, Emmy Catedral, Mia Weathers-Fowler, and Judy Reissmann: we are forever grateful for the countless hours and emails that were devoted to bringing this text to life. Your flexibility and genuine dedication to having this book flourish has been invaluable. Justin O'Shaughnessy, your diligence and attention to detail is unparalleled; you kept us on track and got us to the finish line.

To our loved ones: Admassu Atnafseged, Almaz Awoke, Meaza Admassu, Samuel Admassu, Jen Wood, and Ezana Admassu-Wood: this project could not have been achieved without your love and support. Thank you for making time and space to care for us throughout this journey.

This project was initiated through a fellowship we received from RISD Global under the leadership of Gwen Farrelly. Thank you, Gwen, for supporting the initial visions of this idea. We would also like to thank Matthew Shenoda for his steadfast support of our work from the beginning, and our former colleagues at RISD Museum and RISD Architecture. Riley McClenaghan who photographed the Where Is *AFRICA*? symposium at RISD Museum, Bobby Joe Smith III and Elaine Lopez who designed the graphics for the event, Sara Wintz who carefully transcribed and edited the audio from the interviews, and Re'al Christian whose meticulous editorial support helped us transition this project from a collection of texts and images into a cohesive book.

We are also thankful for the support we received from the Graham Foundation, and to Aristides Logothetis and the ARCAthens team for providing us with space and time to focus on the text through the Athens Residency program.

Lastly, a special thanks to Nontsikelelo Mutiti, whose conceptual approach, sensibility, and experimentation has framed the ambiance of *Where Is AFRICA.* We are grateful for your unrelenting commitment to beauty and impeccable design.

ADAMA DELPHINE FAWUNDU is an artist born in Brooklyn, NY, of Bubi, Bamileke, and Krim descent. Her works reveal the power in ancestral memory as it is archived in the beings of the African diaspora. Fawundu co-published the critically acclaimed book, *MFON: Women Photographers of the African Diaspora*. She is an Anonymous Was A Woman Award and Rema Hort Mann Award recipient amongst others. Fawundu has exhibited internationally, and her works are in numerous public and private collections including the Brooklyn Museum and Princeton University Art Museum. Fawundu is an Assistant Professor of Visual Arts at Columbia University.

AIDA MULOKOZI is the CEO of Dar Centre for Architectural Heritage (DARCH), a nonprofit organization that aims at saving and promoting historical architecture in Dar es Salaam and the wider East African context through research, documentation, education, professional training, community outreach and public cultural events. Prior to joining DARCH she worked for fifteen years with the United Nations Criminal Tribunal for Rwanda (ICTR) at its Arusha and Kigali offices. Mulokozi has lived in Belgium and the United Kingdom. She is a native of Tanzania, and is fluent in Swahili, English, and French. She holds a Master's degree in Linguistics.

AMANDA WILLIAMS is a visual artist who trained as an architect. Her creative practice employs color as an operative means for drawing attention to the complex ways race informs how we assign value to the spaces we occupy. Williams' installations, sculptures, paintings, and works on paper seek to inspire new ways of looking at the familiar and in the process, raise questions about the state of urban space and ownership in America. Her breakthrough series, *Color(ed) Theory*, a set of condemned south side of Chicago houses, painted in a monochrome palette derived from racially and culturally codified color associations, was recently named by the *New York Times* as one of the twenty-five most significant works of post-war architecture in the world. Her ongoing series, *What Black Is This You Say?*, is a multi-platform project that explores the wide range of meanings and conceptual colors that connote blackness. Using her Instagram account as an initial platform to challenge and celebrate black lives, the work has evolved into paintings, soundworks and a year-long public installation in New York.

ANTHONY BOGUES is a writer, scholar and curator. He has published nine books in the fields of Black radical political thought, Caribbean intellectual history and Caribbean art. He is currently working on a book titled *Black Critique* and a project on the political thought of Michael Manley and Jamaica in the 1970s. He is also co-editing some of the unpublished writings of Sylvia Wynter and writing a volume on Haitian art. He is the Asa Messer Professor of Humanities and Critical Theory at Brown University, the inaugural director of the Center for the Study of Slavery and Justice, Brown University, an Honorary Professor at the University of Cape Town and a Visiting Professor of African and African Diasporic Thought at the Free University of Amsterdam. He has curated art shows in the Caribbean, South *AFRICA* and the USA.

ELIAS SIME (b.1968 Addis Ababa, Ethiopia) lives and works in Addis Ababa, Ethiopia. He is a multi-disciplinary artist who creates intricate, wall-mounted works and freestanding sculptures from discarded technological components—including salvaged motherboards, computer keys, and electrical wires. The history of his materials hold meaning, as they are the backbone of all communication systems, whether they be telephone or computer. They suggest the tenuousness of our interconnected world, alluding to the frictions between tradition and progress, human contact and social networks, nature and the man-made, and physical presence and the virtual. His work is included in over twenty-five public institutions and in 2022 was featured in the 59th International Venice Biennale, *The Milk of Dreams*, curated by Cecilia Alemani.

ERIC GOTTESMAN is a Guggenheim Fellow, a Creative Capital Artist, a Fulbright Fellow, an Artadia awardee, and a co-founder of *For Freedoms*. His work in the visual, literary, political, collaborative, and teaching arts addresses nationalism, migration, structural violence, and intimacy, and has been shown at health conferences, on the televised opening of the NFL season, inside government buildings, on indigenous reserves, inside post-war rubble and in art museums around the world. Gottesman is a mentor in the Arab Documentary Photography Program in Beirut, Lebanon.

GERMANE BARNES is the Principal of Studio Barnes. His practice investigates the connection between architecture and identity, examining architecture's social and political agency through historical research and design speculation. His work has been exhibited in the Museum of Modern Art's groundbreaking 2020 exhibition, *Reconstructions: Architecture and Blackness in America*, and the

2021 Chicago Architecture Biennial. He was a winner of The Architectural League Prize and is a Rome Prize Fellow. His work has also been featured in international institutions most notably MAS Context, Milan Design Week, San Francisco MoMA, LACMA, The Graham Foundation, and The National Museum of African American History and Culture, where he was identified as one of the future designers on the rise.

JAY SIMPLE is a son, a brother, a father, a friend, an artist, an activist, and a scholar led by his ancestors and Allah. He is black and his life is eternal and multidimensional. He was born in Chicago, raised in Philadelphia, and currently resides in Charlottesville, Virginia where he serves as the Executive Director of The Bridge: Progressive Arts Initiative. Simple is also the founder and Director of The Photographer's Green Book, a resource for inclusion, diversity, equity, and advocacy with the lens-based medium.

MABEL O. WILSON teaches Architecture and Black studies at Columbia University, where she also serves as the director of the Institute for Research in African American Studies. With her practice *Studio&*, she was a member of the design team that recently completed the Memorial to Enslaved Laborers at the University of Virginia. Wilson has authored of *Begin with the Past: Building the National Museum of African American History and Culture* (2016), *Negro Building: Black Americans in the World of Fairs and Museums* (2012), and co-edited *Race and Modern Architecture: From the Enlightenment to Today* (2020). She was co-curator of the MoMA exhibition *Reconstructions: Architecture and Blackness in America* (2021).

MARIO GOODEN is a cultural practice architect and director of Mario Gooden Studio / Architecture + Design. His work crosses the thresholds between the design of architecture and the built environment, writing, research, and performance. Gooden is also the Director of the Master of Architecture Program at the Graduate School of Architecture Planning and Preservation (GSAPP) of Columbia University and a Research Associate at the Visual Identities in Art and Design (VIAD) at the University of Johannesburg (South *AFRICA*). He is a founding board member of the Black Reconstruction Collective (BRC), a 2012 National Endowment for the Arts Fellow, a MacDowell Fellow, and the recipient of the 2019 National Academy of Arts and Letters Award in Architecture. Gooden is the author of *Dark Space: Architecture*

Representation Black Identity (Columbia University Press, 2016) as well as numerous essays and articles on architecture, art, and cultural production.

MESAI HAILELEUL has over twenty years of experience in dealing, curating and exhibiting Ethiopian art, and has continuously aimed to create a presence for Ethiopian artists in international spaces. Based in Addis Ababa, Mesai is part of the rapid change happening in the Ethiopian capital and has invaluable insight into the evolving cultural climate of Ethiopia.

MESKEREM ASSEGUED is an anthropologist, curator, and writer. In 2002, she founded ZCAC (Zoma Contemporary Art Center) with the artist Elias Sime. Zoma is an artist residency and museum located in Addis Ababa, Ethiopia. Over the last sixteen years, Meskerem has curated numerous exhibitions both in Ethiopia and abroad. These include *Giziawi #1*, an art happening in Addis Ababa (2002); *Divine Light* by David Hammons at ZCAC (2003); *Green Flame* with Elias Sime, Ernesto Novelo, and Julie Mehretu; and the co-curated *Eye of the Needle, Eye of the Heart* by Elias Sime with Peter Sellars (2009). She was a member of the selection committee for the 2004 Dak'Art Biennale and the 2007 Venice Biennale African Pavilion.

MIKAEL 'MIK' AWAKE's essays have appeared in *New York Magazine*, *GQ*, *The New Yorker*, and other outlets. With Daniel R. Day, he is the co-author of *Dapper Dan: Made in Harlem*, a *New York Times* bestseller. His next project, *Playground Moves: The Story of Rucker Park and the World Street Basketball Made*, is forthcoming from Pantheon Books.

MPHO MATSIPA is an educator, researcher, and curator of *African Mobilities*. Mpho was a Loeb Fellow (2022) at the Graduate School of Design, Harvard University, and a Chancellor's Fellow at the University of the Witwatersrand, South *AFRICA* in 2021–2022. She received her PhD in Architecture from the University of California, Berkeley. She has taught Advanced Studio, History and Theory of Planning and Architecture, in the School of Architecture and Planning at the University of the Witwatersrand, The Cooper Union for Art and Science, and Columbia University. She was a co-investigator on an Andrew Mellon research grant on Mobilities and she has written critical essays on art and architecture and curated several exhibitions and discursive platforms including the 14th International Architecture Exhibitions at

the Venice Biennale (2008; 2021); chief curator of *African Mobilities* at the Architecture Museum, Pinakothek der Moderne in Munich (2018); Studio-X Johannesburg, in South *AFRICA* (2014–2016); and she associate curator for the Lubumbashi Biennale in the Democratic Republic of Congo (2022).

NIAMA SAFIA SANDY is a New York-based curator, producer, multidisciplinary artist and educator. Her work delves into the human story, often with stories of the Global Black diaspora at its center. She has participated in and convened programs at TEDWomen, Schomburg Center, MACAAL, MICA, World Around Summit, Harvard University, Oberlin College, The Public Theater, RISD, UNTITLED & more. Past artist residencies include The Watermill Center and Project for Empty Space. Niama is a founding curator of the Southeast Queens Biennial, co-founder of The Blacksmiths and an active member of the artist collective Resistance Revival Chorus. Niama is currently a Visiting Assistant Professor at Pratt Institute, School of Art.

OLALEKAN JEYIFOUS received a BArch from Cornell University and is a Brooklyn-based artist whose work re-imagines social spaces that examine the relationships between architecture, community, and the environment. He has exhibited at venues such as the Studio Museum in Harlem, the Museum of Modern Art (New York), the Vitra Design Museum, and the Guggenheim in Bilbao, Spain. In addition to an extensive exhibition history; he has spent over a decade creating large-scale installations for a variety of public spaces and was recently co-commissioned to create a monument dedicated to congresswoman Shirley Chisholm as part of the City of New York's "She Built NYC" initiative.
Olalekan has been a Wilder Green Fellow at MacDowell and has completed artist residencies with the Drawing Center's Open Sessions program and the Rockefeller Foundation's Bellagio Center. He has won numerous awards for his artistic practice and was the recipient of a 2021 Fellowship by the United States Artists.

RAKEB SILE, a London-based art collector and businesswoman, opened Addis Fine Art gallery together with veteran art collector Mesai Haileleul after noticing a lack of Ethiopian representation in the international art world. With over ten years' experience in business consulting and project management, Rakeb brings a wealth of commercial experience to Addis Fine Art. As an indigene of Ethiopia and a collector of Ethiopian art, she is well versed with the context in which Ethiopian artists are cultural producers, transforming the mundane into nuanced and expressive works of art.

REBECCA MZENGI COREY is a Korean-American arts practitioner based in Tanzania whose interdisciplinary work includes curation, arts management, filmmaking, and installation art. Since 2016, Rebecca has been the Director of Nafasi Art Space, an independent art centre in Dar es Salaam. In this role, she established the Nafasi Academy for Contemporary Art and Expression, as well as setting the overall artistic and strategic direction of the multi-disciplinary art space, which includes residencies, gallery spaces, artist studios, ateliers, festivals, and more. She curates and creates work around themes of community, memory, and creative resistance.

REHEMA CHACHAGE is a visual artist whose practice can be viewed as a performative archive which untraditionally collects stories, rituals and other oral traditions in different media (performance, photography, video, text as well as physical installations), which traces hi/stories directly tied to (and connecting with) her matrilineage, and which utilizes methodologies which are both embodied and instinctual, employing written texts, oral and aural stories, melodies, and relics from several re-enacted/performed rituals as source of research.
She has a BA in Fine Art (2009) from Michaelis School of Fine Art, University of Cape Town; and an MA Contemporary Art Theory (2018) from Goldsmiths, University of London. Currently she is pursuing a PhD in practice with the Academy of Fine Art in Vienna where her research explores alternative ways of knowing/knowledge formation, specifically engaging with inherited knowledges/handed down: songs, names, recipes, building practices, healing rituals, scientific knowledge, etc., as alternative epistemological strategies for rethinking conventional understanding and relationship to knowledge, and in the process, also arguing/legitimising them as knowledges worthy of "mainstream" spaces.

Born in 1987 in Ethiopia, ROBEL TEMESGEN is currently a PhD fellow at Oslo National Academy of the Arts. He received MFA from Tromsø Academy of Contemporary Art, University of Tromsø, Norway in 2015, and a BFA in Fine Art from Alle School of Fine Arts and Design, Addis Ababa University in 2010. Temesgen's work focus on symbiotic relations and the languages around the places, people, and spirits through painting, publication, and installation.

Temesgen's work has been widely exhibited on international platforms in solo and group shows. He received several awards and fellowships, including Lingen Art Prize (2022); Junge Akademie, Akademie der Künste, Berlin (2018); and IASPIS, Stockholm (2017). Temesgen is a Lecturer at Alle School of Fine Arts and Design, Addis Ababa University, and lives between Addis Ababa and Oslo.

SALOME ASEGA is a new media artist and the director of NEW INC, a creative incubator at the New Museum. She was a 2022 United States Artist Fellow in Media, and has previously exhibited at the Shanghai Biennale, the Museum of Modern Art (New York), Carnegie Library, August Wilson African American Cultural Center, Knockdown Center, and elsewhere. Asega sits on the boards of Eyebeam, National Performance Network, and the Guild of Future Architects. She received her MFA from Parsons at The New School in Design and Technology where she teaches classes on speculative design and participatory design methodologies.

TAU TAVENGWA is curator of *Cityscapes*, a print magazine, live event, and exhibitions project focused on re-thinking global cities from a global south perspective.

VALERIE ASIIMWE AMANI is a Tanzanian artist and writer whose practice interrogates the representation of body erotics, language, place and memory. Working between moving image, textile, collage and text, her works are interventions that aim to create communal links between the physical, metaphysical and mythical. She has exhibited internationally including Rele Gallery, Lagos; 31 Project, Paris; and a solo performance at South London Gallery, London in collaboration with the Roberts Institute of Art. Amani holds an MFA from The Ruskin School of Art and was the recipient of the 2021 Vivien Leigh Prize. She is also an art writer focusing on emerging African artists, on the platform Emergent Art Space.

Where Is AFRICA
Vol. 1
2024

ISBN 9781954939011

Editors: Emanuel Admassu, Anita N. Bateman
Design: NMutiti Studio, Nontsikelelo Mutiti
 with Ryan Diaz and support from Alvin Ashiatey
Editorial Producer: Justin O'Shaughnessy
Editorial Support: Emmy Catedral
Copy Editor: Re'al Christian
Printer: C & C Offset Printing Co., Ltd.
Pre-Press: Altaimage, New York

Cover Image: Robel Temsegen, *Last Adbar-Lasting Adbar*, 2023. Courtesy of the artist.

Center for Art, Research and Alliances (CARA)
225 West 13th Street, New York, NY 10011
www.cara-nyc.org

Distributed by Distributed Art Publishers
75 Broad Street
Suite 630
New York, NY 10004
orders@dapinc.com
artbook.com

Graham Foundation

This publication is supported, in part, by the Graham Foundation for Advanced Studies in the Fine Arts.

Special thanks to Camille Crain Drummond for bringing this publication to CARA.

Center for Art, Research and Alliances

CARA is: Executive Director, Manuela Moscoso; Deputy Director, Maya Piergies; Senior Curator, Rahul Gudipudi; Curator of Public Programs, Emmy Catedral; Managing Editor, Rachel Valinsky; Producer, Agustin Schang; Administrative and Production Assistant, Marian Chudnovsky; Bookstore and Visitor Services Associates, Audrey Libatique and Omolulu Refilwe Babatunde; Founder, Jane Hait.